Masterworks

in the

Robert and Jane Meyerhoff

Collection

JASPER JOHNS

ROBERT RAUSCHENBERG

ROY LICHTENSTEIN

ELLSWORTH KELLY

FRANK STELLA

ROBERT SALTONSTALL MATTISON

Masterworks

in the

Robert and Jane Meyerhoff

Collection

HUDSON HILLS PRESS NEW YORK

To Liza

FIRST EDITION

© 1995 by Robert Saltonstall Mattison

All works of art by Robert Rauschenberg and Jasper Johns are © 1995 the artist/Licensed by VAGA, New York, NY

All rights reserved under International and Pan-American Copyright Conventions.

Published in the United States by Hudson Hills Press, Inc., Suite 1308, 230 Fifth Avenue, New York, NY 10001-7704.

Distributed in the United States, its territories and possessions, Canada, Mexico, and Central and South America by National Book Network.

Distributed in the United Kingdom, Eire, and Europe by Art Books International Ltd.

Exclusive representation in Asia, Australia, and New Zealand by EM International.

Editor and Publisher: Paul Anbinder *Indexer:* Karla J. Knight
Copy Editor: Fronia W. Simpson *Designer:* Betty Binns
Proofreader: Lydia Edwards *Composition:* Angela Taormina
Manufactured in Japan by Toppan Printing Company

Library of Congress Cataloguing-in-Publication Data

Mattison, Robert Saltonstall.
Masterworks in the Robert and Jane Meyerhoff Collection: Jasper Johns, Roy Lichtenstein, Robert Rauschenberg, Ellsworth Kelly, and Frank Stella / by Robert Saltonstall Mattison.— 1st ed.

 p. cm.

Includes bibliographical references and index.
ISBN 1-55595-081-7 (alk. paper)

1. Art, American—Catalogues. 2. Art, Modern—20th century—United States—Catalogues. 3. Meyerhoff, Robert—Art collections—Catalogues. 4. Meyerhoff, Jane—Art collections—Catalogues. 5. Art—Private collections—Maryland—Catalogues. I. Title.

N6512.M353 1995 95-18284
709'.73'07475271—dc20 CIP

Contents

Color Plates

Color Plates

Acknowledgments

All books are collaborative efforts, and I wish to thank some individuals who made this one possible. First, Robert and Jane Meyerhoff opened their remarkable collection of modern art to me and allowed me to study it in detail. With Jane, I spent fascinating hours discussing both the works and the artists who created them. I am deeply indebted to her for many insights. I am especially grateful to the five artists who are the subject of this book, Jasper Johns, Ellsworth Kelly, Roy Lichtenstein, Robert Rauschenberg, and Frank Stella. Each one took time out of his busy schedule for interviews, and each reviewed a draft of his chapter. Many new viewpoints and observations in the book result directly from my conversations with the artists. I am thankful to Molly Donovan, Exhibitions Specialist in the Twentieth-Century Art Department of the National Gallery of Art, for coordinating the illustrations and providing factual information about the works. Photographer Edward Owen took the majority of the superb transparencies reproduced in this book.

At Lafayette College, where I teach, my colleagues Diane Cole Ahl and Ed Kerns provided important comments on the text. A teacher also thrives on interaction with his students, and I have been lucky to have had some fine ones who worked on class projects related to this book. Elisa

Freire, Jennifer Ozdoba, Eric Perry, Susana Rodriguez de Trembleque, Gretchen Swilk, and Nancy Zehr stand out among these. Betsy Moore of Lafayette College's Skillman Library has been helpful in ordering numerous publications through inter-library loan.

Sam Hunter, professor emeritus of Princeton University, who lured me into modern art many years ago, has been a mentor, an inspiration, and a friend ever since. This is my second book published with Paul Anbinder, president of Hudson Hills Press. I am delighted to have the opportunity to work with Paul again because of his thoroughness and the high quality of his publications. The editor, Fronia W. Simpson, is also an old friend from Williams College. She wrote me, "I do worry about the meanings of words," and indeed she does. Her precise editing made the text much clearer. Finally, I would like to thank my family: my mother, Carolyn, my wife, Liza, and children, Anna and Spencer, for their emotional support as I worked on this project.

ROBERT S. MATTISON
Lafayette College
Easton, Pennsylvania
January 1, 1995

Introduction

My first visit to Robert and Jane Meyerhoff's Fitzhugh Farm in Maryland is etched in my mind. It was the late spring of 1991, and I had just finished writing a book on the art of the painter Grace Hartigan, a longtime friend of the Meyerhoffs. She arranged for me to meet Robert and Jane and to see their private collection. I knew the Meyerhoff name and recalled a number of specific works that they had loaned to recent exhibitions, but I did not have a complete idea of either the extent or the depth of their holdings. I might be partly excused for this ignorance because both Jane and Robert Meyerhoff are private people who avoid the publicity usually associated with extensive art collecting. Aware of the possibility for damage each time a work of art is moved, they are very cautious about lending; yet the Meyerhoffs readily make their paintings, drawings, and sculptures available when they are needed for a major reconsideration of an artist's career.

I drove to their residence in the countryside north of Baltimore on a fresh spring morning. The house is surrounded by pastureland because Robert Meyerhoff breeds and races thoroughbred horses. The long curving driveway wound past the fenced fields, horse barns, and a pond. The Meyerhoffs' low-lying modern home sits on the crest of a hill, and I passed

Ellsworth Kelly's metal sculpture *Concorde Angle* just before arriving at the house. Jane greeted me at the door. While looking at the paintings in their home, we had the first of many serious conversations about their works. It was immediately evident how much Jane knew and cared about their art and how interested she was in exploring new ideas. It was also apparent that the house, as well as their lives, was dedicated to the art—even the living room was treated as a reading room with the latest art books and exhibition catalogues laid out on a long table. Comfortable chairs with book stands were positioned about the room. We examined Roy Lichtenstein's *Reflections: Nurse*, Jasper Johns's *Racing Thoughts*, Frank Stella's *Gray Scramble*, as well as Ellsworth Kelly's large *Dark Gray and White Panels*, and a number of other works, including a Hans Hofmann painting that had been their first purchase. After exploring each of these with some care, I thanked Jane and told her that she and Robert had put together an impressive collection. She looked at me quizzically and said, "Well, you haven't *really* seen the collection yet."

On the other side of the hill from their house, the Meyerhoffs have added, starting in 1981, six buildings—appearing to be separate structures. They enclose six huge interconnected galleries, each one of which is a single continuous space with a pitched-roof ceiling. Their dimensions (30 × 30 × 60 ft.) are based on the famous double-cube state room designed by Inigo Jones at Wilton House (c. 1649) in England. The white walls of the Meyerhoff galleries are interrupted only by floor-to-ceiling glass corners, which allow intriguing glimpses of the beautiful surrounding landscape. In this way, nature is let into the galleries without being disruptive or taking away from the wall space necessary to display the collection. These galleries strike a balance between a country barn and completely modern architecture. Although the galleries are the size of those in a city museum, the complex is modeled on the idea of a country museum—the engaging Kröller-Müller Museum in Otterlo, the Netherlands, was one inspiration. The Meyerhoffs have created a place where one can escape the hectic pace of city life and, amid the peace of the countryside, concentrate on art. I spent the rest of the day at the Meyerhoffs' home and was barely able to examine, even cursorily, this large and complex collection.

The Meyerhoff Collection is devoted to art made since 1945 and contains major works by a wide range of artists from those decades. But, since 1980, the Meyerhoffs have paid particular attention to the works of five artists: Jasper Johns, Ellsworth Kelly, Roy Lichtenstein, Robert Rauschenberg, and Frank Stella. One gallery is dedicated to each of these artists, and these five are the focus of this book. The decision to collect the works of these artists in depth was not a conscious one. The Meyerhoffs'

acquisitions are based on their belief in the quality of individual works, not on any preconceived theories or plans. Almost to their surprise, they found that these artists began to dominate the collection. As a result of their collecting activities, the Meyerhoffs have become close friends of the five artists. Parties to celebrate major exhibitions will often be held at Fitzhugh Farm. Frequently, one of the artists will arrive to enjoy a quiet weekend, or Robert and Jane will travel to an artist's studio/home to spend several days with him. The artists know that the Meyerhoffs are so interested in their works that they will often ask them to look at new paintings that have especially exciting characteristics. At the same time, the Meyerhoffs attempt to separate the art works from the personalities of the artists and to base their selections only on the particular qualities of a work and its relationship to the group of works by that artist already in their collection. They continue to acquire works judiciously; in fact, they have added Jasper Johns's painting *Spring* (1986) to their collection so recently that I am unable to include a discussion of it in this book.

The Meyerhoffs' fascination with art began in the 1950s. As a young couple, they realized that they were increasingly orienting their travels around art museums in the United States and Europe and thus teaching themselves the history of art. During the 1960s, both held important volunteer positions at the Baltimore Museum of Art. As a result, the Meyerhoffs began to haunt New York galleries, to train their eyes, and eventually to purchase works for themselves. They bought slowly and carefully, wishing to know about an artist's oeuvre before making a selection. Their interest soon turned into a lifelong passion. Twelve years ago Jane Meyerhoff poignantly summarized the couple's view on collecting, one that still applies:

> Why collect art? In a cynical, inflationary era when the word "collectibles" has entered the vocabulary, the question may be moot. Sociologists and psychologists agree that man is naturally acquisitive; that possessions generate pride, prominence and pleasure. I would put emphasis on pleasure. Art cannot be "owned" by a collector since it is proof of someone else's creativity, something unique and often autobiographical, forever belonging to its creator. The de Kooning on the wall opposite me will forever be his albeit it is temporarily in my custody.[1]

The Meyerhoff Collection is dedicated to its artists. It is concerned with presenting as beautifully and coherently as possible the creative endeavors of a number of this century's major painters and sculptors. Yet every private collection bears the stamp of the personalities of the people who assembled it. A private collection does not aim at the inclusiveness of a large public one; rather, it reflects the convictions and values of the individuals who assembled it. The character of the Meyerhoff Collection is

both modern and classical. The artists represented all have charted undiscovered territories of expression at the same time as they cast an eye to the past. They question and revitalize the history of art without destroying it. The Meyerhoffs and these artists still believe in the concept of the masterwork, an artistic creation of great cultural significance made by an individual of profound insight and ability. The collection breathes both originality, which is at the heart of modernism, and the degree of accomplishment that we associate with old-master art. It is the simultaneous individuality and sophistication of these works that this book attempts to capture.

Perhaps the best way to delineate the direction of this book is to describe what it is not. The book is not a commissioned work. After visiting the Meyerhoff Collection several times, I became so intrigued by it that I proposed the project. The last publication about the collection was a very fine, but brief, catalogue written by Nina Sundell in 1980—before the Meyerhoffs began to acquire extensively the works of the five artists named above. The Meyerhoffs allowed me to study their collection because of our mutual artistic interests, and the project progressed as an intellectual adventure. This book does not focus on the Meyerhoffs as collectors. Although their presence is implicit in every choice they have made, there is no discussion of their collecting habits.

The text of the present book is not a critique of the collection. It will be apparent that I admire the vast majority of the Meyerhoffs' selections. These are unquestionably important works by major twentieth-century artists. Rather, my purpose is to explain why the artists made the works and how the art connects with larger issues in their careers and in twentieth-century culture. Despite the quantity of material that has been written on each of these artists, I have discovered information that illuminates the works in new ways. In some cases, these insights may lead the reader to rethink the overall meaning of the artist's work. I have made frequent references to the past critical literature to show how my views differ from it. These differences in turn are reflected in my estimations of the defining features of each artist's oeuvre.

In each of the five chapters, I have alternated between specific investigations of individual works and discussions of general historical and philosophical issues that inform the artists' ways of thinking. I began with the art objects themselves, as the primary sources of information, carefully analyzing each one. I believe that one must attempt to devote the same thoughtful attention to these works that the artists dedicated to them in their creations. Also, I have used information from extensive interviews with the artists, which ranged from discussion of specific objects to general

comments on overall meanings of their oeuvres. The artists' observations provided, on the whole, the most valuable data outside the works themselves. I have also benefited from extensive conversations with Jane Meyerhoff and from her observations about the artists and their works. It was often discussions with the artists and with Jane that set my thinking in new directions.

Finally, although this book does not propose that these artists constitute a group, at the same time, comparisons between them are frequently made. The artists are roughly of the same generation and have many shared experiences. Of course, they have developed in distinctive directions and have produced unique forms of communication. The Meyerhoff Collection, which concentrates on their later works, underscores their mature individuality. But, more than any of the five artists readily admits, they scrutinize one another. Sometimes, they borrow specific discoveries and make direct references to each other's works. More generally, each has enormous ambition and sees the others as benchmarks of imaginative invention. For each of these five artists—Johns, Kelly, Lichtenstein, Rauschenberg, and Stella—the level of accomplishment has been extraordinarily high. This book discusses a portion of their creative achievements.

[1]Nina Sundell, introduction to *The Robert and Jane Meyerhoff Collection, 1958–1979* (Phoenix, Md.: Jane B. Meyerhoff, 1980), n.p.

Jasper Johns

I try to be less enigmatic. And sometimes my mind tends to conjure up the negative of what I am thinking, and I try to see if that's as equally valid as what I am saying. I may get tied up in that kind of activity.

JASPER JOHNS[1]

Discussions of Jasper Johns's work have long focused on the artist's supposed ambiguity. Critics have written either positively or negatively of the uncertainty generated by Johns's art and have seen doubt as his most significant message. Some of the highly regarded articles on the artist contain lists of questions, and others feature adjoining paragraphs with diametrically opposed interpretations of his art.[2] There have been suggestions that his art is impossible to interpret and that the artist himself is unsure of its intent; Johns has been labeled a pessimist.[3] In fact, the opposite is true: Johns is remarkably clear and consistent in the ideas he wishes to investigate. He is notable for his single-mindedness in using his complex art to inquire, in a straightforward manner, into the relationship among seeing, thinking, and picture making. Johns avoids critical stances that attempt to prove or disprove various theories; instead, he is concerned with revealing how we see and think through the particular examples of his individual art works. He examines the ways in which human beings seek coherence from the fragmented and conflicting conditions of life. His work strives to present a great deal of visual information, not to confuse viewers, but to make them aware of alternative readings, options, and choices.

In his art Johns encourages significant visual thinking. He contends that seeing and thinking are not separate processes, as they are traditionally thought to be; rather, they are fully integrated—seeing actively involves speculation, selection, correction, association, analysis, and problem solving. He tries to reveal the roles that memory, predisposition, and anticipation play in perception. Johns demands that we be self-consciously aware of him as creator and of ourselves as viewers. His art leads us to make decisions, ask questions, and form associations, which will eventually lead to a deeper understanding of the visual process and creative thought in general. Johns's art rewards hard looking and thinking. In discussing the flags and targets during a 1965 interview, Johns said, "They're both things which are seen and not looked at, not examined, and they both have clearly defined areas which could be measured and transferred to canvas."[4] Johns's desire, then as today, is to scrutinize and ponder things that are part of everyday

experience. Ultimately, his art expresses a positive belief in the power of perception and thought.

The most recent critical literature on Johns's art has conducted an almost obsessive search for hidden and obscure sources, secret meanings, and camouflaged biographical information.[5] Although this research has occasionally turned up a previously unrecognized source, it has contributed little to the overall understanding of the artist. Johns has always aimed at a public, not a private, language. He has said, "I'm interested in things which suggest the world rather than the personality."[6] He may use a personal incident as a beginning point for a painting, but his intent is not to reveal his intimate history in a romantic or expressionist manner. His desire is to employ that information to address broader artistic problems. The images that Johns paints are mostly common, and their commonality makes them powerful because they lead us to rethink familiar visual experience and to question long-held assumptions. Such images extend from his early flags and maps to the skulls, handprints, faces, and old-master facsimiles in recent works. When a configuration is obscure, like his fragments from Grünewald's *Isenheim Altarpiece,* he repeats it until we can identify it and analyze its presence in many possible variations.

Johns often bases paintings on particular experiences, which he willingly discusses in interviews. These experiences provide the clear and specific events that are the beginning points for his artistic explorations. They include his dream about painting a flag, the first time he drove a car at night, his chance sighting of a car painted with hatch marks, and the view from the bathtub in his Stony Point (New York) house. These incidents have been ignored in the Johns literature or seen as the artist's being deliberately evasive, hiding more important ideas.[7] Actually, the specificity of these occasions tells us of the concrete basis for Johns's art. It is through the prolonged contemplation of particular occurrences, like our sustained contemplation of his individual paintings, that larger artistic and cultural issues arise.

Recent approaches to Johns have overlooked other important aspects of his art. These include the perceptual questions and philosophical implications behind his work, which will be discussed below, as well as its sophisticated, original, and highly coherent structure and the artist's deft painterly touch. In terms of compo-

sitional structure, Johns's images are resolutely two-dimensional and sometimes copied or traced from the objects that prompted them. He has said:

And perhaps I'm more confident working with images of a schematic nature or images that lend themselves to schematization than with things that have to be established imaginatively. At any rate, I seem to be attracted to such things and frequently work with them. Images that can be measured, traced, copied, etc., appeal to me, and I often enjoy that my finished work should contain the suggestion that I used such procedures.[8]

These two-dimensional representations, which undo the accepted "deceptions" of the Western perspectival tradition, are intended to clarify his artistic goals. Because the correlation between his image and the "real" object is so close, the viewer is prompted to think carefully about the nature of the original and to focus on the transformations the artist may have made. Since the relative similarity acts as a control, any change takes on a heightened significance. Thus, the enlarged size of the otherwise exactly reproduced spoon in *Screen Piece #4* leads to contemplation of scale and measurement in art.

Just as Johns avoids traditional modeling in his imagery, he eschews centralized composition, the mainstay of pictorial construction in the West since the Renaissance. Johns has investigated a wide range of other compositional structures, and many of these are featured in the Meyerhoff paintings. They include the allover design of *Night Driver* and *Untitled (E. G. Siedensticker).* In these examples, the viewer's eye moves continuously over the surface, searching for unifying principles and subtle distinctions. Bipolar design is also a favorite mode and can be found in *Perilous Night* and *Two Maps.* These works rely on our natural tendency to compare and contrast; we search for the relationship between the two segments of the compositions. The artist also encourages us to find multi-directional relationships between similar forms. One of the most frequently used in recent works, the picture within the picture, is found in *Racing Thoughts.* There, the various rectangular images, attached to a wall, prod us to seek associations between like shapes despite their very different subjects. Johns also utilizes peripheral organization in which significant images are placed at the outer edges of the canvas. Often, only a small portion of the object is

actually represented, as in *Untitled* (1984) or *Untitled (A Dream)* (1985). In these compositions the viewer completes the work and is made aware of the roles of imagination and experience in the visual process.

Johns's painterly touch, craftsmanship, and sensitivity to materials are other features of his art that have recently been ignored. When his encaustic paintings were discussed in the early criticism of his art, their sensuous surfaces were most often viewed either as a Neo-Dada mockery of Abstract Expressionism or as a gesture of deliberate discontinuity with his subject matter. Actually, Johns's techniques pay homage to and attempt to surpass the Abstract Expressionist involvement with process, and his methods share a similar intent with his imagery. Johns uses techniques that provide as much information about the artistic process as possible, just as his images reveal multiple layers of information. Unlike the work of Robert Rauschenberg or Frank Stella, whose use of materials is directed toward maximum variety, Johns's is characterized by a few materials and techniques—often traditional ones—which he explores with great intensity.

The major material discovery during Johns's early career was encaustic, a medium that has continued to fascinate him. This ancient art substance consists of beeswax to which pigment is added by the artist. The wax, made soft and pliable with heat, has a translucent surface; every gesture made in it leaves its impression. Although it must be worked slowly and carefully, suiting Johns's thoughtful and precise approach, it can easily accommodate change by being reheated. Encaustic can also be used for wax casts, and Johns might integrate two- and three-dimensional forms in the same work, as he does in *Racing Thoughts*. Johns has said of encaustic:

I had read about encaustic, so I went out and bought some wax and started working—it was just right for me. Everything I did became clearer. It coincided with the thoughts I was having about the possibility of anything being discrete. Encaustic keeps the character of each brushstroke, even in layers. It is not like cooking, where things blend together to make a new substance. You can see that these ideas were the thoughts of a young person who wanted to do something worthwhile, something with rigor to it. I don't think my work is any less rigorous now. But now I use a lot of heat and melt everything and let it run. When you become more used to or more skill-

ful with (I don't know which) ideas and media, you don't have to concentrate on them so much.[9]

Johns's oil painting technique has developed out of his use of encaustic—he has had little interest in the more opaque acrylics. In such paintings as *Untitled (M. T. Portrait)*, he mixes varying thicknesses of paint to create controlled slow drips. He varies the density so layers of underpainting are evident, and pentimenti are frequently shown rather than scraped down. Oil paint allows him to indulge in greater detail than encaustic, and images like the watch in this painting reveal an old-master precision and self-conscious virtuosity. In other works we similarly find Johns's intense exploration of media. For instance, *Night Driver* exhibits a subtle mixture of chalk, charcoal, and pastel, showing the potentials of each. These techniques and other aspects of Johns's art may best be examined in terms of specific works.

Night Driver (1960) is an unusual and important work in Johns's oeuvre. This collage drawing, executed in chalk, charcoal, and pastel, is Johns's only abstract drawing until the hatch works of the mid-seventies. All others contain some sort of image, object, or sign, although sometimes barely legible. Even the two rectangular shapes at the base of *Night Driver* are attached to the paper support so that they may not be mistaken for imagery. Nevertheless, the drawing is one of a number of works of the early 1960s that have increasingly less subject matter. (Others include *Shade, No, Disappearance I, Disappearance II,* and *Liar.*) But *Night Driver* is the lone example without recognizable subject matter. It involves one of Johns's career-long concerns, the relationship between the physicality of the art work and its illusionism created through fictive pictorial depth. Johns, of course, realizes that this is an issue that has been at the heart of Western art at least since the Renaissance. The abstraction of *Night Driver* highlights this matter.

This large-scale drawing (45 x 37 in.) consists of a single sheet of paper to which has been attached a second sheet that covers the upper seven-eighths of its surface, except for a narrow border at the top. Joined to the lower area are two small rectangular sheets, separated from one another and abutting the larger sheet. The smaller rectangles have been colored in yellow and red chalk. The surface of the entire work, including the smaller rec-

tangles, has been overlaid with complex layers of black, gray, and white chalk and black charcoal, with small but brilliant highlights of colored pastel. The chalk areas have been smoothly rubbed into the surface to suggest atmospheric depth, but this illusion is deliberately contradicted by the work in charcoal, which alternates between scribbled lines and barely articulated horizontal striations.

The deliberate lack of pictorial definition in *Night Driver* is intended to prod the viewer to pose specific phenomenological questions; the drawing suggests visual paradox. It is simultaneously a concrete object and an almost undefinable visual presence. Johns has suggested that its "abstract nature exists equally with its objective reality."[10] The work is large for a drawing but not so large as to fill our peripheral vision. We see it as a two-dimensional thing hanging on the wall and at the same time are absorbed visually into the complex and indeterminate space suggested by its graphic markings. The large and two small attached sheets stand out as defining forms in the absence of others, yet they too are covered with chalk and charcoal, denying their importance as separate presences. Are they the subjects of the work? Is it possible that draftsmanship itself is the content? We can differentiate subtle areas of colored pastel from rubbed and scribbled marks of chalk and barely discernable horizontal bars drawn in charcoal. Yet the marks are so dense and interwoven that none stand out as focal points. According to Johns, the drawing has a "sense of space that is different from that of many paintings."[11] *Night Driver* is a work that forces the artist and the viewer to question the roles of rational analysis and imaginative intuition in art. The drawing reminds the viewer of the material nature of the work, in contrast to the amorphous space it simultaneously implies. Johns has said that the object quality of *Night Driver* "keeps it where it is, but simultaneously it draws you into somewhere else."[12]

Night Driver stands in interesting contrast to contemporaneous works. It is opposed to Minimal art of the day, which focused solely on the tangible character of the art object. Yet it is also distinct from Abstract Expressionism, particularly the atmospheric works of Mark Rothko, where an attempt is made to deny the physical character of the painting as much as possible in favor of its visionary qualities. The drawing differs from Ad Reinhardt's black paintings, which eventually reward our visual search in a more simplistic fashion with hidden, mystical shapes. Robert Rauschenberg's Black Paintings of 1951–52 are much more tangible and related to specific materials and environments. Johns associates *Night Driver* with the first occasions on which he drove at night. On one level, its artistic meditations are derived from those experiences in which real space seemed especially indeterminate.

Ultimately, *Night Driver* asks us how we respond to its lack of subject and focus. It forces the viewer in upon herself to explore visual and intellectual responses. Can we intellectually impose structure on its maze of marks, and do we require such coherence to comprehend the work? Should we instead allow imagination and intuition to guide our vision? Is our response to its lack of focus curiosity, hostility, sadness, frustration, or imaginative substitution? One good example of the latter is Ruth E. Fine's otherwise precise catalogue essay on Johns for the 1990 exhibition of his drawings at the National Gallery of Art. Confronting *Night Driver,* she imagines that a hanged man appears in the work and uses this "discovery" to discuss its emotional content.[13] No hanged man is visible, and Johns specifically denies the presence of such imagery in an interview Fine printed in the same catalogue. *Night Driver* informs us about our own visual methods, needs, preconceptions, and prejudices.

Screen Piece #4 (1968) is one of six paintings titled *Screen Piece* that Johns created between 1967 and 1968. The first three are identical in size (72 x 50 in.) and were exhibited at the Castelli Gallery in 1968. *Screen Piece #4, #5,* and *#6* are smaller and were done later, in 1968. The main image in all six works is a silkscreen of a fork and a spoon hanging from a wire, and all the paintings were executed in gray oil paint with touches of color. Other elements in the works vary slightly, encouraging the close comparisons among them that Johns favors in his art.

The image of cutlery has appeared frequently in Johns's work. A spoon suspended from the bent wire of a coat hanger appeared in *According to What* (1964; Mr. and Mrs. S. I. Newhouse, Jr., Collection), and a fork and spoon are found in *In Memory of My Feelings—Frank O'Hara* (1961; private collection) and *Voice* (1964–67; private collection). Johns's use of cutlery has been subjected to many interpretations, some quite fanciful.[14] When asked

about the appearance of this imagery in his works, Johns emphasized straightforward connections: "I have the usual associations: eating, mixing, blending, cutting, touching and not touching."[15] In order to find an analogy for his art, Johns turned to one of the experiences we all share, the preparation and consumption of food. The analogy is reinforced by Johns's own long-held interest in cooking. The suggestion is that both art and perception, like food, are common, yet essential, experiences of our lives. With proper preparation, food can lead to subtle and sophisticated responses that invite prolonged contemplation. The fork and spoon are crude tools that when handled precisely—cutting, measuring, blending—can provide these experiences. Johns has included a fork and a spoon in *Screen Piece #4* just as he has shown his own paintbrushes and even a studio broom in other paintings.

Johns has indicated that it is most important to consider the "changes" that have been made in the images of *Screen Piece #4*.[16] Perhaps the most obvious transformation of the implements is their scale: the spoon is about fourteen inches long. Johns makes it absolutely clear that we are to consider this enlargement by including an image of a ruler in proper scale at the top of the composition. Through the size distortion we are made aware that we are looking at a photographic reproduction of the object rather than at the thing itself or its imprint; an aspect of Johns's transformation is thus clarified for us. We are also reminded how easily we accept arbitrary and radical size distortions in art when, for instance, we look at a tiny landscape painting and understand that it depicts miles of terrain. The increased size of the fork and spoon in *Screen Piece #4* resulted from a chance event. A lithograph based on the painting *Voice*, which Johns was preparing, included a photographic reproduction of the fork and spoon. On the photograph Johns wrote the instructions that in the finished work the "fork should be 7″ long," or life-size. The print technicians included his instructions with the image. This mistake then became the impetus for the artist to focus attention on the issue of scale and measurement. Transferring the photograph to silkscreen allowed it to be enlarged, and in several of the *Screen Pieces* Johns's written instructions are included, which, like the ruler, highlight the relationship between the original object and the artist's re-creation of it. We are urged to consider four levels of physical and imaginative change —from object, to photograph, to silkscreen, to painting.

The fact that the fork and spoon hang leads us to question another pictorial assumption, gravitational weight. In painting, forms are typically massed toward the bottom of the composition. This tendency, which makes no sense in terms of the reality of the pictorial surface, is not only evident in realist art but extends to such abstract genres as Cubism and Abstract Expressionism. Johns's suspended cutlery makes us aware of the spurious nature of gravity in painting because the device of suspending them is so patently artificial.[17]

The fork and spoon in *Screen Piece #4* also suggest movement. At the bottom of the composition Johns has drawn a double arc with an arrow at one end. We commonly read this sign as the graph of motion, as if the cutlery were swung on its wire, although we know such motility of the silkscreened images is impossible. Here, Johns is leading the viewer to consider another common pictorial effect—that of potential kinesthesia on the picture surface. Earlier, Johns had presented the results of an object that had actually been moved across the canvas surface, smearing the paint, in *Device Circle* (1959; private collection). The question of why we commonly see the arrow as a sign of potential motion had been explored in Gestalt psychology, which will be suggested as an important influence on Johns. Further, Gestalt arguments were examined by Ludwig Wittgenstein, who extended the use of an arrow to include the direction of a "proposition" as well as simply physical movements.[18] These theories form a partial background to Johns's use of this device.

Before creating the *Screen Pieces*, Johns had avoided working with silkscreen (although he was already involved extensively with other print media) because of the anonymity of the medium and the relative difficulty of manipulating it. Its commercial and mechanical effects were more suited to an artist such as Andy Warhol, although Robert Rauschenberg had already demonstrated painterly and expressive uses of the medium in such silkscreen paintings of 1962–64 as *Brace*, which may have led Johns to further investigations. In *Screen Piece #4*, enlarged screen dots are used throughout to provide a rich texture, and Johns lavishly painted the surface in gray tones with areas of red, blue, and yellow pigment appearing at the upper left edge.

These primary colors form the foundation for all the color mixtures in the painting, just as the ruler is the basis for size relationships. The pigment varies from creamy thickness to thin rills; the artist's hand is everywhere evident. Johns then took pieces of wire mesh of the type used for fences and pressed them into the pigment in the lower center and upper areas. The idea must have been generated by the limitations of traditional screenprinting and is on one level a pun on the term *screen*. Yet the pun is transformed into a powerful artistic device, which gives the surface a richer texture than traditional brushwork could impart. This transformation and the use of the common wire mesh in a new manner are made apparent to the viewer, as are the other artistic devices employed. In *Screen Piece #4*, Johns's method is to reveal, not conceal, information—a notion that has important philosophical underpinnings.

It has long been known that Johns has a deep interest in the writings of the Viennese philosopher Ludwig Wittgenstein, whose work has been a major factor in schools of linguistic analysis in the twentieth century. Johns's interest in Wittgenstein apparently began in 1961, and it has been reported that during that decade he read most of the philosopher's writings,[19] primarily the posthumously published *Philosophical Investigations* (1953), which Barbara Rose called the artist's *livre de chevet*.[20] Despite the attention that Johns's interest in Wittgenstein has received, there has been a fundamental misunderstanding among the artist's commentators as to the meaning of Wittgenstein's ideas and thus Johns's interest in them. The language games that form the foundation of *Philosophical Investigations* are not intended to induce confusion and ambiguity. Instead, their purpose is to clarify the use of language. The games are simplified linguistic situations in which the actual working of language is perspicuously displayed.

In *Philosophical Investigations* Wittgenstein rejected his earlier idea that a universal basis for language could be found. He came to regard words as tools whose use and meaning depended on their context. Wittgenstein's maxim became, "The meaning of language lies in its usage." Wittgenstein wrote in simple, nontechnical, but nevertheless elegant prose, so that his ideas would be made interesting and commonly understood. He believed that the clarity he sought was to be found in common language and specific examples. He stood resolutely against universal principles of most philosophical thinking, claiming that we can know only through specific examples. He wrote, "I fight continually against making up rules in philosophy instead of simply seeing what is there."[21] Wittgenstein also believed that things could be *shown* by the artist that could not be *said* and that art could "represent the particular so that it has the whole world as a background."[22]

Like Wittgenstein, Johns seeks to clarify, not obfuscate, in his work. He does so through presenting particular perceptual situations in his paintings in direct terms. The intense concentration on specific visual problems, the care with which he limits his imagery, the near obsession with certain motifs in subtly varied forms over long periods of time, the concision of his compositional structure, and the transparency of his working methods are all directed to this end. Johns has said of his understanding of Wittgenstein, "I believe he was saying that the things you work with, those are the thoughts you have to use." He added that Wittgenstein found limitations natural, that the range of thoughts is limited, and that we must follow where those thoughts lead. Johns concluded, "We do what we must."[23] Johns seeks a common language that will make complex visual issues understandable.

Johns's belief in his ability to create and in the viewer's ability to comprehend underlying structure amid complex visual information is nowhere more evident than in his Hatch paintings, which were created between 1974 and 1982. These include *Untitled (E. G. Siedensticker)* of 1979 in the Meyerhoff Collection. The Hatch paintings mark Johns's most prolonged involvement with a single motif and are surprisingly abstract for an artist who had become known as an image painter. The primary motifs in the paintings are groups of short parallel marks—between four and seven—that abut adjoining groups of marks, which are oriented in a different direction. In the literature they have been consistently called "Crosshatch" paintings, but this is incorrect. Johns's hatch marks do not overlap. He is avoiding the traditional linear method of creating fictive depth through crisscrossed lines of varying density, a form of modeling. His structure is simultaneously more clearly defined, more resolutely two-dimensional, and more complex than traditional cross-hatching.

The hatch marks in Johns's paintings have been compared to a wide variety of artistic sources. These include Vincent van Gogh's and Paul Cézanne's striated brushwork and Pollock's allover drip technique.[24] The use of hatch patterns in Matisse's Moroccan paintings has been cited, as well as the hatch marks that fragment forms in many of Picasso's paintings. A remarkable and, according to Johns, coincidental similarity between the hatch marks and the painted bed cloth in Edvard Munch's *Between the Clock and the Bed* (1940–42; Oslo, Munch-Museet) also has been discovered.[25] In the latter two cases—Picasso and Munch—strained arguments have been made for the biographical and expressionist intent of the Hatch paintings.[26]

Johns may have been aware of many of these sources, particularly the more frequently repeated instances of hatching in works by such artists as Cézanne and Picasso, but the most important sources of the Hatch paintings are more universal than any of these. And this is perhaps why the motif fascinated Johns for a prolonged period. The hatching pattern relates to basic structures in the natural world, social patterns, and to the way we organize thought. The paintings embody ideas of constancy and change. They are based on fluctuation, progression, sequence, and periodicity. Out of their apparent randomness, we struggle to find underlying order. The Hatch paintings are models for the way we attempt to order the fragmented sensory experiences of our world. During the course of making the Hatch paintings, Johns developed his strategy for them. He has indicated that the only plan he had in the beginning was to have hatch groups of three dominant colors and to have no group of one color touch a group of the same color. He continued, "I found that interesting and saw that other possibilities could occur, such as breaking the canvas into sections and hiding the edges between those sections."[27]

For the viewer, there are four stages of perception in the Hatch paintings. First, there is the immediate impression of complex and beautifully integrated, but undecipherable, pattern. This impression is followed by the realization that certain systems are being used. With careful study, if the attention is devoted, an even more subtle and sophisticated system may be found. Finally, there is the realization that even the elaborate schema does not account for all the variations in the work.

Specifically, in *Untitled (E. G. Siedensticker)*, we are first struck by a feeling of great unity. The broadly horizontal work (90 in. wide) fills our visual field with an allover pattern. The second stage is one of nearly immediate visual understanding of an ordering process. We see that almost all of the color areas consist of the three secondary hues —green, orange, and purple—separated by gray areas and containing dashes of primary color. Also, the hatching marks vary between four and seven; five, the number of fingers on one hand, evoking counting and the artist's touch, dominates. None of the hatch marks overlap and no color cluster touches another.

This comprehension may be followed by a more intensive visual investigation. With scrutiny, *Untitled (E. G. Siedensticker)* reveals a complex underlying order. The painting is divided into five sections. At the junction between the first and second areas, the adjoining hatches differ in both color and direction. Between the second and third portions, the direction is continuous but the color differs; between the third and fourth, color is the same but direction differs. Finally, at the junction between the fourth and fifth sections, both color and direction are continuous. So, reading from left to right, one finds increasing states of unity. The underlying morphology of the painting extends even further. The left and right edges of the composition may be coordinated, and one can imagine the painting bent into the form of a cylinder. Johns has indicated that he wondered whether the ends of the hatch canvas could be related as well as correlating the internal edges of the sections within the canvas. He doubted, at first, if people would notice this refinement because "there is so much to look at in these paintings," but he now suspects that this relationship is essential to integrate the painting internally, even if the viewer does not consciously realize its presence.[28]

If the left and right ends of *Untitled (E. G. Siedensticker)* were joined, four diamond shapes would be made. Seeing these shapes is a particularly difficult perceptual leap because of the painting's width. The viewer cannot stand close enough to see the hatch marks clearly and simultaneously see both ends of the work, so one of the configurations must be held in the mind as the diamonds are imagined. Johns has pointed out two red dots on either edge of the composition, which can be used to aid in conceiving this configuration. He has also indicated that the diamond patterns were a source for the design of a later

Hatch work, *Dancers on a Plane* (1979; collection of the artist).[29] The allusion to a cylindrical shape for the painting is a new way to suggest three-dimensional space, since in actuality the painting remains perfectly flat and does not employ traditional linear perspective.

The cylindrical shape that we may visualize for *Untitled (E. G. Siedensticker)* confirms continuity, progression, and sequence as Johns's themes. Subsequent to one's delight in unraveling this mystery, there is the realization that other elements do not follow any discernible pattern. For instance, no two clusters of hatch lines throughout the entire composition are identical, and areas of primary color have been added seemingly at random. The painting contains black brush marks along its upper and right edges. Do these represent an intent to change the design of the work? When asked about these marks, Johns commented that they represented "artistic liberty"—they are an indication of the arbitrariness of the artist's rules and his freedom to remake or ignore them at any time.[30] While the above analysis may sound intellectual, it has a strong emotional aspect. Just as we experience joy and wonder at first seeing the work, the mind is elated to discover order and to solve problems, albeit incompletely. The eye and the mind seek order and exhilarate in discovery; Johns's Hatch paintings teach us to see and think better.

Remarkable similarities exist between the Hatch paintings and a number of natural structural systems, such as duplex crystals in a copper-silicon alloy. During the 1960s and 1970s, individuals in the science and art communities speculated that all forms are fields of forces, an idea that is germane to the universal language of the Hatch paintings. This notion was first propagated by D'Arcy Thompson's popular book *On Growth and Form*, which was published in an American edition in 1942. Thompson, a biologist with a deep interest in the arts, proposed that living organisms need not be explained in terms of function but could be understood in terms of pure form. He argued that growth and evolution were a series of permutations of abstract shapes. Thompson also wrote of the sheer beauty of form development and believed that his thesis could be applied to all aspects of life, "from reading Shakespeare to reconstructing Greek city states."[31]

During the 1970s Thompson's ideas were taken up by Cyril Stanley Smith, a chemist from the Massachusetts Institute of Technology, who, like Thompson, developed an interest in the arts and wrote popularly on structure. Smith believed that the nature of hierarchy in all things is most accessible to human understanding through visual patterns. Smith summarized his ideas in *A Search for Structure: Selected Essays in Science, Art and History*, in which he attempted to show that patterning pervades all fields of understanding, be they science, social structure, or the arts. He wrote:

Though the units in different fields are different, in all of them meaning comes through communication: patterns of communication are common to all, with aggregation leading to diversity or unity, and clumps of unity, the clumps of unity themselves in turn to units of larger structure based on more complex but still direct communication.[32]

Smith concluded his book with the suggestion that in order to increase our understanding of basic structures we must abandon linear thinking and adopt a "roving viewpoint." He suggested that scientists can learn from artists in this regard:

Sooner or later, however, science in its advance will have exhausted the supply of problems that will involve only those aspects of nature that can be freshly studied in simple isolation. The great need now is for concern with systems of greater complexity, for methods of dealing with complicated nature as it exists. The artist has long been making meaningful and communicable statements, if not always precise ones, about complex things. If new methods, which will surely owe something to aesthetics, should enable the scientist to move into more complex fields, his area of interest will approach that of the humanist, and science may blend more smoothly in the whole range of human activity.[33]

Thompson and Smith are key figures in a wide-ranging scientific tendency toward broadly integrated structural thinking.[34] Their orientation is primarily visual, and their focus is on the universality of such concepts as pattern, sequence, continuation, and disjunction as ways of understanding the world. These ideas are at the basis of the Hatch paintings. Johns is creating patterns that mirror the manner in which we make order out of the seemingly chaotic events and forms of life. It is the complexity and pervasiveness of this project that gives the individ-

ual paintings their profound interest and that kept Johns fascinated by the series for nearly a decade.

Following the Hatch paintings, Johns introduced a range of new imagery into his work. In the literature on Johns, this subject matter is frequently seen to differ radically from such earlier public subjects as the flags, maps, and targets. The new iconography has been characterized as secretive, autobiographic, and disturbing. In truth, the change may not be as great as is thought. The content of these new works remains the nature of observation, visual thought, and creativity. The change is in approach rather than in principle.

Perilous Night (1982) is among the first of Johns's new works. The painting is executed entirely in encaustic (with the exception of a wooden stick attached to its right edge), linking it to the artist's earlier, pioneering use of that medium. *Perilous Night* is clearly divided into left and right portions, a configuration that connects it structurally to his earlier bipolar compositions and strongly encourages comparisons and contrasts between the two sections. The painting juxtaposes an unfocused and fragmented vision in the left segment with a more analytical approach on the right.

As has been observed since the first exhibition of *Perilous Night,* the left-hand portion is based on a detail from Mathias Grünewald's *Isenheim Altarpiece* (1512–15; Colmar, Musée d'Unterlinden). The detail is of the fallen knights before Christ's tomb in the Resurrection panel. When asked about the use of the Grünewald image, Johns commented quite directly, "Don't all artists see other art and continue to use it in different ways?"[35] Since Johns's early career, the old-master artists whom he has considered with the greatest enthusiasm are Albrecht Dürer, Grünewald, and Leonardo. Johns, who does not like to travel, visited the *Isenheim Altarpiece* three times: in 1976; in 1979, with Teeny Duchamp, Marcel Duchamp's wife; and in 1990, with the Meyerhoffs. On each visit, he was struck by the overwhelming visual and intellectual complexity of Grünewald's art. Johns recalls that the first time he saw the painting it made its most powerful impression on him because he was nearly alone in the room with it. He was surprised to find the panels disassembled and "exploded throughout the room and [I was] interested in the challenge of mentally reassembling them."[36] In 1981 a German dealer in old-

master drawings sent Johns, as a gift, a fine set of reproductions of the altarpiece, which isolates details from it.[37]

In the left side of *Perilous Night* Johns re-creates a visionary event. As subject matter the knights are literally "knocked out" by seeing Christ's Resurrection, as Johns was "knocked out" by his first viewing of Grünewald's complex and masterful work. This is perhaps one reason that he chose the particular detail from the painting that he did. The figures that Johns re-creates—the soldiers and, later, the plague victim—are linked by their common humanity. They are neither divine personages, saints, nor demons. Instead, the magic of the event acts upon them. They are spectators, as Johns is before Grünewald's painting, and as we are before *Perilous Night.*

Johns was fascinated by the complex patterning of the Grünewald image. He recalls, "I had the details of the painting in a book of reproductions that were very beautifully cropped. The patterning was interesting, and I thought I could see something in its rhythmic structure that would be very interesting."[38] Johns took the complicated rhythmic structure of Grünewald's detail, which was meant to communicate the confusion of the knights, and greatly added to its compositional ambiguity. Significantly, he blurred the contrast—already vague in Grünewald's work—between figure and ground. The colors are all dark, and the knights are barely differentiated by low-value purple outlines. The most basic and common distinction we make in everyday vision is separating figure from ground. Here, this fundamental perceptual process is called into question. As we struggle to separate the knights from their background, we must contemplate the underlying complexity of this frequently performed visual task. In addition, Johns has reversed the entire image of the knights—as if it were seen in a mirror—and rotated it ninety degrees clockwise. We recognize, for instance, the foreground knight's sword with its hilt in the lower left corner of the painting and its scabbard running at an angle toward the upper center.

This kind of image manipulation, particularly the reversal, is extremely difficult to master conceptually, for both the artist and the viewer. Johns has also painted this portion of the canvas expressively. The encaustic was applied while it was extremely hot, creating in thicker areas drips and rills. In other regions, the encaustic has been lifted from the surface to show the

underlying canvas as ragged white highlights. Sometimes these areas have been further emphasized by the addition of white pigment. Johns has consciously and carefully created an expressive, confusing, and tumultuous equivalent to a visionary experience. He has suggested that the left-hand side of *Perilous Night* takes one spatially into it in a very mysterious way.[39]

Although the Grünewald images are made deliberately difficult to read, they are not necessarily secretive, as has been claimed by Jill Johnston and others.[40] In fact, when *Perilous Night* and other paintings incorporating this imagery were exhibited at Castelli Gallery in 1984, gallery personnel pointed out the references, and they were soon cited in publications accompanying national exhibitions.[41] Johns has indicated that his purpose in transforming images like Grünewald's "was not to hide them but to make me feel they are my own."[42] Johns has used images from the *Isenheim Altarpiece* in over seventy works, including drawings and paintings. He prods us to puzzle out the images in their various forms and thus to pay close attention to the works. The fragmentation, reorientation, and reversal in *Perilous Night* are intended to present a particular type of visual experience, not to hide meaning from the viewer. It should be noted, nevertheless, that in his earlier work Johns rarely quoted as directly from other art as he has in *Perilous Night* from the *Isenheim Altarpiece*. In addition to Grünewald's imagery, later paintings contain borrowings from Picasso and others. This type of erudite reference differs from such common images as the American flag. Like Roy Lichtenstein, whose later works refer to the masters of the early twentieth century, Johns is self-consciously placing his work in the context of art history and alluding to his own status as a master. The same tendency, with less visually direct references, may be found in the later work of Frank Stella. Johns has phrased his reciprocal relationship with earlier art in the sort of philosophical mode and with the reversal of ordinary assumptions that typify his thinking. "Old art offers just as good a criticism of new art as new art offers of old."[43] In keeping with the theme of *Perilous Night* as a fragmented vision subjected to artistic and intellectual control, Johns recognized that Grünewald is not simply an expressionistic artist. He saw the German master as an artist who took an emotionally charged subject and in the spirit of the High Renaissance brought it under

rigorous and brilliant, intellectual command, rendering it through an intricate set of symbols, just as Johns has done in *Perilous Night*.

Johns has said that the right-hand side of *Perilous Night* "attempts to keep you in the present."[44] That side contains more clearly articulated and organized elements, set against an illusional wall with imitation wood paneling in the lower section. Hanging from the upper edge of the painting are three wax life-casts made at three-year intervals from the arm of John Higgins, the son of a friend. The arms are mottled with patches of light and dark, and the top of each is painted with a different primary color. Behind the center arm is an encaustic rendering of one of Johns's Hatch paintings "attached" to the wall by illusional nails. Directly below this "painting" is a trompe-l'oeil grisaille drawing of the identical detail from the *Isenheim Altarpiece*, only now in the same orientation as the original. Also, an image of a handkerchief is tacked to the wood paneling. To the far right, we find a reproduction of the cover and first page of the score for John Cage's 1943 musical composition *The Perilous Night*. We can read most of the title as well as Cage's name. In front of the score is a two-inch-wide piece of wood lathing, hinged at the lower edge of the canvas and attached by a hook halfway up so that it projects from the surface of the work.

Overall, the right side of *Perilous Night* reminds one of an artist's studio wall with various art works, modeling casts, and other objects attached to it. This is not a new theme for Johns. Ever since *Fool's House* (1962; Jean Christophe Castelli Collection) Johns has painted works that suggest the studio environment, including *Studio* (1962; New York, Whitney Museum of American Art) and *Studio 2* (1964; Mrs. Victor Ganz Collection). Generally, artists' workshops have been a popular subject since antiquity, but an important change in this theme took place during the Renaissance with the advent of humanism and the idea of individual creative responsibility. The artist's workshop was no longer a site for collaborative activity; instead, it became a place of solitary creative endeavor and private study—thus the Italian term, *studio*. It was not simply a place of physical manufacture; the valued products were those of the mind—ideas and inventions. The most significant renderings of artists' studios contain the presumption that we should be interested not only in what the artist makes but how he or

she does it. Artistic thought is assumed to be of such importance that it became a subject of its own. In the post-Renaissance era, famous examples include Jan Vermeer's *Allegory of the Art of Painting* (1670–75; Vienna, Kunsthistorisches Museum), Gustave Courbet's *The Studio: A Real Allegory Concerning Seven Years of My Artistic Life* (1854–55; Paris, Musée d'Orsay), and Picasso's many studio depictions as well as examples by Matisse. Homegrown examples of studio walls by John Peto and other American still-life painters are particularly relevant, as are Lichtenstein's studio paintings (1973–74).

Perilous Night participates fully in the idea of the studio as a place where intellectual process is uncovered, and it attempts to be more directly revealing about that procedure than any of the above-mentioned works. On the right side of the painting, Johns reconstructs the manner in which his mind might make order of the visionary event on the left. The Hatch painting reminds the artist and viewer of the connection between Johns's earlier works and his new imagery. The fragmented design of the fallen knights presents a visual puzzle to be solved, just as do the hatch marks. Abstraction and representation are conjoined rather than differentiated. Johns also reminds us of the fine line between images within and outside particular works. The hatch drawing is not a reproduction of any preexisting work by Johns but a new creation. We are notified that the artist's development is fluid, not a matter of set periods, and are prompted to question whether the hatch drawing is any less significant for being incorporated in another composition instead of being a separate creation. The grisaille rendering of the fallen knights is below the hatch drawing, and an arrow drawn behind the central encaustic arm points downward to it. The grisaille drawing is more clearly articulated than the left side of the painting and faces in the same direction as Grünewald's original, thus clarifying the theme. In traditional art, grisaille is a preparatory study, but Johns has frequently used grisaille drawings as a way of rethinking images already recorded in finished works.

Technically, *Perilous Night* is significant in that it is executed entirely in encaustic, the material that has come to be identified with Johns's art. The artist's use of encaustic throughout the painting signals both continuity with his earlier works and the flexibility of the medium as he varies it from the expressionistic handling in the left-hand section to the more detailed rendering on the right. In addition, wax allows three-dimensional creation. The three wax casts hang as they might on a studio wall as models for a painting in progress. Johns has stated that the three arms represent the "idea of time and growth."[45] They can be ordered and measured, and the sequential, temporal experience they symbolize is opposed to the visionary character of the left side of the canvas. The varying sizes of the casts, the result of creation over a six-year period, comment on the lengthy consideration that Johns's art entails, another theme of the painting.

The arms also suggest an ordering process to which the fallen knights are subjected. The arms are mottled—a stylized version of the uneven light pattern in the Grünewald. The top of each is a different primary color, the basis of the artist's palette—just as primary colors were used at the top of *Screen Piece #4*. Because of the position of Grünewald's knights, only three arms are readily visible, and because of perspectival foreshortening, the arms are three different sizes. Peculiarly, in Grünewald, the arm of the closest knight is smallest and the most distant is largest. Johns's arms comment on this arbitrary feature and, by extension, the willfulness of creativity. In light of Cage's musical score, the three arms might also represent a triumvirate of art during the late 1950s and 1960s, that is, John Cage, the choreographer Merce Cunningham, and Johns. As the arms differ in scale, the three individuals differ in age from each other, by about a decade.

At the bottom of *Perilous Night* is an image of a cloth nailed to the wood paneling. It has been suggested that this cloth is derived from Picasso's Weeping Woman series of 1937.[46] It is known that Johns admires these works, and there may indeed be a connection—Johns would later paint a Picasso-derived face on a cloth in *Untitled* (1987)—but this does not necessarily indicate an emotion-laden reading of the painting. The handkerchief is not being used to wipe away tears; it has been put aside. Its apparent use here is related to artistic procedure, perhaps to wipe down the drips of red, yellow, and blue pigment that appear near it. On the right edge of *Perilous Night*, the attached wooden slat also signifies a device of artistic control. It measures the height of the composition and, if unhooked and allowed to extend out-

ward, would determine an ideal viewing distance from the painting, one at which we may see all its details and still take in, at a glance, the overall composition. As the painting rejects fictive depth—the only three-dimensional objects are the actual wax casts—the slight angle of the slat gives a measure of real projection into our space. Finally, the slat resembles a flattened version of the artist's traditional mahlstick, a control device on which the painter rests his hand so as to execute his work steadily and accurately.

The musical score *The Perilous Night,* two pages of which are reproduced at the right of the painting, is the source for its title. The connection probably came to Johns as a verbal pun, Grünewald's knights in peril reminding him of *The Perilous Night.* Also, John Cage has recalled that the title of the musical composition was originally *The Perilous Bed,* named after an Irish folk story about a bed that was on a floor of polished *jasper.* For Johns, who believes that all things are connected, these are fascinating relationships, and their playful character masks more serious considerations. Johns is providing evidence for the way mental associations may be made. An initially witty, but superficial, correlation sometimes leads to a more profound connection, as it does here. *Perilous Night* is about historical connections; Johns's use of the Grünewald painting establishes that as a major theme. As mentioned above, Johns's personal artistic history is significantly linked to that of John Cage. Johns was particularly influenced by Cage's early decision to eschew overt emotionalism in his music for feelings generated by intellectual rigor. Apparently a seminal work in that redirection was *The Perilous Night.* Cage recalled that the piece was concerned with the "loneliness and terror that comes to one when love becomes unhappy." He remembers, however, that the score was not perceived as such by its listeners. One critic likened it to "a woodpecker in a church belfry." Cage's conclusion was, "I had poured a great deal of emotion into the piece, and obviously I wasn't communicating this at all. Or else, I thought, if I *were* communicating, then all artists must speak a different language, and thus speaking only for themselves."[47] Soon after this experience, Cage became involved in a long, structured work that set out to express the "nine permanent emotions" of Indian aesthetic tradition; thus began the first truly experimental phase of his career. Similarly,

Johns's *Perilous Night* is a model for restructuring emotionalism. The mood of this dark painting is somber and controlled, reflecting the essential loneliness of thought and creation. References to Cage's composition, which began as a chance association, became an important statement of artistic direction and values. Johns has called *Perilous Night* a homage to John Cage.[48]

Two other important reference points for *Perilous Night* are the nineteenth-century still-life paintings of John Peto and the 1973–74 Studio Wall and Trompe-l'Oeil paintings of Roy Lichtenstein. There are a number of motifs and devices in Johns's early work that bear resemblance to the art of the American trompe-l'oeil painters around 1900. These include hanging objects, the use of newsprint, the reproduction of photographs and other art works, and images of the reverse side of canvases. In 1961, when Johns painted *Good Time Charley* (Mark Lancaster Collection) with the drinking cup attached to its surface, Ileana Sonnabend commented on its similarity to Peto's *The Cup We All Race 4* (c. 1900; The Fine Arts Museums of San Francisco). After that coincidental relationship was pointed out, Johns clearly paid more attention to Peto's art. His painting *4 the News* (1962; Düsseldorf, Kunstsammlung Nordrhein-Westfalen), derives its title from Peto. The folded newspaper in it, which separates two sections of the canvas, comments on Peto's illusional rendering of newsprint, and the painting has stenciled at its bottom two names, "Peto Johns." The influence of Peto on Johns has been highlighted in the Johns literature. After an extensive discussion of Johns's affinities with American trompe-l'oeil painting, Barbara Rose concluded, "With these native sources in view, Johns's early paintings do not appear so weirdly unprecedented. In fact, they reveal Johns initially, despite extraordinary painterly and conceptual gifts, as essentially a provincial painter, whose ideas regarding illusion were determined largely by limited experience with local sources."[49]

Given the images attached to walls in Johns's works of the 1980s, the issue of Peto's influence reemerges. Johns has indicated that he was primarily interested in Peto for "the idea of workmanship."[50] Through his detailed visual attention and meticulous execution, Peto makes even the simplest objects seem profoundly important, and this is an aspect of his painting that parallels Johns's work. Conceptually, however, the two artists are worlds

apart. Peto is grounded in a nineteenth-century belief in the veracity of traditional illusional rendering. His paintings seek simply to fool and delight the eye with imitations of still-life objects. (His painted objects are even close to the actual sizes of the original objects.) There is no intent in his work to question the nature of standard pictorial rendering. In fact, the shallowness of Peto's space—an approximation of actual depth—increases the illusionism of his work. Johns found something in Peto that the artist never intended. Johns's deliberate denial of illusionism is supposed to emphasize the painting as a new and separate reality. The relationship between images in his works and those in the outside world is meant to act as a benchmark by which we may better measure differences and thus better see the changes that are made. His careful choice of images—for example, the arm casts and Cage musical score—is similarly meant to inform the creative process. Johns was never so naive as to intend to deceive the eye. His desire is, by contrast, to reveal some aspects of the workings of the mind. In the case of Peto and Johns, we learn more by contrast than we do by similarity.

Roy Lichtenstein also has an interest in American trompe-l'oeil painting, which is most clearly reflected in his own paintings of 1973–74. Johns owns one of these Lichtenstein works and has professed particular interest in this period of Lichtenstein's career, which shows objects tacked to wooden walls and to canvas stretchers. These works were probably in the back of Johns's mind as he created his own paintings of the 1980s. The distinctions between the two artists tell us something about each. Lichtenstein, of course, rejects the nineteenth-century illusionism of the trompe-l'oeil paintings, as does Johns. The difference is that Lichtenstein fully accepts the painting as a creation of fantasy, a world separate from outside reality. The comparisons back and forth between what the artist sees and how he depicts it, which Johns urges the viewer to contemplate, are not a pressing issue for Lichtenstein. Everything that appears in Lichtenstein's art has been predigested and turned into the artist's signature style before it appears in the work. His renderings of the backs of paintings are not meant to remind us that the artist has turned those three-dimensional objects—stretchers and canvases—into something else. They are pure fiction and demonstrate the totality of Lichtenstein's control over his artistic world,

front and back. The images that Lichtenstein creates are much more part of a closed and controlled system than are Johns's speculative renderings. Johns's open-ended investigations of the way things are transformed into art are opposed to Lichtenstein's confident assurances of the separation of his art from a world outside.

In *Perilous Night* Johns has established two artistic domains—one that re-created a visionary experience and the other that analyzed that vision. He has speculated on the component parts that allowed translation from one experience to another. *Racing Thoughts* (1984) explores a different type of mental and visual event. It deals with associations that are multidirectional. The phrase *racing thoughts* is a term used in psychology to indicate the mind moving rapidly from subject to subject beyond conscious control. Johns has recalled that he was experiencing seemingly random images at night that made him anxious. One evening at a dinner party, he was telling a psychiatrist about these incidents, and the psychiatrist told him that the condition was called "racing thoughts." Johns later commented, "At least, I was glad that it had a name."[51] Johns's painting does not truly exhibit racing thoughts, but he used this concept as a motivating idea. In fact, the painting is highly controlled and shows the artist contemplating mental flow. It investigates how we build a storehouse of images, the manner in which we reconceive and order our own histories, the relationship of memory and anticipation to perception, and the fact that context alters the meaning of everything. Of these types of associations, Johns said: "Seeing a thing can sometimes trigger the mind to make another thing. In some instances the new work might include, as a sort of subject matter, reference to the thing that was seen. And because works of painting share many aspects, working itself may initiate memories of other works."[52]

As in many of Johns's other works, the painting began with a specific experience, which became the source for a meditation on larger ideas. The painting shows a view of the bathroom wall as seen from the bathtub in Johns's studio-home in Stony Point, New York. The edge of the tub and the water spigots can be seen to the lower right of the painting. All the objects were ones actually in the house. Johns has said, "Every image or object in *Racing Thoughts* was something from the studio or the house. The portrait of Leo Castelli in the painting is a jigsaw

puzzle—a Christmas present years ago from someone in the gallery."[53] While a bathroom scene might appear to be a trivial subject, bath time is one of the few periods in hectic modern life when we are free to let our minds wander and to ruminate on associations made then. The meditative, solitary nature of the experience shares more with events in the studio than might at first be imagined.

When asked about his bathtub-eye-view works Johns has noted, "I think about how to divide the space of the support and how to introduce objects that need to be shown. They are not very tricky—quite straightforward."[54] The statement tells us three things. We should pay attention to pictorial structure and the way the picture surface is partitioned. The phrase "need to be shown" indicates that the selection of images is significant, rather than casual, and the term *straightforward* specifies that direct interpretations should be sought. In terms of pictorial structure, the images of objects against a wall, as in *Perilous Night*, allow Johns to depict them two-dimensionally and thus to emphasize their separate but related character to objects in the world. The artist has commented:

Yes, but there is always a question of how to show such things in painting and drawing. There was something slightly offensive about my making conventionally illusionistic representations of three-dimensional objects....I knew there were other ways of seeing and showing the world, and I was reluctant to fall back on conventional means that others had used more skillfully.[55]

In addition to the objects that populate *Racing Thoughts*, the painting is remarkable for the variety of ways Johns has filled the regions between them. These become a compendium of possibilities for the manners in which the ground around images might be painted. The variations explored here will be used in different combinations in later works. They include wood graining, which hides another figure from Grünewald. The wood graining alone contains narrow and wide striations, circular patterns, hatch marks, and solid and broken lines. To the right side of the composition, Johns uses diagonal striations, which suggest raking light, large areas of pure black, and the shadow of a face in profile. To the lower right, he fills the surface with rivulets of pigment.

The primary manner, however, through which the painting is structured is pairing. The overall composition and the images within it are arranged in couples. These pairs include the left and right sections of the canvas. The images of Leo Castelli and the Mona Lisa, two Italians of the art world—male and female—form another set. The two pieces of pottery are a connoisseur's example of early American folk pottery by the Mississippi ceramicist George Ohr and a cheap tourist vase manufactured to commemorate the Silver Jubilee of Queen Elizabeth II. The skull to the far right is paired in location and design with the faucets and spigot directly below it. And the Barnett Newman print—the only original work of art reproduced in its entirety—may be paired with the whole painting. In terms of locations, the comparisons relate vertically, horizontally, diagonally, near and far.

One of the fundamental ways that we understand the world around us is through comparisons: we pair objects in order to understand them. Our experience indicates that it is easier to describe objects by comparison with each other and that the correspondences and contrasts sharpen our understanding of the qualities of each. In making such comparisons we are led to realize the hierarchical and selective nature of vision. That is, when we confront an object, we make immediate visual choices about which aspects of it will be deemed consequential and which will be dismissed. Comparisons not only sharpen the nature of vision, they also distort the way we see. Aspects of an image that may seem unimportant when the image is viewed in one context will take on new significance as the result of a specific comparison.[56] Pairing forcefully indicates that everything depends on context. The comparisons highlight what conditions we need to determine similarity and also remind us that the mind simultaneously works in two opposing directions. It simplifies in order to find generality, and it records detail in order to differentiate. All these aspects of visual thinking are emphasized by *Racing Thoughts*.

Johns's images in *Racing Thoughts* are personal to the extent that they are things Johns owns, yet they are not cryptic. They are well-known subjects, at least within the art community. Johns's presentation of them makes them public. The artist is revealing, not hiding, his own history and searching for its shared meaning. The images are also carefully, not randomly, selected, and Johns's interest in them is confirmed by their repetition in other

paintings and drawings. The images of Leo Castelli and the Mona Lisa remind us of Johns's history as well as of the borrowed and transformed nature of all his artistic imagery. Johns's dealer and first supporter, an Italian known for his enigmatic smile, is seen in a painted simulation of a photographic image that had been made into a puzzle. A puzzling individual, he is compared to the Mona Lisa. She reminds us of Johns's lifelong admiration for Leonardo, who was—as Johns regards himself—involved in exploring the nature of visual perception and in balancing the visual and conceptual aspects of his art. The importance of Duchamp, who applied graffiti to a postcard in *Mona Lisa L.H.O.O.Q* (1919; private collection) and thus questioned the originality of works of art, is also apparent. Johns's Mona Lisa is a painted image of an iron-on silkscreen that was taken from a black-and-white photograph of Leonardo's painting. Layer upon layer of borrowing is revealed.

While Castelli and the Mona Lisa emphasize Johns's history as a public personage and his use of art history, the two vases speak of the artist's sources in high and low culture, a predilection since his first flag painting. The Ohr pot, one of several examples Johns owns, reveals a connoisseur's taste for a little-known but highly respected ceramicist. The vase, with its lively organic shape, is represented in subtle brushwork. The anonymous Silver Jubilee pot, by contrast, is rendered in simple outline with a stylized shadow. This piece of tourist bric-a-brac features the negative profiles of Prince Philip and the queen, the latter of which is further caricatured by the additional shadow.

Yet the simplicity of the Jubilee pot is misleading. Its kitsch double profile is a vehicle to explore the perceptual relationship between figure and ground that has been a subject of much of Johns's work. The negative image is derived from a visual puzzle called a Rubin figure, named for the Danish psychologist Edgar Rubin, who was one of the founders of Gestalt psychology and who studied figure/ground differentiation. It is one of a number of Gestalt puzzles including the famous rabbit/duck and young/old woman that Johns used in his work during the 1980s and 1990s. Rubin showed that with a change in focus certain images may alternately be read as either figures or grounds.[57] Johns uses the Gestalt image as an example of how, through such a change of focus, more information may be provided and the basic

visual distinction between figure and ground may be questioned. This piece of popular art provokes associations as sophisticated as the fine Ohr pottery.

To the far right of *Racing Thoughts* is a skull whose source is a Swiss road sign, which Johns owns, that warns of avalanches. It bears the multilingual inscription "Gletscherabbruch/Chute de Glace/Beware." The skull is not a secretive image but society's most common international sign of death, danger, and mortality. The proximity of the skull and the written warning reminds us of our two most important modes of communication in modern society, the sign and the written word. We ask, which type of message do we process first, which provides the most immediate warning, and which the most complete information? Although recent studies in perception have shown that the modern individual increasingly reads words before she sees images, Johns has given the visual sign a distinct advantage through the fragmentation of the language and complexity of deciphering the triple warning. In the arts, a skull most frequently appears as a memento mori, or reminder of mortality. Images of skulls have figured with some frequency in Johns's work. As early as 1963–64 he painted a skull in the lower right of *Arrive/Depart* (Munich, Bayerische Staatsgemäldesammlung), and in 1982 he made an imprint of an actual skull on a paper towel. The same year he drew two sketches of skulls, and in 1979 he had suggested a skull-like form in *Dancers on a Plane.* In *Racing Thoughts,* just as the images of the Mona Lisa and Castelli refer to Johns's past, the skull indicates the inevitable future. This reminder of the inevitability of death carries an emotional charge, but those emotions are carefully universalized, compartmentalized, and ordered just as are the references to the history of art.

The skull is placed directly above a faucet to which it has a marked resemblance. The triangular arrangement of the two eye sockets and the nasal cavity is like that of the handles and spigot. Johns has put the skull above the faucet in a number of drawings, reinforcing this relationship. It is this type of visual similarity between seemingly disparate objects that starts the mind working and leads to chains of associations—racing thoughts. While the skull signals death and stasis, the faucet is a source for water actively flowing, movement and progress. Fluidity as a theme is emphasized by the rivulets of paint running between the two images. Yet the Swiss sign also

warns of the dangerous movement of water in a different state, falling ice. Is the cascade of water and ice like the flow of ideas, and is the suggestion being made that such ideas can be either comforting or disconcerting? The spigot and its two handles resemble the male sexual organs and relate to the anthropomorphism of machine parts in the work of one of Johns's favorite artists, Francis Picabia. Johns, who is an avid reader of Sigmund Freud, may have thus provided the symbols for what Freud regarded as the driving motivations behind existence, the life and death forces (eros and thanatos).[58]

Barnett Newman's 1961 lithograph *Untitled* is the only complete work of "high" art pictured in *Racing Thoughts.* It is extremely rare that Johns will show the work of another artist without extensive alterations, as was the case of the Grünewald fragments. Johns's special interest in Newman is confirmed by the fact that he owns several prints by Newman and has recently begun to acquire drawings by the artist. Also of significance is the care with which Johns renders the Newman lithograph. Johns re-creates every nuance of its surface, a remarkable feat given the irregular and nebulous pattern of its abstract marks. Even a reproduction of Newman's signature is precisely rendered at the bottom of the print. Johns's attraction to Newman is based on the contrast between the two artists. Each throws into sharper light the values held by the other. In this manner, Newman's print acts as a foil for *Racing Thoughts* in its entirety. In the generation before Johns's, Newman stood for the absolute and unequivocal, while everything in Johns's art is based on context and individual example. Newman's art is completely nonobjective and, according to him, nonrational. Johns is a maker of images, and the relations between structures and images are his primary concern. Newman's art developed toward increasing simplicity, while Johns's has moved toward greater complexity. Newman proposed a mystical basis for his art, founded on his idea of sublimity, while Johns explores problems of memory, perception, and understanding. Yet despite these fundamental differences, there are similarities between the two artists. Newman used his intellect to distance himself from pure emotion, as does Johns. Newman's famous "zip," for all the metaphysical connotations that the artist found in it, is visually related to the vertical divisions Johns frequently inserts between parts of his canvases. Newman's richly textured surface connects to the painterly surfaces of Johns's oil and encaustic paintings. In fact, the manner in which Newman created his lithograph, which entailed using a stick to mask out the vertical zip and then employing that same piece of wood to wipe over the lithographic tusche, is not unlike Johns's use of the stick to smear paint in *Device Circle* and other related works. More important, Newman represents for Johns a major example of advanced, profound, and honest thinking in a particular artistic direction. When asked about his interest in Newman, Johns replied that what stands out about Newman is "his directness and recognizability."[59]

Racing Thoughts makes the basic assumption that the mind seeks associations; it looks for connections and order and attempts to solve visual and intellectual puzzles. Specifically, a number of the perceptual puzzles Johns uses in this painting, and others, come from Gestalt psychology. Just a few examples include the appearance of an afterimage in complementary colors in *Green Flag* (1955; private collection), the relative color and value scales in *According to What*, puzzles like the Grünewald fragment and the Rubin vase in *Racing Thoughts,* the young/old woman in *Untitled* (1984), and the rabbit/duck in *The Seasons.* Although founded in 1912 by the Frankfurt psychologists Max Wertheimer and Wolfgang Köhler, Gestalt psychology flourished in America during the late 1950s and 1960s; Köhler's very popular book *Gestalt Psychology* was published in New York in 1959.

Although Johns's art has never been considered in light of Gestalt psychology, he has read extensively in the area and has much in common with its investigation of the links between seeing and thinking. According to Gestalt psychology, processes of association, discrimination, and organization take place simultaneously with vision. Visual perception plays the primary role in our understanding of the world, and vision is not a passive but an active mechanism through which we learn. Further, Gestalt proposes that perception depends on context. We do not perceive discrete objects but fields of information. Seeing and thinking for Gestalt are multidirectional, not linear, enterprises, and layers of information, which may be contradictory, are absorbed simultaneously. Gestalt psychology shows that we see and understand objects in a variety of manners, and Gestalt puzzles demonstrate that we become better and

more subtle visual thinkers through prolonged looking. About his uses of Gestalt images, Johns remarked, "There is always another way to see things, isn't there? It is interesting to me that the world is not the same to us."[60] Johns continued, saying that the possibility of differing perception is apparent not only in vision but in such areas as morality. His comments indicate that the visual problems he explores should be regarded as models for a broader consideration of human thoughts and beliefs.

Wittgenstein was preoccupied with Gestalt psychology and commented on it in *Philosophical Inquiries,* citing such visual puzzles as the rabbit/duck and Rubin vase. Gestalt visual puzzles provide one source for Wittgenstein's verbal riddles. Both Wittgenstein and Johns reject as simplistic the tenet of Gestalt psychology that holds that perception is a product of neurological routing for which all the rules will eventually be revealed. Instead, they see issues of visual understanding as so complex and sophisticated that, although guiding examples may exist, simple solutions to the way perception functions are unimaginable. For both of them, this belief is not a source of frustration but a fascinating impetus for continued exploration.

Untitled (1984) reflects Johns's further use of ideas taken from Gestalt psychology. The central section of the painting is a puzzle whose forms are outlined in flesh tones and filled in with striations of complementary red and green. The jigsaw is Grünewald's plague victim, shown close up and rotated 180 degrees. In trying to decipher the form, we pay close attention to the work. In Gestalt psychology, such incomplete puzzle images are called "memory traces."[61] In Johns's painting, the fleshy tones and lushly applied pigment reveal his own involvement with the painting process, while simultaneously reminding us of the art of Willem de Kooning. Shortly before painting *Untitled,* Johns had seen de Kooning's retrospective at the Whitney Museum of American Art. Early in his career Johns had stated his desire to develop a style distinct from that of de Kooning. Now he is able to incorporate discoveries from the older artist within his own vision and thus abstractly suggest a human presence.

At the same time that the central portion of *Untitled* suggests a human presence it is also like a rough stucco wall on which further images have been taped—these associations are additive, not contradictory. Only a portion of these images are included, yet we immediately recognize the one to the left as part of one of Johns's drawings or prints of a flag. This recognition should be followed by a contemplation of the procedures through which we are able to understand these short horizontal bars as the American flag and subsequently as one of Johns's early images. Imaginative completion has allowed us to comprehend the image; we picture it in our minds without actually seeing it. Amid our thoughts about this mental process, we note that the image is of a flag, which first figured in Johns's art in an encaustic painting and then in drawings and prints. It was subsequently transformed into a fragment rendered in oil paint preparatory to this work. Added to this thought process may be the more particular knowledge that among Johns's drawings and prints of flags, there is no example of the flag in its true colors with the size border shown in this painting. The representation was invented solely for this work. Issues of invention and appropriation are raised as well as the role of specialized knowledge in understanding all of the ramifications of the work.

Whereas the flag refers to Johns's earlier history, the drawing to the right is one of his contemporary interests; it is another puzzle adopted from Gestalt psychology. Conceived by W. E. Hill in 1915 and called *My Wife and My Mother-in-Law,* it became famous when the American psychologist E. G. Boring used it as an example of a perceptually variable figure. The image can be seen as a fashionable young woman with a ribbon around her neck or as an old woman with a huge nose and chin. The idea that with a change of viewpoint the same image can produce radically different information fascinates Johns. Boring also suggested that the image one saw first depended on one's age—younger individuals had a predisposition to see the pretty young woman first and vice versa. The theme of age as it relates to perception fits with Johns's use of the early flag contrasted to the later discovery of the Hill drawing. The fragment of the young/old woman, like the flag fragment, emphasizes the amount of visual information we need in order to complete a form mentally. The drawing is cut off right at the ear of the young woman (eye of the old woman). It is this detail that makes the transition between the two images possible. If the picture were segmented just an inch to the left, read-

ing the image would be much more difficult, as can readily be seen by blocking that area of the painting from one's vision. The nail near the center of *Untitled* promulgates ideas about two-dimensionality versus obvious illusional devices and leads us to speculate what else might be "hung" on that nail and thus added to the painting.

Yet another change of focus is possible in *Untitled*. While our first tendency is to concentrate on the flag and the young/old woman and to read the center of the painting as background, that area also attracts our attention because of the Grünewald puzzle and the lush paint handling. If the central area is read as figure, it forms a large capital I at the core of the painting. This was first noticed by Ellsworth Kelly, when he was studying the painting with Jane Meyerhoff, and was subsequently confirmed by Johns. The giant formal I is not a biographical revelation. Instead it reminds us of the artist's public role as the creator of a unique work; its discovery is a reward for careful and creative looking.

Between 1984 and 1987 Johns made a group of works we shall call Seascape/Faces. Each work in the series features eyes, a schematic nose, and lips, which float at the perimeters of the canvas. The series began with a graphite drawing. This was followed by seven paintings made between 1985 and 1987 and five more related drawings in 1987. Two of the paintings, *Untitled (A Dream)* (1985) and *Untitled (M. T. Portrait)* (1986), and one of the drawings are in the Meyerhoff Collection.[62] *Untitled (A Dream)*, like the other works in the Seascape/Faces series, simultaneously suggests a female image and a seascape. When asked about these works, Johns stated that they represented "the idealized mother,"[63] blending the idea of the nurturing female with that of the restorative powers of Mother Nature. As is the case with other paintings by Johns, the series has its origins in a particular situation. Since the early 1980s, Johns has spent much of each year at his studio-home in St. Martin, French West Indies. He has come to love the locale for its beauty, gentle climate, and the peace it offers him to work. Although not all the paintings in this series were executed in St. Martin, they reflect Johns's meditations on that region.

The face in *Untitled (A Dream)* consists of two floating eyes, one in the upper left corner and the other at the right edge of the picture. At the base of the painting are sen-

suously curved lips and to the lower left is a schematic loop indicating nostrils. Johns's face is derived from Picasso's painting *Straw Hat with Blue Leaf* (1936; Paris, Musée Picasso); it was one of the works that the Spanish master kept in his private collection. Johns first saw the painting at a 1979 exhibition of Picasso's own collection at the Grand Palais in Paris, and it was subsequently reproduced in David Duncan's book, *Picasso's Picassos*, which Johns owns. Johns has said that he likes the Picasso painting for being "more than one thing," and that "it's informed with sexual suggestion and very complicated on that level."[64] In his painting, Picasso flattened the face in a Cubist-derived manner so that we see simultaneously both the eyes and the nose in profile. The facial features are separated by large areas of flesh, which suggest open space. Johns has said, "I was working with Picasso's *Straw Hat with Blue Leaf*. He extended the woman's features to the outer edge of her face. I got the idea to push the features to the outer edge of the canvas, the canvas with features attached to it."[65] In an imaginative leap, Johns associated the open center of the painting with a view of nature, so that, in his words, it is "more than one thing." In addition, as Johns states, Picasso's face is sexually suggestive. The two protuberances on its right side are like breasts, particularly the lower one, where the eye plays a double role as nipple. Thus, Picasso connected the idea of sexuality in terms of the nourishing breast to the nourishing quality of vision.

The face Johns created is far more radically distorted than Picasso's. Not only does it become the entire picture surface, but it suggests, through placing the eyes at the outer edge of the composition, that in order to complete the head one must mentally form the painting into a cylinder, as one does for different reasons in *Untitled (E. G. Siedensticker)*. Such a design for the face may also be related to the blonde female at the center of Lichtenstein's 1978 painting *Razzmatazz*, which Johns had seen many times in the Meyerhoff Collection. In *Razzmatazz*, the figure's wide eyes and voluptuous mouth are pushed to the outer edges of her face, with the eyes extending suggestively beyond the head, and modulations in Lichtenstein's Benday dots ambiguously hint at the cylindrical nature of the head. Whereas both Lichtenstein's and Picasso's faces look outward, Johns's appears to stare fixedly inward, perhaps at the marvel of the artistic transformation. Picasso's eyelashes become

radiating lines of vision. Unlike Johns's earlier body fragments from plaster casts, in which critics have noted a disturbing character, these features, ranging from the wide eyes to the full lips, have a gentle, sensuous character.[66]

Johns's Seascape/Faces have another important source that has not been previously noted in the literature. After Johns completed several paintings and drawings in this group, he realized that the images resembled one that he vaguely remembered from thirty years before. In a 1952 issue of *Scientific American,* Bruno Bettelheim, who subsequently became a noted psychologist, published the article "Schizophrenic Art: A Case Study." The article contains a series of drawings made by a young girl during three years of care at the Sonia Sahnkman Orthogenic School of the University of Chicago. The girl suffered mentally because of the early death of her father and mistreatment by her mother. Bettelheim demonstrates that the drawings progressively show the reintegration of her personality. The particular drawing that Johns recalled after so many years revealed, according to Bettelheim, her acceptance and even idealization of her mother. In Bettelheim's words:

In picture 10 which she called "Baby drinking Mother's Milk from the Breast," she seems to have recaptured her mother's face. This was a pictorial world that consisted only of the mother's breasts and, just above them, what the infant sees—mouth and eyes. As if to emphasize the primitive sensations, she put fingerprints all around the border.[67]

Johns apparently ran across the article in 1952, soon after returning to New York from military service. Recently, when Johns sent a studio assistant to look up the article after recalling the connection, he was astonished to discover how close his images were to this drawing, which had remained in the back of his mind for decades. Johns's first works in this group contained the circle of the breasts and occasionally fingerprints, but in subsequent paintings, as Picasso had done in *Straw Hat with Blue Leaf,* the breasts merged with the eyes. The drawing in the Bettelheim article perfectly coincides with Johns's works that explore the theme of the nurturing quality of the idealized mother and Mother Nature. It is important to emphasize, despite Johns's first subconscious reference to the drawing in the Bettelheim article, that his theme of the ideal mother was self-conscious,

and that he deliberately meant his paintings to reveal the idea of a gentle, nurturing presence. To risk stating the obvious, Johns did not suffer as a child the particular situation of the little girl in the article, he is not schizophrenic, and his art is not therapeutic.

In his pursuit of the notion of the idealized mother, Johns contacted his family to find out the eye color of his step-grandmother Montez with whom he had spent several years as a child. Accordingly, he changed the eyes in some of his paintings from Picasso's brown to Montez's crystal blue. One of the paintings in the series is, in fact, titled *Montez Singing* (1985–86; collection of the artist), yet Johns's work is not autobiographical. His memories have been universalized to encompass the concept of the gentle female and bountiful nature. The paint texture and pink-tan color of *Untitled (A Dream)* simultaneously imply flesh, the famous sand beaches of St. Martin, and the stucco walls of Johns's studio-home. Reading the painting as a seascape, the eyes are like the sun, their lashes are its rays. The lips closely resemble the island Saba with its twin volcanic peaks that Johns can see from his house. The curved line of the nostrils is like a seabird in flight. The painting *Montez Singing* reinforces the seascape association. Its view is framed by trompe-l'oeil wooden boards, and the effect is as if one were looking out a window under construction, and the lips (island) rest on a waterlike horizon line. The work contains an image of a little red boat. Johns's step-grandmother used to sing him the song "Red Sails in the Sunset," and a boat with red sails also passes by Johns's house every afternoon.[68] As with the sensitive character of the female face, the view of nature in these works is temperate and enriching.

As well as being a face and a seascape, *Untitled (A Dream)* suggests a wall. Johns has said, "Once something is stretched out, you try to find meaning. The seascape and the wall are possible solutions."[69] On the wall are hung a drawing and a watch with a red wristband. The drawing is once again the puzzle of Grünewald's plague victim. If anything, the plague victim has here been rescued by Johns; the victim appears to swim amid the colorful patterns, and perhaps his skin affliction is transformed into nothing more serious than a sunburn. The watch fits with the relaxed mood of the whole work because our wristwatches are the constant reminders of passing time and tasks to be completed. We take them

off when we vacation and especially when we go to the beach. The removal of the watch symbolizes the dismissal of passing time and perhaps an attempt to freeze a pleasurable moment. In nearly every painting of the series, Johns's watches—playful because of their bright red bands—read between 5:00 and 7:00, late in the day when we are particularly relaxed.

Although Johns never meant to hang the two works together, *Untitled (M. T. Portrait)* looks like a pendant for *Untitled (A Dream),* and the artist is delighted that both are in the Meyerhoff Collection. Their relationship speaks of the closely integrated ideas in Johns's work. *Untitled (M. T. Portrait)* reverses the association between the puzzle and the seascape/portrait, and consequently the readings are even more multiple. Because of its painterly activity, the puzzle adheres to the surface. The "drawing" is nailed to the surface and, at the same time, because of its relative emptiness, seems like a window in the wall. Its shadowed right and bottom edges may ambiguously signify either the drawing hanging on a wall or a windowsill. In this painting, as in the earlier work, many pentimenti are visible, showing the subtle changes Johns made in the design. When asked if the large areas of pink-tan pigment and relatively few images made these paintings easier to execute than his earlier works, Johns responded, "Well, they were intended to be."[70] His response indicates the lyrical intention of the paintings. It also points out that this lyricism was arrived at, like everything in Johns's oeuvre, with a great deal of thought and effort.

The startling interplay between face, landscape, and wall in the Seascape/Faces is particularly reminiscent of Surrealism. Among the Surrealists, Johns has had a long-held interest in René Magritte. He owns several of Magritte's works, including the important 1936 painting *The Key of Dreams,* and has become an expert on the artist. *The Key of Dreams* is one of Magritte's works dealing with visual signs and language. In it, a number of dryly painted representational images are arranged in a grid, and beneath each of these is a written identification that bears no relationship to the object depicted. Aptly, the work Johns owns is the only one in which the words are in English. Both artists are concerned with philosophical problems of vision, language, and representation. There are, however, profound differences between

Johns and the Belgian Surrealist, which have not been noted adequately in the literature. Magritte is concerned with breaking down common assumptions; his art is primarily disjunctive. *The Key of Dreams* is intended to show the slippery and tentative nature of "reality." When Magritte wrote "the door" beneath an image of a horse and "the wind" below a clock, he demonstrated how easily our common means of communication are upset— that is, society's agreement that certain images and written signs will mean the same thing can be shattered with simple means. When this correspondence is broken, our ability to communicate falls apart and we lose that common state we call "reality." Johns uses Magritte as a starting point. While Johns breaks down traditional modes of perception, he also suggests new ways of seeing and different associations that may be made, whether these are the underlying structures of the Hatch paintings, the relationship between the left and right panels of *Perilous Night,* or that between the pairs of *Racing Thoughts.* Magritte's art relies on the shock of disassociation, while Johns's urges us to reconsider and reconstruct basic mental and visual processes.

Many individual motifs of the Seascape/Faces may have been inspired by Magritte. Johns's wristwatch is like the timepiece in *The Key of Dreams.* (One also thinks of the nearly ubiquitous clocks, which freeze the moment into eternity, in Giorgio de Chirico's paintings of empty piazzas.) The idea of the face/seascape and particularly the eye as sun resembles Magritte's famous *False Mirror* (1929; New York, The Museum of Modern Art), in which the iris becomes the sky and the pupil a dark, negative sun. Magritte's *Human Condition I* (1933; Claude Spaak Collection) illustrates a painting that is paradoxically in front of a window and is also the landscape seen through the window. Yet, in all of these works, Magritte relies on magical and inexplicable effects. Johns urges us to follow his thought progression more coherently, as he creatively blends wall and face and seascape. Magritte's presentation of fantastic impossibility is remade as a process of imaginative connections in Johns's Seascape/Faces.

Generally, the Seascape/Faces employ Surrealism as a way to free the imagination and to spark inventiveness. This use of Surrealism has a tradition in American art that extends back to the Abstract Expressionists and includes such different Surrealist-inspired works as those Roy Lichtenstein made during 1977–79 and Frank

Stella's Exotic Birds series of 1976–77. Because of their relative abstraction, the schematic nature of their forms, and their painterly character, *Untitled (A Dream)* and *Untitled (M. T. Portrait)* also resemble Joan Miró's works, particularly *The Hunter (Catalan Landscape)* (1923–24; New York, The Museum of Modern Art). In Miró, as in Johns, nature is signified by broad areas of color, and Miró uses a similar pink-tan for his landscape. The forms in each are treated as schematic two-dimensional signs, and in both works, an eye floats in the sky as a sun symbol. Generally, the two artists share a view of nature as nurturing and gentle. Miró's preliminary studies show that, like Johns's, a great deal of planning was required to create the seemingly spontaneous composition. The major distinction between the works is that Miró much more thoroughly creates a world apart, one of lyrical fantasy, whereas Johns constantly reminds us of his sources and the way his imagination has transmuted them.

Johns's *Untitled* (1987) is closely associated with the Seascape/Faces. In fact, one of them appears as an image within the painting. It is typical of the layered thought that Johns favors that the earlier work would now become part of a new and extended context. In *Untitled*, Johns has arrived at a new device to show objects that are two-dimensional yet strongly reminiscent of their sources in the three-dimensional world. He has provided the representation of painted cloths tacked loosely to a wall. The idea was apparently generated by Francisco Zurbarán's *Veil of St. Veronica*, which he saw in 1987 at the Zurbarán exhibition at the Metropolitan Museum of Art. Johns later said that he only wished the face of Christ had not been on the painting.[71] Of course, the cloths are also direct descendants of the images of works on paper—drawings, prints, and photographs—attached to walls in his earlier paintings. In addition, the cloths resemble unstretched canvases.

In the Seascape/Faces, Johns showed Picasso's *Straw Hat with Blue Leaf* as it had already been reformed. Now he takes us back to the source for his ideas. Reading left to right, we see Johns's transformed image in the form of a face and a blue seascape, the Picasso—minus what Johns considers extraneous elements—and finally the familiar Gestalt image of the young/old woman. This third image provides the theoretical source for what Johns has done. It demonstrates that we can see an image in two entirely different ways—in Johns's words, with a different focus. (A single image can be a face, a wall, and a seascape.) These three cloths, so carefully arranged at the bottom of the composition, stand in marked contrast to the rest of the work. There, in dark green pigment mixed with gray-rose and burgundy that have been rubbed and washed layer upon layer, two indistinct images of the plague victim appear—one upside down at the upper center of the painting and the other right side up to the left side. While a single version of these images provided a sufficiently difficult visual puzzle in earlier works, two examples, which overlap, make reading them even harder. Johns has contrasted an indistinct and indeterminate vision in this part of the composition with the clearer and more programmatic character of the three cloths. The relationship between the two areas is highlighted by visual associations. The cloth to the left seems to cover up the naked body—a trompe-l'oeil device used with some frequency in such nineteenth-century paintings as Raphaelle Peale's *After the Bath* (1823; Kansas City, Nelson-Atkins Museum of Art), which Johns certainly knew because the Meyerhoffs sent him a reproduction of it. Also, the upside-down victim wittily has the Picasso head where its head should be. In *Untitled*, Johns opposes two distinct visual experiences, one fragmentary and elusive and the other clear and lucid. This idea resembles that found in *Perilous Night*, except that the references to the artist's studio are less specific and the two perceptual experiences are seen as overlapping and complementary rather than as one directly inspiring the other. It might even be suggested that the hanging cloths of *Untitled* are in fact the cloth tacked to the wall in *Perilous Night*, spread out and painted with images.

The United States map is one of the subjects most closely identified with Johns's art. His first map (1960) was a small work (8 x 11 in.; Robert Rauschenberg Collection) in encaustic on paper mounted on canvas, which had its origin in a simple map of the type children use to identify and color in the various states. Rauschenberg gave such a map to Johns, who painted over its printed outline. Subsequently, he made his first large painting of the subject, *Map* (1961; New York, The Museum of Modern Art), by transferring the outline of the map onto canvas, which he painted freehand. The lively contrast

between the map as a diagram and the lushly painted surface became a leitmotif of the series. In 1962 and 1963 Johns made a small map and two large encaustic and collage versions. He varied the composition in 1965 by stacking two maps on the canvas in *Double White Maps* (private collection); this work was later severely damaged. In the process of restoring it in 1989, Johns joked that it would be easier to repaint the entire work and said, "Later I wondered what it would be like to do that, and so I began to do it."[72] The result is the monumental *Two Maps* (1989). By creating this work, Johns was able to ensure that an undamaged example of this composition would exist in the world.

Johns's attraction to the map as subject matter has received a wide range of interpretations. It has been viewed by some simply as an available starting point with no additional consequence. Other critics have seen it as either a real or an ironic power play in which the artist can obliterate entire states with a flick of his wrist. The loosely painted surfaces of the Maps have also been called a sign of existential freedom in the face of rigid structure. In contrast to these theories, the maps could be seen to raise important questions about observation and apprehension of symbolic visual systems. A map is an extremely sophisticated representation on a two-dimensional surface of the distribution of natural elements in space. It is one of the more complex sign systems that we regularly use. Johns deliberately chose the most familiar geographical area for an American. The children's map that Rauschenberg gave him undoubtedly led to memories of civics classes, where as a child Johns, like most of us, memorized the forms, positions, and names of the states. The American map is, thus, a complicated set of learned shapes and information. Understanding the map also requires an advanced sense of abstract transposition. As children we learn that the map is not nature or territory; rather, it represents a concept of these notions. We form imaginative bridges in time, space, and geography. Even to the young child, certain points call forth visual images of particular landscapes. We understand that the map is a symbol, a tool, a way of thinking. All of this information—without which it is impossible to understand the map—we absorb on an unconscious level. Johns's Maps urge us as adults to reexamine this learning process. The manner in which Johns paints the Maps and their final appearance

encourage this interpretation. John Cage has described the creation of one:

He had found a printed map of the United States that represented the boundaries between them. It was not topographical nor were rivers or highways shown. Over this he had ruled a geometry which he copied enlarged on a canvas. This done, freehand he copied the printed map, carefully preserving its proportions. Then with a change of tempo he began painting quickly, all at once as it were, here and there with the same brush, changing brushes and colors, and working everywhere at the same time rather than starting at one point, finishing it and going on to another.[73]

What Cage describes is a constant and repeated test of the artist's eye, hand, and memory. It begins in a calculated fashion with the enlarged drawing and continues in an intuitive manner as he nearly obliterates the structure of the map, then rescues it. Working all over the surface of the canvas rather than from point to point not only ensures stylistic unity, it makes the challenge of retaining the map in memory and preserving its overall form that much more difficult. As observers we experience something akin to Johns's working process. We know the American map but probably do not recall all the details of its contours or all the shapes of the states. Johns's Maps are difficult to read; we can barely recognize many of the forms. They force us to struggle to remember learned boundaries and to make imaginative leaps where the design is not clear. We are reminded what a complex set of associations the map represents. Not only are Johns's map boundaries obscure, but the letters that identify each state vary in typography, size, and clarity. In some states abbreviated letter codes are used, while others include both the whole names of the states and assorted abbreviations. We are reminded that language encompasses subtly variable signs no less complex than the shapes of the map. Because we are naturally compelled to complete the map's structure, we focus with new intensity on the variations Johns has made. The sensitivity and originality of his brushwork, which extends from creamy impasto to thin glazes of pigment and which is applied in all manners, from razor-sharp lines to broadly scumbled patches, fully occupy our attention.

As has been mentioned earlier, Johns is an artist who bridges tradition and modernism. Just as he has recon-

ceived the still life, the portrait, and the abstraction, his maps are conceptualized landscapes. *Two Maps* was probably inspired, not only by his desire to retry his earlier Maps but by his Seascape/Faces, which are also excogitations of nature. *Two Maps* is a particularly successful version of this subject. The painting's large scale is visually compelling; it makes a monumental impression. Its size (90¼ x 70¼ in.) also reminds us of the sophisticated understanding of scale needed to read a map. *Two Maps* is not, of course, as large as the landscape, but it is far bigger than the maps we commonly encounter, so that the relative scale between what the map depicts and the map itself becomes an issue to contemplate.

The color of *Two Maps* is also very successful. The nearly monochromatic painting forces us to concentrate to read its information. We are pushed to the very edge of our perceptual limits. The slight variations of white that exist only in the small range between titanium and ivory are so hard to perceive that, despite its scale, the painting can be read only within a distance of twenty feet of it. The total absorption that *Two Maps* requires produces an almost hypnotic effect. Its impact is more effective than the brashly colored maps of the 1960s and is rivaled only by Johns's nearly black maps in graphite on paper. In addition, the dual images of *Two Maps* work well because they encourage us to compare and contrast. Although the maps appear identical at first, they are painted differently in nearly every passage. A general rule, perhaps employed unconsciously by Johns, is that a geographical area that is relatively clear in one of the two maps is particularly obscure in the other. For instance, North Dakota in the upper map consists of comparatively dark pigment with drips and slashed brushstrokes. Its borders are unclear and the name of the state, "N Dakota," is difficult to see. In the lower map the borders of the state are firmly drawn and its surface is constructed of flat patches of pigment. Its name is depicted with relative clarity both in pure white and cream-colored paint as "N.D." and "North Dakota." Throughout Johns's *Two Maps* we are prompted to reexamine visual and intellectual systems otherwise too easily taken for granted.

Johns's concern with redefining the past to make sense of the modern world reached an apex during 1985 and 1986. At that time, he undertook a series of paint-

ings, the Seasons, related to two of the great themes in the history of art, the four seasons and the four ages of man. In art history these subjects date from late antiquity and are first found in Roman frescoes and mosaics. They have a continuous history in the visual arts through the nineteenth century and are also major subjects in literature, particularly pastoral poetry. The theme of the seasons is also related to Johns's immediate artistic circle. In 1945 John Cage wrote the musical score *The Seasons*, for the New York Ballet Society, which was performed several years later by the Merce Cunningham Dance Company. In *The Seasons* Cage tried to express "the concept of seasonal cycles found in Indian philosophy—spring symbolizing creation; summer, preservation; fall, destruction; and winter, quiescence."[74] This connection parallels Johns's use of Cage's *Perilous Night* in his painting of similar title. The universal symbolism Cage sought in Indian philosophy is precisely the type Johns aims at in the Seasons, and his individual paintings and drawings may be linked to the four ideas of creation, preservation, destruction, and quiescence. Just as Cage sought to make these traditional ideas and the conventional instruments for which he was writing the score sound new, so Johns found a fresh and unfamiliar appearance for his Seasons.

Traditionally, both the seasons and the ages of man attempt to make sense of existence, to see the passage of time and the events of life as meaningful, related, and orderly. When the two themes are joined, as they often are, human life is given continuity through connection to the larger natural world and its ongoing cycles. Johns uses his Seasons to clarify the idea of the artist's life. While the images in the series are drawn from his own career, they are not simply autobiographical. He has rearranged and manipulated history in order to portray an idea of cyclical change, an order and logic that life itself does not often possess.

Johns did not begin his paintings of the seasons with the idea of a series. He created *Summer* as a single work in 1985 to commemorate moving to his new studio in St. Martin. Subsequently, he executed an etching called *Summer* as the frontispiece for a volume of collected poems by Wallace Stevens, one of his favorite poets. He was affected by reading Stevens's poem "Snow Man" and began *Winter*. While Johns was painting *Winter*, he completed in January 1986 the four large-scale drawings in

the Meyerhoff Collection. Like the entire concept of the seasons, these drawings are retrospective in a very self-conscious manner. They are not actual "working drawings" since the paintings were already underway, but Johns commented that he was thinking about "what working drawings would look like." The drawings, therefore, became an essential component in Johns's calculated meditations on different modes of creativity and the passage of time. The Meyerhoff drawings are the only complete suite of Seasons drawings; because the paintings have been dispersed to various locations, they provide a unique opportunity to view the cycle together.

As was the case with many of Johns's works, the idea of the Seasons began with specific events and locations. Each of the paintings refers to one of the artist's studios: St. Martin; Stony Point, New York; Houston Street; and midtown Manhattan. In addition to rethinking his own art, Johns's Seasons draw on two art sources. They are two paintings by Picasso, *Minotaur Moving His House* (1936) and *The Shadow* (1953), both in the Musée Picasso and both reproduced in David Duncan's book *Picasso's Picassos*. Johns borrowed the specific images of rope, ladder, cart wheel, and stars from *Minotaur Moving His House* and the shadow as a stand-in for the artist from *The Shadow. Minotaur Moving His House* must have particularly struck Johns for the similarity of its subject to Johns's own life. (Johns's astrological sign is Taurus.) Picasso made his painting when he was the same age as Johns and in the process of moving his studio. When Johns was making the Seasons, he was establishing new studios in both St. Martin and in midtown Manhattan and was gathering his possessions, the physical records of his ideas, in preparation for the relocations. Also, Johns was considering his relationship to the acknowledged master of twentieth-century art. Yet the paintings reveal that Johns's connection to Picasso exists as much by contrast as by the similarities that have been pointed out by recent critics.[75] In *Minotaur Moving His House,* the tough, confident minotaur—Picasso's symbol for himself—controls the scene. His personality dominates all that surrounds him, just as the artist's shadow overwhelms the fragile figure of Françoise Gilot in *The Shadow.* In the Seasons art dominates—things the artist conceived and collected. It is a world of ideas and interests, not of an overbearing ego. Johns's shadow

is featureless, floating and awkward compared to the bright clarity of the things he shows. His notion of art as a speculative enterprise in which the artist's personality is secondary to his creations is diametrically opposed to Picasso's viewpoint.

The shadow is the most commented-upon feature in the Seasons. It is the result of Johns casting his own shadow on the floor of his studio and having a friend trace it. This template was used in all the paintings, and a reduced version of it appears in the Meyerhoff drawings. We are reminded of Johns's interest in schematic, two-dimensional forms that come from the outside world but are not illusionistic. In terms of content, the shadow has been almost universally interpreted as Johns's furtive attempt to reveal his personality. The paintings have been seen as a tentative first step in an autobiographical and emotionally revealing art.[76] On the contrary, the shadow does not reveal Johns's struggle and subsequent inability to expose himself; rather, it represents his determination not to do so. Johns's shadow is an incomplete and inactive form; it is deliberately anonymous. Johns commented, "I wanted some suggestion of a person. Although it is my shadow, from my point of view, the self was of no interest."[77] The shadow may be contrasted with the brilliant accumulation of creations that surround it. Because of their clarity, variety, and interesting interactions, these creations are the primary focus of the Seasons. Johns is stating emphatically that the artist, as an individual, should not be confused with his art.

Each of the Seasons drawings symbolizes a different artistic stage, not as it actually occurred, but as Johns conceptualized and reordered the idea of an artist's past and future. *Spring* contains the fewest objects, and it is the least assertively drawn work of the series. Although its shadow is incompletely formed, it is at the center of the drawing, creating a relatively simple composition and suggesting adolescence's focus on self. The left and right edges may be visually joined to form a cylinder, an idea particularly appropriate to the cyclical nature of the series. In the upper section, the stars, taken from Picasso and perhaps representing the visions of adolescence, have been drawn, erased, and redrawn so that the earlier images are clearly visible. They call to mind changed ideals and goals. The slender tree to the right, with its fragile budding branch, is a common conceit for

childhood and the generative powers of nature. To the right are images of the Rubin vase, the rabbit/duck, and Boring's young/old woman. Although recent images in Johns's works, they represent the different points of view or alternatives at which a young mind wonders. (These images are frequently used in tests conducted on children to determine aptitude.) Two drawing styles are explored in the pottery, one shaded graphite and the other pure outline. The vase might even signify a dreamed-of mother and father, the king and queen, and the Boring illustration is significant in that it is supposedly seen differently by people of various ages. The circle to the lower right, taken from the wheel of the cart in Picasso's painting, becomes in the Seasons a metaphysical clock that indicates the passage of time; in *Spring* it is unmarked. At the bottom center is a group of shapes like children's building blocks, which appear in all four Seasons drawings as well as in the paintings. They signify basic structures—efforts to order—which have been evident throughout Johns's career. (One of his favorite artists, Cézanne, reportedly said that all nature could be rendered in forms based on the cylinder, cone, and sphere.) Here the blocks are pushed together in a centralized and simplistic manner as a child might do.

In *Summer* the shadow has been more completely defined in strong graphite strokes, but it is also moved from its central location to make way for the array of images that fill the right side of the drawing. The tree above the shadow is now foliated, and Johns has personalized the symbol by placing on its branch a hummingbird, a creature of incredible energy and speed, which proliferates near his home in St. Martin. All of the forms to the right side are drawn in a clear, forceful, and assured manner. The stars dance across the composition and the ladder thrusts energetically in a diagonal direction. Below the ladder are images that have compelled Johns throughout his career and have become synonymous with his art. The objects chosen span his oeuvre and represent the fertility and accomplished creativity of youth. They include his flags, the Mona Lisa, the Ohr pots, and the puzzle of the Grünewald plague victim. The artist is thus shown to discover Leonardo, Grünewald, Duchamp, and Ohr—old-master, modern, and folk art. He is flooded with new ideas, and his vision, as represented by the alignment of the images, their diagonal direction,

and the puzzle, is respectively clear, dynamic, and of growing complexity.

A seahorse, a nimble creature of the sea, as the hummingbird is of the air, appears toward the center of *Summer,* a work that seems to be about the creative agility of youth. In addition, both the seahorse and the hummingbird are species in which the male nurtures the young. In recent years, Johns has taken a particular interest in children; the painted version of *Spring* contains the shadow of a child, and Johns's friends have noticed how he dotes on certain of their offspring. This interest is part of Johns's own more encompassing and retrospective view of creativity, as he seeks to understand both the impulsive freedom of youth and the sophistication of maturity.[78] In this regard, one thinks of William Wordsworth's famous line "The Child Is Father of the Man" from the poem "My Heart Leaps." In the lower area of the drawing *Summer,* the geometric blocks are aligned in a more dynamic and interesting pattern than in *Spring.* The circle contains a particularly powerful image. It is a single imprint of Johns's left hand rendered against the white paper with a directional arrow indicating forward movement beyond the boundaries of the drawing. Although Johns had used hand imprints in a number of earlier works and included such an image in the painting *Summer,* this is one of his most forceful imprints because of its clarity and its scale relative to the overall work. It fully embodies the confidence and energy of an artist at the early height of his powers.

Of the Seasons drawings, *Fall* contains the most varied and sophisticated graphic renderings. Concise outlines are set against an assortment of striations. The artist creates a wide range of visual effects by using the side of the charcoal stick to make broad strokes and then rubbing some of them with his fingers. The geometric blocks now feature trompe-l'oeil wooden surfaces, and Johns's hand imprints mix oil and rubbed charcoal in rich patterns. Maturity includes technical mastery, but it also brings a realization of limitations, mortality, and threatened disorder. *Fall,* like *Spring,* is in three parts, but here the shadow is split in two at the edges of the composition. The left-hand image, which resembles that in *Spring,* appears literally to be departing, and the tree branch is broken. Similarly, the ladder is broken and the rope has become untied. Images them-

selves "fall," and the skull from the avalanche poster is depicted as a graphic reminder of mortality. In *Fall*, the rope appears for the first time, and it fails to repair the ladder. The spoon recalls the consuming character of art, and the Rubin vase contains a negative profile of Picasso similar to the one Johns created in *Sketch for Cup 2 Picasso/Cups 4 Picasso* (1971–72, collection of the artist). Picasso's old-age creative vitality has been a source of both inspiration and competition for Johns. In the circle of *Fall*, handprints are rendered as if frantically moving in every direction. One is reminded of the third phase of Cage's *Seasons*, destruction. Yet in Johns's drawing, the stars have been replaced by the wooden blocks. They are dynamically ordered and raised aloft as a creative ideal, which contradicts the stylistic disarray below. *Fall* is filled with inventions employed to discuss the idea of human and artistic limitations. One is reminded of Albrecht Dürer's *Melancolia I* (1514) and its subtle irony. In that engraving, Dürer invented one of the greatest art works in history in order to discuss the idea of an absence of creative inspiration.

Winter represents a state of quiescence. The shadow is once again whole and, like the stars and other forms, veiled in a soft gray atmosphere. The composition is united by the allover pattern of crystal-like snowflakes. The rope has rebound the broken ladder and other possessions. The Ohr pots are now realigned and upside down, suggesting that their contents (ideas) have been drained; however, they are also like gardening pots that have been inverted, ready for reuse in the spring. The handprint extends peacefully downward, having made a decisive sweep of the circle. At the bottom of the composition, the blocks are lined up more serenely than ever before. Their relationship is no more or less coherent than in any of the other Seasons, but simply different in spirit. Below them a small portion of the flag appears, underlying all that is built above it. To the left-hand side of the drawing a new image emerges—that of a snowman. It is a reminder of childlike innocence and creative vitality. Its energetically raised stick arms are formed by the broken branch of the tree in the *Fall* drawing. The snowman completes the cycle from old age to childhood. It is also a tribute to Wallace Stevens's poem "The Snow Man," which concerns stepping outside one-self to contemplate life's mysterious themes and to seek elusive meaning and order in existence, a subject simi-

lar to that of Johns's Seasons. The poem captures better than any prosaic statement the spirit of Johns's Seasons. It ends:

For the listener, who listens in the snow
And, nothing himself, beholds
Nothing that is not there and the nothing that is.[79]

While Johns's Seasons are meditations on the past as a series of stages, *Mirror's Edge 2* (1993) concentrates on the idea of origins; and, like the Seasons, the theme is both personal and universal. The structure of *Mirror's Edge 2* is, as Johns has indicated, collagelike.[80] Since invented by Pablo Picasso and Georges Braque around 1912, collage has been used to reflect the multiplicity of information in the modern world. The forms in *Mirror's Edge 2* differ from traditional collage, however, in two significant ways. First, there are no elements actually attached to the surface; only the illusion of objects is painted on the canvas. Second, while collage is usually executed in two or perhaps three layers, Johns's painting suggests no fewer than six overlapping layers. Johns has used the first of these methods, painted illusional renderings of nearly flat objects, frequently since his early career, whereas the second is new. His overlay of images has usually been restricted to two or three layers. When he has wished to show increased complexity, he has placed images side by side, as in *Racing Thoughts*, rather than on top of one another. The illusionism and the complex layering in *Mirror's Edge 2* combine to make the painting seem to balance on a tightrope between physical and mental imagery. We can conceive of the possibility that these different types of drawings are attached to a wall, and that Johns has attempted to preserve the physical "reality" of the objects by showing one of them with folded corners and pieces of tape attached to it. Yet, there are so many likenesses and the layering is so complex that the kind of contrasting, merging, and shuffling through images that we are encouraged to do is more like the mind's ability to rapidly accumulate and sift wide varieties of information. The subtle, painterly handling of the surface also encourages a degree of "unreality." Johns's deft touch in applying laye'rs of encaustic with impasto, drips, and rills commands our attention as much as do his representations. The painted surface in which "Johns gray" is interwoven with a rich variety of other colors unites all the representations and

encourages us to see them as an integrated idea rather than as discrete objects.[81]

Johns's immediate impetus for *Mirror's Edge 2* was a Giovanni Battista Piranesi engraving, *Del Castello dell'Acqua Giulia* (1761), which had been given to the artist. The print, almost surreal in character, shows an illusional overlay of several architectural drawings. While the individual drawings seem reasonable, the contrasts between them evoke states of fantasy. Johns has said of Piranesi's engraving:

Someone had given me a Piranesi, and I was taken by his representation of folded paper, curling paper, so I used something like that in the poster [for the Festival d'Automne, Paris, 1992]. I have used it a couple of times since. . . . It was something to play with. At first glance the Piranesi seemed to represent architectural studies. Later, I saw another level of representation, suggesting that the studies were on several unrolled sheets or pages. This complication, this other degree of "reality" or "unreality," interested me.[82]

Underlying *Mirror's Edge 2* is an architectural drawing. We recognize portions of a rectilinear house plan with a surrounding porch and a bay window to the lower right, all set on a blue-gray ground, which resembles the color of the photosensitive paper used to copy architectural plans. The floor plan is Johns's recollection of his grandfather's house in Allendale, South Carolina, where the artist spent his childhood.[83] While the use of the architectural plan may have been partly inspired by the Piranesi drawing, Jane Meyerhoff recalls that Johns had been talking of the house plan for several years. The plan relates to Johns's interest, since his early career, in diagrams and schema, two-dimensional information systems. Like Johns's use of maps, already discussed in the context of *Two Maps*, architectural plans are fairly simple designs that represent complex spatial and temporal ideas. Also, like maps, architectural plans are used so frequently that we often forget the intricate mental imaging that they entail. Additional complications are added to Johns's particular floor plan because we see only a part of it and must imaginatively project the rest of the design, and because Johns is testing his own memory by trying to recall, more than fifty years after the fact, what the house was like. For Johns, the house plan is a way to objectify his early experiences and to make some

aspect of them clearer both to himself and to the viewer. In the architectural drawing, memory and origins are set out as primary concerns for *Mirror's Edge 2*.

The clear, although incomplete, design of the floor plan is opposed to a less visible jigsaw puzzle of gray lines around it. When studied carefully, these configurations reveal themselves to be several fragments of the knights from the Resurrection panel of Grünewald's *Isenheim Altarpiece*, which Johns first used in *Perilous Night*. Recently, Johns has said quite simply of the knights, "I think they're in a state of awe."[84] The awe that the knights feel is related to another type of beginning, because in Christian theology the Resurrection is the origin of a new era for humankind. In the unseen portion of Grünewald's Resurrection panel, Christ explodes from his sarcophagus like a radiant celestial body. The dominant image in *Mirror's Edge 2* is a representation of a spiral galaxy, not unrelated in appearance to this image of Christ.

Overlapping the floor plan and partly covering it is a gray crosslike configuration. This design first appeared in Johns's untitled etching of 1990, a work in which he cut up the printing plate used in a version of the Seasons and pieced it together, recombining the images. In fact, several of the representations that appear in *Mirror's Edge 2* are found in this print. On this gray shape, Johns has included a number of child-related images. To the lower center, upside down, is the image of a youngster originally taken from a tracing Johns made of the three-year-old child of a friend, which the artist included in the painting *Spring*. Overlapping the child are basic shapes that resemble building blocks, and it might be noted that Johns has signed the painting in the upper right corner with two Js seemingly printed on children's alphabet blocks. To the left side of *Mirror's Edge 2* are stick figures, one large and three small. Not only are these the types of drawings that a child might make, they also resemble prehistoric drawings that have been found in various parts of the world. The three smaller figures first appeared in the ink drawing *Perilous Night* (1982; collection of the artist). They wield either tools or weapons, and thus remind us that one of the classic anthropological definitions of humankind is the ability to use tools, as well as the close relationship between our creative and destructive impulses. A common idea in psychological and anthropological circles during the 1950s, which Johns might have picked up, is that each individual

reflects in her development the development of the entire species. In any case, Johns seems to be suggesting the relationship between personal and more universal signs of origins.

A ladder also overlaps the gray cross shape of *Mirror's Edge 2*; it is, in one regard, a studio object. Such a ladder appears prominently in the Seasons as well as in one of their sources, Picasso's *The Minotaur Moves His House*; Johns has a similar ladder in his New York studio. The ladder is also a sign of progress and even escape. It appeared in this guise in such Miró paintings as *The Harlequin's Carnival* (1924–25; Buffalo, Albright-Knox Art Gallery) and Rauschenberg's *Rose Condor*; de Kooning once said that he used ladders in his works to get out of the paintings. The ladder in *Mirror's Edge 2* leads to the next level of the work, although it does so ambiguously, of course, because there is no actual space. On this plane is another illusional rendering of paper, complete with curling edges, on which Johns has created a sensuously painted puzzle of the plague victim from the *Isenheim Altarpiece*. Over this paper, the artist painted two images of Barnett Newman drawings that he owns and a drawing of a spiral galaxy. Newman's works have appeared with some frequency in Johns's recent paintings, including *Racing Thoughts*. The artist has commented, "I've used the Newman drawings in too many things for my taste, but that's the way my mind works. I can't do what I don't think to do."[85] Johns has noted that the Newman works seem to be opposites of the figurative expressionism in Grünewald. "One thing that is interesting about art—about painting—is that we accept so many different kinds of things as painting. And certainly these seem superficially to suggest two poles—the Grünewald and the Newman."[86] The Newman drawings, however, are particularly appropriate for *Mirror's Edge 2* because Newman viewed his art as expressing fundamental truths. Working from a sensibility tied to the Old Testament, Newman believed that he expressed a creativity related not only to the origins of art but to the very source of the universe. Accordingly, he titled paintings *The Command, Onement,* and *Galaxy.* The Newman drawings embody a type of belief in origins, although one that Johns demonstrates is only one of many possible viewpoints.

Directly below the Newman drawings, Johns has painted an image taken from a photograph of a spiral galaxy, in a way to suggest that either a photograph or a drawing of it was attached to the surface of the canvas. The artist has noted that this image began to have potency for him when he studied the stars in the Seasons paintings and some of them appeared to be small spirals.[87] In *Mirror's Edge* 2, a spiral galaxy is the dominant image. The particular nature of a spiral galaxy perfectly fits the motif of origins because such galaxies are the most formative type of star clusters; they contain the current reservoirs of gases from which new stars are formed. This contrasts with such formations as scattered and elliptical galaxies, which, not containing gases, are not currently forming stars. The spiral galaxy, with its concentrated core and curved, extending arms, looks the most energetic of the galaxy types, as indeed it is. It is also noteworthy that our own galaxy is spiral, and while Johns's image was probably taken from a photograph of the galaxy commonly known as M101, he may have been thinking of the dynamic, evolving form of our own galaxy, which is, of course, impossible to picture except in the imagination.[88]

The right side of *Mirror's Edge 2* depicts a trompe-l'oeil wooden strip, which represents the painting's wooden stretcher as seen from the side. If we look at the canvas from its side, the imagery disappears, as does the illusion of collaged papers; even Johns's rich paint handling is difficult to discern. From the edge, all of Johns's creative sophistication is reduced to the "reality" of a piece of cloth with a thin layer of paint on it, stretched over a wooden frame. In a similar manner, the definitive way to undo the illusion of a mirror is to look at it from its edge.

Johns's paintings, including *Mirror's Edge 2*, embody some of the most sophisticated, careful, and complex thinking of the late twentieth century about the relationships between vision and thought. His investigations of sight, recollection, expectation, and correlation lead to a deeper understanding of creativity. Yet, finally, Johns reminds us that all of this thoughtful and felt investigation is the opinion of one individual, that it is, thus, all a kind of illusion. In order to understand what Johns is about, we must look and think about his works with the same analytical and questioning eye that he has used to examine the world around him. As well as looking into the mirror, we must be willing to look at the mirror's edge.

1 Jasper Johns, interview with David Bourdon, "Jasper Johns: 'I Never Sensed Myself as Being Static,'" *Village Voice*, October 31, 1977, 75.

2 For instance, see Max Kozloff, "Jasper Johns," in *Renderings: Essays on a Century of Modern Art* (New York: Simon and Schuster, 1968), 206–11. The essay is a reprint of Kozloff's review of Johns's 1964 exhibition at the Jewish Museum in New York.

3 Rolf-Dieter Herrman, "Johns the Pessimist," *Artforum* 16 (October 1977), 12.

4 Walter Hopps, "An Interview with Jasper Johns," *Artforum* 3 (March 1965), 36.

5 See particularly Jill Johnston, "Tracking the Shadow," *Art in America* 75 (October 1987), 128–43; and her "Jasper Johns' Artful Dodging," *Art News* 87 (November 1988), 156–59. Kenneth Silver, "Modes of Disclosure: The Construction of Gay Identity and the Rise of Pop Art," in *Hand-Painted Pop: American Art in Transition* (New York: Rizzoli International Publications, 1993).

6 Jasper Johns, interview with David Sylvester, in *Jasper Johns Drawings* (London: Arts Council of Great Britain, 1974), 7.

7 Fred Orton, "Present, the Scene of . . . Selves, the Occasion of . . . Ruses," in *Foirades and Fizzles: Echo and Allusion in the Art of Jasper Johns* (Los Angeles: Wight Art Gallery, University of California, 1987), 168–75.

8 Jasper Johns, interview with Nan Rosenthal and Ruth E. Fine, in *The Drawings of Jasper Johns* (Washington, D.C.: National Gallery of Art, 1990), 70.

9 Jasper Johns, interview with April Bernard and Mimi Thompson, "Johns on . . . ," *Vanity Fair*, February 1984, 65.

10 Jasper Johns, interview with the author, January 18, 1993.

11 Ibid.

12 Ibid.

13 Fine, in Rosenthal and Fine, *The Drawings of Jasper Johns*, 58.

14 Orton, "Present, the Scene of . . . Selves," 81.

15 Johns, interview with the author, January 18, 1993.

16 Ibid.

17 Johns is not the only modern artist to investigate suspended objects. Duchamp's *Hat Rack* (1917; Milan, Galleria Schwarz Collection) as well as hanging objects in Rauschenberg's early Combines and the tools suspended in front of some of Jim Dine's canvases come to mind.

18 Garth Hallett, *A Companion to Wittgenstein's "Philosophical Investigations"* (Ithaca and London: Cornell University Press, 1977), 486.

19 Jasper Johns, in conversation with Roberta Bernstein, in Roberta Bernstein, *Jasper Johns' Paintings and Sculptures, 1954–1974: "The Changing Focus of the Eye"* (Ann Arbor, Mich.: UMI Research Press, 1985), 92. Also Max Kozloff, *Jasper Johns* (New York: Harry N. Abrams, 1974), 39.

20 Barbara Rose, "Decoys and Doubles: Jasper Johns and the Modernist Mind," *Arts Magazine* 50 (May 1976), 71.

21 Peter Higginson, "Jasper's Non-Dilemma: A Wittgensteinian Approach," *New Lugano Review* 10 (1976), 55.

22 Ibid., 56.

23 Johns, interview with the author, January 18, 1993.

24 An issue has been made of the similarity of title between Johns's Hatch painting *Scent* (1973–74; private collection) and Pollock's allover painting *Scent* (c. 1955; Marcia Simon Weisman Collection). When Johns learned of this coincidence, he tried to change the title of his painting.

25 It was only after this similarity was pointed out to Johns that he painted his first work using the Munch title, *Between the Clock and the Bed* (1981; New York, The Museum of Modern Art).

26 Richard Francis, *Jasper Johns* (New York: Abbeville Press, 1984), 100.

27 Johns, interview with the author, January 18, 1993.

28 Ibid.

29 Jasper Johns in conversation with Jane Meyerhoff, communicated to the author, January 20, 1993.

30 Johns, interview with the author, January 18, 1993.

31 John Tyler Bonner, "D'Arcy Thompson," *Scientific American* 187, no. 2 (August 1952), 63.

32 Cyril Stanley Smith, *A Search for Structure* (Cambridge, Mass.: The MIT Press, 1972), viii.

33 Ibid., 68.

34 Smith's bibliography lists works on the arts, chemistry, philosophy, physics, and psychology.

35 Johns, interview with the author, January 18, 1993.

36 Ibid.

37 Rosenthal and Fine, *The Drawings of Jasper Johns*, 36.

38 Ibid.

39 Ibid.

40 Johnston, "Tracking the Shadow."

41 Rosenthal and Fine, *The Drawings of Jasper Johns*, 39.

42 Johns, interview with the author, January 18, 1993.

43 Vivian Raynor, "Jasper Johns: 'I Have Attempted to Develop My Thinking in Such a Way That the Work I've Done Is Not Me,'" *Art News* 72 (March 1973), 21.

44 Johns, interview with the author, January 18, 1993.

45 Ibid.

46 Mark Rosenthal, *Jasper Johns: Work since 1974* (London: Thames and Hudson, 1988), 65.

47 Calvin Tomkins, *The Bride and the Bachelors* (Middlesex: Penguin Books, 1962), 97.

48 Johns, in conversation with Jane Meyerhoff, communicated to the author, May 12, 1993. Cage made a special trip to the Meyerhoffs to see the painting.

49 Rose, "Decoys and Doubles," 73.

50 Johns, interview with the author, January 18, 1993.

51 Ibid.

52 Ibid.

53 Johns, interview with Bernard and Thompson, "Johns on . . . ," 65.

54 Rosenthal and Fine, *The Drawings of Jasper Johns*, 82.

55 Ibid., 78.

56 Rudolf Arnheim writes on this issue in a penetrating manner in his *Visual Thinking* (Berkeley: University of California Press, 1969), chapter 4, "Two and Two Together."

57 Edgar Rubin, *Visuell wahrgenommene Figuren* (Copenhagen: Gyldendal, 1921).

58 Johns, interview with Bernard and Thompson, "Johns on . . . ," 65.

59 Johns, interview with the author, January 18, 1993.

60 Ibid.

61 Wolfgang Kohler, *Gestalt Psychology* (New York: The New American Library, 1947), 170.

62 The title in parentheses, *M. T. Portrait*, was added to the work by Jane Meyerhoff, not by Johns. In the spirit of Johns, the title is, of course, a phonetic play on "empty."

63 Johns, in conversation with Jane Meyerhoff, communicated to the author, October 13, 1993.

64 Jill Johnston, "Trafficking with X," *Art in America* 79 (March 1991), 164.

65 Johns, in conversation with the author, January 18, 1993.

66 Roberta Bernstein, introduction to "An Interview with Jasper Johns," in *Fragments: Incompletion and Discontinuity,* ed. Lawrence D. Kritzman (New York: New York Literary Forum, 1981), 280.

67 Bruno Bettelheim, "Schizophrenic Art: A Case Study," *Scientific American* 186, no. 4 (April 1952), 33.

68 Johns, in conversation with Jane Meyerhoff, communicated to the author, October 13, 1993.

69 Jasper Johns, interview with the author, January 18, 1993.

70 Johns, in conversation with Jane Meyerhoff, communicated to the author, October 13, 1993.

71 Johnston, "Trafficking with X," 164.

72 Rosenthal and Fine, *The Drawings of Jasper Johns,* 78.

73 John Cage, "Jasper Johns: Stories and Ideas," in *A Year from Monday: Lectures and Writings by John Cage* (London: Calder and Boyars, 1967), 78.

74 Tomkins, *The Bride and the Bachelors,* 105.

75 Judith Goldman, *Jasper Johns: The Seasons* (New York: Leo Castelli, 1987), n.p.

76 Goldman, *Jasper Johns: The Seasons*; Rosenthal and Fine, *The Drawings of Jasper Johns,* 103; Barbara Rose, "Jasper Johns: The Seasons," *Vogue,* January 1987, 194.

77 Johns, interview with the author, January 18, 1993.

78 The more psychologically oriented critics view the inclusion of the seahorse as Johns's frustrated desire for progeny. See Rose, "Jasper Johns: The Seasons," 259.

79 Wallace Stevens, "The Snow Man," in *The Collected Poems of Wallace Stevens* (New York: Alfred A. Knopf, 1972), 9.

80 Mark Rosenthal, *Artists at Gemini G.E.L.* (New York: Harry N. Abrams, 1993), 66.

81 An earlier version of the painting *Mirror's Edge* (1992) was exhibited at Johns's 1992 show at the Leo Castelli Gallery. The first *Mirror's Edge* has a slightly different composition, but, most significant, it is a rather diagrammatic painting and contains little of the rich paint handling found in *Mirror's Edge 2.*

82 Rosenthal, *Artists at Gemini G.E.L.,* 58.

83 Johns, interview with the author, January 18, 1993.

84 Rosenthal, *Artists at Gemini G.E.L.,* 63.

85 Ibid.

86 Ibid.

87 Ibid.

88 This galaxy is represented in Timothy Ferris, *Galaxies* (San Francisco: Sierra Book Club, 1980), 82.

JASPER JOHNS

Night Driver, 1960

Chalk, charcoal, pastel, and paper
collage, 45″ × 37″ (114.3 × 94.0)

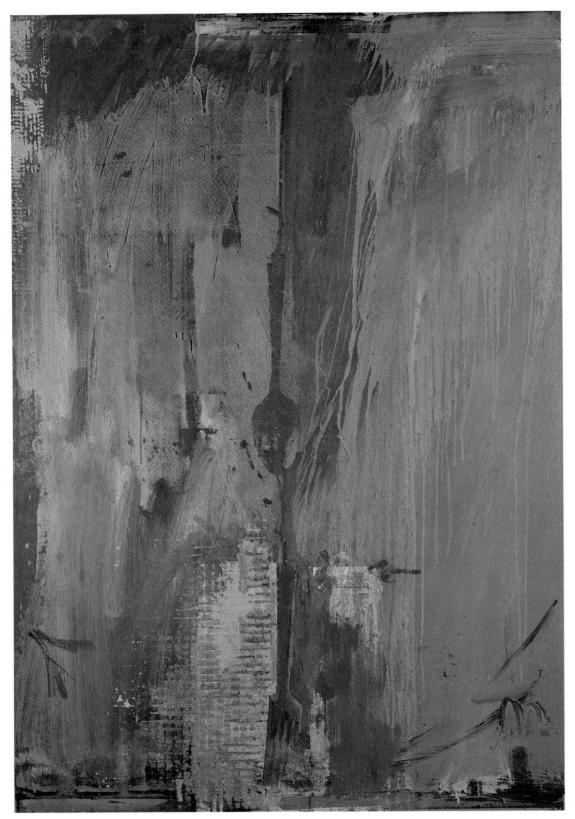

Facing page

JASPER JOHNS
Perilous Night, 1982
Encaustic on canvas with
objects, 67″ × 96″ × 5″
(170.2 × 243.8 × 12.7)

JASPER JOHNS
Racing Thoughts, 1984
Oil on canvas, 50″ × 75″
(127.0 × 190.5)

JASPER JOHNS
Screen Piece #4, 1968
Oil on canvas, 50¾″ × 34¼″
(128.9 × 87.0)

50

51

JASPER JOHNS
Untitled (E. G. Siedensticker), 1979
Encaustic and newsprint collage on canvas,
30″ × 90″ (76.2 × 228.6)

JASPER JOHNS

Untitled, 1984

Oil on canvas, 51″ × 35″
(129.5 × 88.9)

JASPER JOHNS

Untitled (A Dream), 1985

Oil on canvas, 75″ × 50″
(190.5 × 127.0)

JASPER JOHNS

Spring, 1986

Charcoal on paper, 42″ × 29¾″
(106.7 × 75.6)

JASPER JOHNS

Summer, 1986

Charcoal on paper, 42″ × 29¾″
(106.7 × 75.6)

JASPER JOHNS

Fall, 1986

Charcoal on paper, 42″ × 29¾″
(106.7 × 75.6)

JASPER JOHNS

Winter, 1986

Charcoal on paper, 42″ × 29¾″
(106.7 × 75.6)

JASPER JOHNS

Mirror's Edge 2, 1993

Encaustic on canvas, 66″ × 44″
(167.6 × 111.8)

Roy Lichtenstein

Do you intend to be satirical?

Not satirical about the way people live. It might have a little of that but the purpose is to make a naive arrangement or composition or way of drawing into something strong, or make it art or some such thing.
ROY LICHTENSTEIN[1]

Roy Lichtenstein's paintings are most often associated with Pop art, and Lichtenstein is regarded as one of the founders of that movement. Although both Lichtenstein's supporters and detractors commonly see him as lowering the high-minded dialogue of art so that it is conversant with popular culture, his aim is actually in a different direction. Lichtenstein intends to raise popular culture to the level of high art by transforming it in his work; he takes devalued forms of visual communication, redeems them, and possesses them through re-creating them in his paintings. As such, Lichtenstein's art is the polar opposite of that of Robert Rauschenberg, whose constructions remain closely linked to the environments from which they were taken. Because Lichtenstein has carefully con-

sidered and minutely adjusted every line, form, and color area, his art breathes finesse and refinement. Like Matisse, whose works he admires and has used as sources for several paintings, Lichtenstein proclaims the artist's ability to create an order, interest, and degree of perfection not found in the ordinary world. Lichtenstein views art as an entity, a unit independent of everyday experience. Thus, in his paintings and sculptures, he transforms primarily other types of art, and the content of his work arises from his asking questions about his place in the context of modernism as well as his meditations on the nature of picture making.

To visit Lichtenstein's studio reinforces this view of his art; it is characterized by absolute precision. Brushes, paints, and rolls of premade stencils

for his well-known Benday dots are laid out in meticulous order. Easels are lined up so that preparatory studies may be placed next to large-scale final canvases in various stages of completion, which are evenly spaced on walls around the room. There are large rolling mirrors so that each composition may be viewed in reverse, and rotating easels so that smaller compositions may be painted from every orientation. Each incomplete painting has a final study arranged next to it. In turn, each one of these studies is the result of several other preliminary drawings, a traditional artistic procedure. Close examination of even the final studies reveals a multitude of minute changes. Lines, forms, and color patterns have been adjusted, sometimes by only a fraction of an inch, to arrive at the exact relationship

Lichtenstein desires. These sketches are then placed in an opaque projector and displayed on the canvas surface. Lichtenstein has emphasized that he deliberately uses an old projector that provides slightly inaccurate images so that he feels free to vary the appearance at any time. In the final canvases, the compositions are first drawn in pencil, and many alterations are indeed visible as the artist fine-tunes his design once he sees it full-scale. Areas between the drawn lines are marked with color and pattern codes. Recently, Lichtenstein has had rolls of paper with different colors and sizes of Benday dots made for him. He is able to cut these out and temporarily attach them to the canvas with his drawn images already on it and thus visualize the entire painting. All aspects of design, color, and placement can be seen before execution. This method is not akin to the twentieth-century uses of collage as an independent medium; rather, it parallels the use of cartoons to aid in the execution of large-scale historical works. Lichtenstein's compositional methods are not mechanical, as some critics have claimed. His thoughtful planning, extremely careful design, and meticulous craftsmanship are of an entirely different order. They more nearly resemble the precision of the old masters.

Even during the 1960s, when Lichtenstein's art seemed most completely to embrace popular culture, his goal was to show the changes that he wrought upon his sources. It is actually his art of the 1970s and 1980s, which frequently involves his re-creations of modern styles and masterpieces as well as quotations from his own earlier "masterpieces," that clarifies his directions of the 1960s. Lichtenstein's choice of comic books and newspaper advertisements as sources for his paintings, beginning in 1961, was neither simply a glorification of those media, as some critics contended, nor an ironic commentary upon our consumer culture, as others thought. Instead, the comics provided an ideal starting point for Lichtenstein. By using them, he had already removed himself from the outside world to a realm of image making. Lichtenstein has said, "Because you're starting with somebody else's art, it says something about communication. You're not looking at a nature garden, or something. You're taking known symbols and styles of things and re-creating them."[2] In the comic-book drawings, the artist recognized a style of linear design, simplification, color clarity, and boldness that related to what he viewed, and still does consider, as a common language of modernism. At the same time, the comics were works with many flaws that he could easily correct. He altered their small scale, spatial ambiguity, weak form relationships, and sentimentality into forceful personal expressions.

Now that the shock both in the art world and among the general public has long worn away regarding Lichtenstein's popular sources, we see more clearly his important alterations. In spite of his significant changes, Lichtenstein's sources are always apparent. Unlike Ellsworth Kelly, whose natural sources for his abstract canvases clearly remain a secondary concern, Lichtenstein invites, indeed forces, us to make comparisons with the original and thus to see the mastery of his transformation. (At the same time, Lichtenstein has expressed his admiration for the formal clarity of Kelly's art.[3]) In the early paintings, Lichtenstein relied on the viewer's general knowledge of the comics, a vocabulary with which most of us are familiar from youth, to contrast with his art. Recently, Lichtenstein's use of modern masterpieces makes his transformations even more exciting and challenging. As Matisse once said about his own paintings, Lichtenstein's art now does not so much shock as surprise us.

Lichtenstein is a firm believer in the language of modernism. He has referred to "the industrial, manufactured look" of his art as "a symbol of modern life"; "It ties with it being very mathematical."[4] What Lichtenstein means in this statement goes far beyond simply an industrial look, which his art does not really have. The artist is fascinated by the power and universal appeal of early modern design. Its two-dimensionality, strong linear patterns, clarity of structure, use of bright unmodulated colors, all are central to his art. That style, which became synonymous with industry and manufacture up through the 1960s, was co-opted and improved upon in Lichtenstein's paintings. The immediate positive response that Lichtenstein's art receives among the general public demonstrates the wide appeal that such modern design still enjoys.

Lichtenstein's paintings are often humorous; the artist loves such visual puns as eliminating the word balloon from the drawing Conversation so that

it contains no conversation, and painting a rococo frame around Abstract Expressionist paint marks, an anathema to that art movement, in *Painting with Statue of Liberty*. But Lichtenstein's wit, one of the elements that make his art so interesting to look at, should not be confused with deep-seated irony. Some recent Lichtenstein literature has attempted to view him in a postmodern and deconstructive mode because of his appropriation of images, and his seemingly mechanical modes of creation were said to participate in the destruction of the concepts of authenticity and originality in art.[5] Yet such negativism has no place in Lichtenstein's thinking. His art neither appropriates without change nor is it mechanical. He is guided by a belief in the modernist aesthetic and the artist's ability to utilize the tradition of modernism to increase the power of his own art. Referring specifically to his early use of comics, Lichtenstein has commented:

It's not really an issue of irony. It was something about the nature of the line in the comics. It's not really calligraphy and it didn't have the wonderful character of Abstract Expressionism or expressionism, but it had something very modern. They had a certain use. The subject and form were equally brash. The comics had compositions of sorts, but not really good. They didn't really have the sense of unity that a painting has. It's a different sort of seeing really. It was making the subject matter of comics into art by restructuring it, and then it takes on other meanings.[6]

There is, however, another level to Lichtenstein's relationship with modern art, namely the competition that Lichtenstein has set up between himself and the whole history of modernism. Beneath the self-effacing humor in his art and his personal shyness is an enormous ambition which has grown in his later career. When he re-creates a masterpiece by Picasso or redoes a whole style, like Futurism, albeit with wit, he is insisting that his art be matched against the earlier works. A challenge is being made.[7] In these paintings, Lichtenstein is demonstrating that he can co-opt, "improve," and remake into a signature Lichtenstein nearly any type of modern art or design. The paintings combine a mischievous delight— "Look what I can do!"—with a more important claim. His mastery over every aspect of modernism makes Lichtenstein's art so much more interesting and significant than a mere parody of previous styles would be. When viewing *Girl with Beach Ball III,* the alert viewer immediately conjures up such relevant Picassos as *Girl before a Mirror* (1932; New York, The Museum of Modern Art) and the Boisgeloup paintings. One asks, "Has Lichtenstein outdone even Picasso in his metamorphoses of the human form?" In Lichtenstein's *Cow Triptych (Cow Going Abstract),* the tiny De Stijl drawings by Theo van Doesburg (Museum of Modern Art, New York) are brought to mind. Has Lichtenstein improved on the design of these drawings and asked questions about the nature of abstraction that did not occur to Van Doesburg? Of course, in these comparisons, Lichtenstein has stacked the deck in his favor. He begins, not from scratch, but from the other artist's work, and he is able to use historical hindsight to pick those features in his model that are the most compelling. Yet, Lichtenstein is so successful at remaking these earlier works into newly exciting, thoughtful compositions that we can hardly begrudge him his advantage.

Conversation (1962) is one of Lichtenstein's relatively rare drawings that is not a study for a painting. These independent drawings were all executed in black and white and pre-date 1970. In fact, most of them were done between 1961 and 1963, after which Lichtenstein began to use drawings as studies for paintings. The very idea of the finished drawing self-consciously restricted to black and white so that it might specifically explore the potentials of that medium is an old-master concept that was carried into the twentieth century by such modern artists with an eye to the past as Matisse and Picasso. In executing these drawings, Lichtenstein is equating his practice with theirs. *Conversation* differs from many of his drawings of this period in several ways. Unlike such drawings as *Turkey* of 1962 (private collection), which consist of a centralized image of a single object articulated by a continuous outline, *Conversation* more radically dislocates the image from reality by fragmentation and compression of the two figures; both are seen within the tight framing edges of the composition and close to the picture surface. This compression gives the imagery a pictorial charge, and Lichtenstein has continued to use it as one compositional device throughout his career. In fact, *Conversation* might be profitably compared to

works like *Expressionist Head* of 1980 (see below).

The specific comic-book source for *Conversation* has not been discovered, but we may easily point to differences between the drawing and our common memory of the comics. The comic book would probably have contained such spatial indicators as overlapping foreground forms. It would also have placed the figures in a naturalistic environment filled with secondary objects. Although the images might have been cropped, the truncation would not have been as radical as Lichtenstein's, and the figures would not have been pressed so closely together. Of course, the comic picture would be a tiny design on a page full of such images; it would represent simply one step in a narrative sequence. The comic would also contain text. It is precisely these mental comparisons that Lichtenstein wishes the viewer to make in order to appreciate his drawing. Through his re-creation, the cheap sentimentality of the comic is turned into a powerful pictorial event. Through the two figures, he develops a contrast between the sharp, angular outline of the male and the soft, curvilinear design of the female. The man and woman are opposites in every way, ranging from such obvious contrasts as his lost profile and her apparent expressiveness to subtle juxtapositions like his jutting nose and the delicate curve of hers, which is more suggested than drawn. Lichtenstein finds this opposition between male and female principles a useful cliché and translates it into two of the characteristics of his art: assertiveness and refinement. As such,

it appears in various guises throughout his career. Two of his early themes, war and romance comics, are vehicles for this idea, and it reappears quite obviously in such Surrealist paintings as *Razzmatazz*.

Given the contrasts between the man and woman in *Conversation,* the area between them becomes a focal point of the composition, and it attracts our attention because of the graphic activity contained there. In drawings like *Conversation,* Lichtenstein first used stippling, which led to the signature dots in his later paintings. The dots were inspired by the Benday dots used in the photomechanical reproduction method of comics and advertising. As early as *Conversation,* however, Lichtenstein's Benday dots differ profoundly from those of commercial art. Unlike the comics, Lichtenstein's dots are large enough so they register with the viewer as areas of artistic activity. As his art developed, the dots grew in scale relative to the overall picture surface and thus further asserted their presence. In the artist's words, "They became a symbol of surface. At least, I tried to sense them all on one plane."[8] In *Conversation,* the Benday dots were made with a frottage method. Lichtenstein soon replaced this procedure with a stencil placed over the drawing or canvas, which produced more regularized marks. He noted, "The early dots made with frottage showed a certain amount of modulation which was kind of beautiful, but I have eliminated that as much as possible to make the works tougher and give them a sort of edge."[9]

In *Conversation,* the stippling activates that portion of the drawing between the faces, balancing it with the larger, but relatively empty, areas of the people's faces. The stippled section also refuses to recede into the background; rather, it establishes a middle tone, which works two-dimensionally to emphasize the picture plane, which Lichtenstein believes to be a central aspect of modern art. Also, *Conversation* contains no words. Many of Lichtenstein's works of the 1960s feature language from the comics as well as their images. On one level, the absence here is an indication of Lichtenstein's wit; *Conversation* contains no conversation. On another level, it foreshadows his elimination of language in his later works in order to concentrate on purely visual effects. Commenting on the relationship between comic strips and his paintings in an early interview, Lichtenstein said:

What I do is form, whereas the comic strip is not formed in the sense that I'm using the word; the comics have shapes but there has been no effort to make them intensely unified. The purpose is different, one intends to depict and I intend to unify. And my work is actually different from the comic strips in that every mark is in a different place, however slight the differences seem to some. The difference is often not great, but it is crucial.[10]

As Lichtenstein notes, his art translates the simplistic naturalism and melodrama of the comics into a pictorial structure of a high order. As such, it deserves comparison to the art of Georges Seurat. References to Seurat have been assiduously avoided in the Lichtenstein literature, probably due

to the critics' fear of being accused of a one-to-one equation between Lichtenstein's Benday dots and Seurat's pointillism. Yet the similarities between these two artists' work go far deeper than their surfaces. Both are picture architects of the highest order. Lichtenstein has commented:

Although it didn't start that way, there is something about the activation of the surface by the dots and diagonals and things like that which I find very compelling in Seurat. Also, his works seem anonymous but are really very personal. Seurat made an entire world from his art.[11]

Both Seurat and Lichtenstein view art as an endeavor separate from and superior to everyday reality, and both are concerned with willfully imposing their artistic visions on the world around them. Both are highly intellectual artists who enact these transformations with the greatest care. Seurat's points and Lichtenstein's dots do serve as one, but only one, symbol of their ordering processes. In neither case does the architectonic structure of their works eliminate the possibility of evoking feelings. In fact, like Lichtenstein, Seurat was very much aware of the playful and humorous aspects of the world around him. One thinks of the peculiar monkey in *Sunday Afternoon on the Island of the Grande Jatte* (1884–86; The Art Institute of Chicago), the parody of the woman in *Girl with a Blue Powder Puff* (1890; London, Courtauld Institute Galleries), and the sheer comedy of *The Circus* (1890–91; Paris, Musée d'Orsay). Yet, also like Lichtenstein, Seurat combined his humor with a monumental compositional structure, which both makes his

wit more effective and offsets it with high-art seriousness. While Lichtenstein works more with sources taken from past art than did Seurat, thus assuring his removal from the everyday world, the two artists are highly aware of the incorporation of other art, common and exotic, high and low, as well as frequent self-quotations. In their use of popular culture—Seurat was extremely interested in the street posters of his day—each artist raises popular culture to the level of commanding artistic expression. In both Seurat and Lichtenstein, all of these features assert the presence of the artist and his control over the creative process.

In 1965 Lichtenstein created his Brushstroke series, of which *White Brushstroke II* is an example. Here, for the first time, Lichtenstein assimilated not a specific work but an entire movement, Abstract Expressionism. This style had personal ramifications for the artist. Not only was it the most authoritative American art movement of the twentieth century, but Lichtenstein himself had painted in an Abstract Expressionist mode from 1957 until 1960. In the process of assimilating it, he was remaking his own history. Abstract Expressionism is notorious for its broad, freely executed brushwork, found particularly in the works of Franz Kline and Willem de Kooning, and it is this aspect of the style on which Lichtenstein focused. In the critical literature, Lichtenstein's Brushstrokes have been taken as an ironic attack on the supposed spontaneity and uniqueness of Abstract Expressionist brushwork. They are, in actuality, much more complicated

homages, assimilations, and critiques. Simply to question the authenticity of Abstract Expressionism in 1965 would be nothing new. This had already been accomplished by Robert Rauschenberg's identical "spontaneous" paintings *Factum I* and *Factum II,* the encaustic surface of Jasper Johns's Flags, the mock painterliness of Claes Oldenburg's food, and the works of many other artists.

In the Brushstrokes, Lichtenstein takes a style that had already been depreciated, recovers it, and in the rescue attempts to possess it. *White Brushstroke II* shows Lichtenstein's analysis of a single Abstract Expressionist brushstroke. He studied the massing of light and dark created by a broad brush dragged through thick paint, re-created these as templates on an even larger scale, and carefully executed their design. Simultaneously, he rejected those elements of Abstract Expressionism with which he could not temperamentally identify. These include the immediacy of execution, the impasto of the paint surface, and the raw, unfinished look. In *White Brushstroke II,* Lichtenstein bettered the Abstract Expressionists by composing the painting from a single brushstroke, something not even they dared to do. Simultaneously, he united their signature discovery with his own, a field of Benday dots, showing that in his hands two styles, called antithetical by artists and critics alike, could be melded.

But the Brushstroke paintings are more than just an observation about Abstract Expressionism. These works are a component of Lichtenstein's running commentary on the whole history

of art. In a statement that indicated how broadly he thinks about that history, Lichtenstein said:

It's a big thing in art, you know, art that acknowledges that it is using the brushstroke; Hals, Van Gogh, and others as opposed to north-country Renaissance, where the brushstroke is suppressed. Except in the south, the work of Titian, Tintoretto, and the rest looks more realistic than, say, Holbein because you don't really see with that kind of exactness. It's a continuous tradition from El Greco up through Abstract Expressionism.[12]

Lichtenstein's Brushstroke paintings further fuse the romantic and classical traditions, two modes that have been set up as diametrically opposed throughout the history of art. Lichtenstein explained, "I was interested in taking it [the brushstroke] and turning it into something else. I was thinking of the contradiction of the classical and romantic. It is a bravura mark but done in a very careful way."[13] Lichtenstein's self-conscious sense of art history and his ability to remark upon, and even redefine, that tradition is paramount in his thinking.

The artist has contrived to endow each of the stylized Brushstroke paintings with a different character. Some feature exuberant baroque curves, while others are architectonic. Lichtenstein has noted, "Each one has a feeling. It's not letting out big emotions but it is a subtle feeling. Part of it is the position, and part is just what it is."[14] The particular character of *White Brushstroke II* is delicacy. It is unusual among the Brushstroke paintings because it is a vertical composition. The painting features a single black-

and-white brushstroke set against a field of blue Benday dots. The brushstroke is peculiarly suspended at the top of the canvas. It is a complicated form, consisting of eleven undulating striations. Although the brushstroke is made from a carefully designed and cutout template, it conveys the rhythmic irregularity we might expect in an actual paint stroke. In the varying thickness of the black lines, we imagine the drag of the brush and even texture, as fictive layers of pigment pile up on the surface. Yet, we are simultaneously aware that all of these effects are carefully wrought illusions created by the artist, and the black-and-white brushstroke is no more or less contrived than the field of blue Benday dots surrounding it. We are urged to contemplate the validity of one of the great conceptual divisions in the history of art, that between spontaneous emotion and intellectual control. The ultimate sign of spontaneity is the accidental paint drip, which artists sometimes allow to appear unaltered in finished paintings as a sign of extreme artistic freedom. In *White Brushstroke II,* the rills and splashes are also calculated, again breaking down traditional barriers in our ideas about paintings. In truth, the single long paint drip in *White Brushstroke II* takes on an entirely new role. Because of the precarious extension of the paint stroke at the top of the canvas, it appears as if that form is delicately balanced upon the fragile, stylized drip that extends below it. Here, all traditional compositional methods are called into question. *White Brushstroke II* leads us to doubt some of the basic principles

with which we have been trained to look at art, and in the process provides us with a fresh vision. Lichtenstein has called his Brushstrokes "a major breakthrough" and has indicated that his overwhelming concern was to pose questions about the very nature of seeing and evaluating art works:

What makes one mark or group of marks art? Why is this work so good and this one not so good? And it could boil down to just one mark or two marks. That was something I really pursued and was interested in. What makes art art? I guess that is really the pursuit of modernism in a way.[15]

In 1973 Lichtenstein created *Fragmented Painting of Lemons and Melon on Table.* It is one of a series of still-life paintings he created between 1972 and 1974 that show him taking on another artistic tradition. In the history of art, still life has been known for its power of mimesis. Conventionally, the artist manipulates objects, space, and light to create the representation most likely to fool the viewer's eye. It is not surprising that when Paul Cézanne began to question the relationship between the two-dimensional reality of the picture surface and the three-dimensional nature of the world, he chose still life as one of his themes.

Whereas Cézanne struggled with a duality, Lichtenstein wittily assures us of the illusional essence of art; his assertion is that art is a creative fiction from start to finish. In *Fragmented Painting with Lemons and Melon on Table,* the lemons and melon are signs, not mimetic objects. There is absolutely no sense of the different

characters of the fruits, which is essential to conventional still-life painting. They are uniform in color and texture and do not cast shadows. In addition, their red contours visually project toward the viewer, assuring a surface reading. Their flat colors, as well as their size and slight shape differences, lead us to think about the compositional balance between the three smaller shapes and the single larger one. Concerning his color and shape distortions, Lichtenstein has noted:

Since I am not modulating the color usually, it becomes a question of how much yellow I can put. You have to have a way of expanding or contracting that amount of color so it looks like collage. And because you don't have to be particularly realistic about the subject, you can make things larger or smaller, or put the same color on a number of things. It becomes wholly an art problem.[16]

The fact that the larger shape (the melon) is placed on the upper corner of the table totally negates the traditional artistic device of spatial diminution. The tabletop is conceived in reverse perspective, since it angles outward rather than inward, and its surface is thus visually forced onto the surface plane of the painting. Only the edge of the table has traditionally converging recessional lines, creating an effect opposite to that of its surface. With these elements, Lichtenstein deliberately catches us in an unsolvable visual conundrum. Lichtenstein's creation of shadow and background may be the most completely arbitrary aspect of this capricious painting. The comblike shape with regular projecting points to the left side of *Fragmented Painting with Lemons and Melon on*

Table has nothing to do with any realistic shadow we can conceive. It is a completely willful and perverse device. Lichtenstein defined the background mostly as unmodulated diagonal stripes, which project toward the viewer rather than recede. To the upper left, he humorously added a schematic curtain. Such curtains are the most patently artificial devices used by both still-life and portrait painters since the Renaissance. In many less distinguished paintings, they become simply space fillers. Lichtenstein's witty use of this curtain as a standard art prop again reminds us that art is a "fabric-ation."

In the lower right corner, Lichtenstein peels back the canvas to reveal its stretcher. Of course, the image of the stretcher is also a painted illusion. This gesture is related to Lichtenstein's trompe-l'oeil paintings of 1973, which depict objects tacked to illusional stretcher bars. In turn, these works refer back to the American nineteenth-century trompe-l'oeil paintings by William Harnett, John Peto, and others. Yet the nineteenth-century works were done with the opposite intent of Lichtenstein's painting. They were supposed to reveal the underlying and humble reality of the artist's world and his ability to mimic every aspect of that environment, no matter how trivial. Lichtenstein's goal is conceptual, not mimetic. He demonstrates that art is an illusion that can occur in seemingly endless layers. Beneath the created fiction of the melon and lemons, even the canvas stretcher is illusion. Lichtenstein's painting of the fictive stretcher further removes his art from everyday reality

to a realm of creative fantasy. His interest in the devices of the nineteenth-century American trompe-l'oeil painters parallels that of Jasper Johns, who discovered the work of John Peto around 1961. Johns, however, uses trompe-l'oeil devices as a way of questioning the manner in which things are transformed into art. In contrast, Lichtenstein uses them to emphasize that art is an entity separate from life.

Lichtenstein's Still Life paintings, and indeed much of his art, are also indebted to the spirit of Synthetic Cubism, a movement in which he has had a long interest.[17] In the hands of Picasso, Georges Braque, Juan Gris, and others, Synthetic Cubism reintroduced recognizable objects into painting after the radical fracturing of Analytic Cubism. Yet the flat patterns, bright colors, strong outlines, and schematic dots and stripes of Synthetic Cubism are perhaps even more arbitrary pictorial devices than were the modeled shapes of Analytic Cubism. These devices ideally suit Lichtenstein's desire to invent artistic signs that are independent of familiar reality. Lichtenstein has further recognized the way in which the strong two-dimensional patterns of Synthetic Cubism inspired and are related to aspects of popular modern design. His *Fragmented Painting with Lemons and Melon on Table,* and other Still Life works, draw together these aspects of art and design so that the pictorial vocabulary is at once familiar to us in its overall look and new in its particulars. Despite the advanced pictorial signs used by Synthetic Cubism, that art movement also clung to the vestiges of three-dimensional space.

Forms still overlap, there are shadows, dots and striations sometimes are closely linked to the differing textures of the objects portrayed. Lichtenstein has eliminated many of these remnants of mimetic vision from his works. From his point of view, he has clarified Synthetic Cubism and pushed it to its logical conclusion. Lichtenstein's interest in the style differs from that of both Robert Rauschenberg and Frank Stella. Rauschenberg has affinities with its use of everyday materials, while Stella concentrates on the spatial paradoxes inherent in Synthetic Cubism. As shown in *Fragmented Painting with Lemons and Melon on Table,* Lichtenstein is fascinated by Synthetic Cubism for the clarity of design and the fact that recognizable objects are depicted through a vocabulary of relatively arbitrary signs, which indicate the removal of his artistic process from the world of ordinary things.

It has been suggested that in the 1960s Lichtenstein metamorphosed popular illustration into an advanced art form. During the 1970s and 1980s he increasingly used a more sophisticated tradition, that of modern art from Cubism to German Expressionism to Surrealism, as starting points for his own creations. This important shift in emphasis alters the parameters of Lichtenstein's art in several ways. In these later works, the artist has digested and synthesized more complex styles. His metamorphoses of those styles had to be more sophisticated—after all, rethinking Picasso is a more demanding task than "improving" a comic-book page. Lichtenstein

has upped the ante in his high-stakes poker game of art, and the paintings make far more serious contentions. In these later canvases, Lichtenstein is virtually demanding that his work be compared to the entire history of modernism. The Lichtenstein literature has often asserted that his use of modern paintings is simply an indication that modern art had become part of popular culture. Lichtenstein views his use of these motifs differently: "It's more than that really, it's a matter of re-seeing it in your own way."[18] These later paintings are also addressed to a more sophisticated audience. In the comic-book paintings, Lichtenstein could rely on an almost universal common memory of his sources. Despite the growth of popular interest in modern art since the 1960s, it remains a specialized knowledge. The full content of Lichtenstein's art and the nature of the pictorial questions he is asking cannot be appreciated without understanding in some detail the development of modernism. His art is increasingly directed to the critic, art historian, museum curator, collector, and informed layperson. Although Lichtenstein's art of the 1960s still receives the most critical attention, his work has continually grown in artistic intelligence, complexity, and degree of challenge.

In 1974 Lichtenstein returned to the polyptych arrangement he had used occasionally during the 1960s. One of his most important later investigations of the multicanvas format is *Cow Triptych (Cow Going Abstract)* (1974). The earlier multicanvas paintings were based on the sequencing of comics images, and Lichtenstein generally

was concerned with replacing their narrative order with visual relationships. For instance, the three panels of *As I Opened Fire* of 1964 (Amsterdam, Stedelijk Museum) show the increasingly dramatic power of simplified large-scale forms. From left to right, they grow and become more dominant in each panel. The five panels of *Live Ammo,* also from 1964 (Morton G. Newmann Family Collection), concern the effects of visual discontinuity—no two panels use similar design principles. In *Cow Triptych (Cow Going Abstract),* the three panels question the modernist understanding of abstraction. To fully appreciate the query Lichtenstein is posing, we must have in mind at least three representations of bovines in the history of art. In 1945 and 1946 Picasso created *Bull,* eleven states of the same lithograph, which progressively abstract a line drawing of a bull until the most elemental linear schema is reached. Despite the fascinating simplifications in every state, Picasso chose, as in the rest of his oeuvre, not to push his investigation into the realm of nonobjectivity.

Earlier, in 1916 and 1917, the De Stijl artist Theo van Doesburg created two cow compositions, one a collage and the other a drawing (Museum of Modern Art, New York). Lichtenstein's interest in De Stijl dates at least to 1964, when his Non-Objective Paintings paid homage to Mondrian's belief in a universally modernist visual language and simultaneously investigated the Dutch artist's stylistic rigor. Lichtenstein's relationship to Van Doesburg's works is different. Van Doesburg's collage is a relatively unex-

citing composition that closely imitates discoveries Mondrian had made during the previous two years. Van Doesburg's drawing contains four sections beginning with a rather inept academic rendering of a cow and ending with a tentatively drawn De Stijl composition; in this didactic progression from naturalistic to nonobjective art, Van Doesburg has reduced De Stijl ideas to a simplistic formula.

Cow Triptych (Cow Going Abstract) is a monumental work, 68 by 246 inches, in which Lichtenstein challenges and defeats Van Doesburg's uninspiring collage and drawing. In the first painting, Lichtenstein boldly divides the canvas into a black, white, and yellow ground. These three simple areas act as symbols for the entire natural world. The strong continuous outline of the cow dominates the surface. Such an awkward animal is turned into a powerful compositional element. Its straight back mirrors the (unseen) horizon line, while its underside reflects the curves of the clouds. The cow's patterning humorously is more atmospheric and cloudlike than the sky.

In the second painting, the relationship between the cow and landscape is made evident: sky, clouds, and cow interact in a series of dynamic diagonal vectors. The transformations are visually exciting and clever, as the tail opens and soars in a great S pattern to fill the upper left quadrant of the painting, and the horns to the lower right fold into a single plane. One leg becomes an enormous diagonal vector that extends from top to bottom, and the other is transformed into a single pencil-thin line. The amorphous

shadow of the cow is converted into black bands, which are among the most forceful shapes in the composition. The cow's udder becomes a cloud floating to the upper right corner.

In the final painting, dynamism and order seem in balance. There, we can visualize the cow and even its shadow, although no single representational clue remains. The composition arrives at a harmony between diagonal and rectilinear forms, although the lines do not meet at right angles and no line is either parallel or perpendicular to the edge of the canvas. We remember the famous modernist story about how Van Doesburg's use of diagonal lines drove him and Mondrian apart. Perhaps Lichtenstein has created a dynamic balance, without the use of rigid perpendicular lines, that even Mondrian would have been able to accept. In addition, the third painting tests itself against recent abstraction, especially Frank Stella's geometrically complex Brazilian Series paintings, which were being done at exactly the same time.

Simultaneously, Lichtenstein has challenged Picasso by creating a series of paintings that takes the cow from representation to nonobjectivity—the border over which Picasso would not step. Yet, this progression by Lichtenstein is not so simple. The final query that *Cow Triptych (Cow Going Abstract)* asks is whether its first painting is any less conceptual and abstract than the other two. Here, Lichtenstein questions the modernist idea of a development toward nonobjectivity. "You don't learn any more about it as you go from one painting to the next.

It's the idea that the first cow is just as abstract as the last."[19] It is not coincidental that the first painting most resembles Lichtenstein's own early style. He is thus showing the conceptual and abstract roots of his art as well as making the sort of direct connection between his own beginnings and the origins of modernism that many of his critics have been unwilling to concede.

Unlike the variations of *Cow Triptych (Cow Going Abstract),* Lichtenstein's Entablatures are seemingly among the most straightforward of his paintings, yet they also contain significant complexities of meaning. The series occurred in two phases: ten works were done in black and white between 1971 and 1972; and twenty-eight, containing colored elements, were created between 1974 and 1976. *Entablature* (1975) belongs to the later group. The horizontal canvas is divided into registers consisting of cornice, frieze, and architrave, as can be seen in classical architecture. The series was based immediately on photographs the artist took of entablatures on nineteenth-century buildings in the Wall Street area of New York. It has been suggested that the paintings are an ironic commentary on the death of classicism and the mechanical character of those carvings.[20] The care with which the paintings were executed and even the concern with which the photographs were taken indicate otherwise. In the entablatures of these buildings, neglected by everyone else, Lichtenstein discovered an unnoticed area of clarity, order, and creativity amid the visual chaos of the city.

The dialogue carried on in Lichtenstein's Entablatures is not only with architectural decoration but also with tendencies of early and late modern art, as well as with his own painting ideas. He has said, "The entablatures mean art, particularly classicism. They were also used in early modern paintings by Cézanne, and they are like the Minimalism found in Don Judd and others."[21] The Entablatures are the close relatives of the moldings of room interiors Cézanne used in his still lifes and portraits to suggest multiple viewpoints. Later, in Synthetic Cubism, such interior moldings were employed to mix background and foreground in a compressed space and to provide decorative accents as a way of emphasizing pictorial design at the expense of naturalism. The Cubist moldings simultaneously call to mind picture frames moved within the composition as a way of denying the Renaissance notion of the painting as a framed window onto space. These connections are highlighted by the fact that after creating his first group of Entablatures, Lichtenstein then incorporated them as moldings in his own Cubist-derived still lifes of 1973 and 1974 and subsequently reappropriated them in his second series of Entablatures, begun in 1974. Most recently, the Entablatures have reappeared in the context of his Interiors. Such repeated uses of a motif tell us of the interior dialogue about the nature of art and its subjects in which Lichtenstein is continuously engaged.

Whereas moldings remain a relatively minor element in Cézanne and Synthetic Cubism, as indeed the entablatures in the nineteenth-century buildings are, they became the sole focus of Lichtenstein's paintings. Through them, he declares the compositional authority and visual interest of two-dimensional, repetitive, sequential design, which was only partially realized in early modernism. The Entablatures suggest new methods of compositional exploration in Lichtenstein's art. We read them immediately as a unit because of the clarity of the overall design. In a second stage of perception, the eye moves horizontally through each register. Because the registers are clearly separated, we tend to scan them from left to right and self-consciously to compare our visual response at each level. In Entablature, our vision rolls over the cornice area, with the baroque curves of its wave molding, in a movement distinct from the staccato meter encouraged by the architrave. There, the egg molding moves the eye along at a sharp, regular rate, while the ropelike, twining stem molding below it encourages slight forward-and-back eye movements. In contrast, the blank frieze areas give rise to random eye patterns as we attempt to find a focal point. We are also urged to compare our visual responses to elements of color and texture in the lower areas of the painting with its overall black-and-white, light-and-shadow design.

Lichtenstein's emphasis on modes of visual perception in the Entablatures is linked to similar concerns in Minimalist art during the 1970s. But Lichtenstein's Entablatures, while no less structured than works by Carl Andre and Donald Judd, are cleverer and more witty. Not only do they include references to other art, high and low, which those artists eschewed; the Entablatures appear more playful. Such elements as the arabesques at the top of Entablature are antithetical to the strict geometry of the Minimalists. In addition, we realize that all the shapes in Lichtenstein's Entablatures amusingly signify, not the solid forms of the original three-dimensional moldings, but their cast shadows—their most insubstantial aspect. This reversal prompts a typical Lichtensteinian query about the nature of art. Such an inversion of spatial and material integrity is totally opposed to the physical structures so prized by the Minimalists. In Lichtenstein's seemingly spare Entablatures, he paradoxically reveals art as fantasy and individual invention.

Lichtenstein's interest in issues of perception and composition may be traced back to his early artistic experiences. During the 1940s, Lichtenstein attended Ohio State University, first as an undergraduate and then, after the war, as a graduate student. At Ohio State, Lichtenstein studied with Hoyt L. Sherman, who was a friend for many years and about whom Lichtenstein later said:

Yes, he was important. I went to Ohio State in 1940, because my parents thought I should have a degree and I wanted to study art, so this was a way to satisfy everybody. There were few universities at the time that offered a degree in studio art. Sherman had what I thought were the best ideas on what form is about, on seeing, on unity in art, etc.... He was more interested in the problems of mass education, in teaching how to see rather than how to make artists. He believed that he could teach

people to see in a way that would say something about the nature of aesthetic space and how artists through history have put things together.[22]

Sherman emphasized seeing as the development of "perceptual unity," and he stressed exercises that led to comprehending objects as clear, simplified patterns. Sherman's teaching principles, which he detailed in his 1947 book, *Drawing by Seeing,* were based on Gestalt psychology which, as we have already noted, is also an interest of Jasper Johns. According to Sherman, drawing is to be accepted as an "artificial form" that converts the three-dimensional structure of objects into the "two-dimensional terms of the paper," and his students were directed to concentrate on "positional relationships" in their drawings. For Sherman, "An image seen with perceptual unity must be drawn without the interference of any competing image which might arise externally or in the mind of the student."[23] Sherman's most famous way of teaching these principles was his "flash lab." In a totally darkened room, beginning students would draw from a simple object that was illuminated by an intense light for one-tenth of a second. Thus, the students would be forced to rely largely on perceptual afterimages and to draw the most salient two-dimensional features of the object. Although Lichtenstein never actually participated in one of Sherman's flash labs, he did use this procedure later in his own teaching.[24] Lichtenstein's sensibility is removed from the didactic aspects of Sherman's approach, and he is not interested in the issues of mass education that

occupied his teacher. But the goal of Sherman's teaching was to show that common objects could be depicted in a powerful, concise, and unified two-dimensional design. This aspect of Sherman's thought had a profound influence on Lichtenstein, who has been able to present mass-cultural images according to the tenets of a virtually classical aesthetic. Generally, Lichtenstein's sensibility owes more to his early involvement in the academic environment than is frequently stated. He was a graduate student and professor during the postwar education boom, at a time when modern art was being systematized in books and classes as a progression of related periods.[25] Lichtenstein has stated that he first learned about modern art from books. His self-conscious positioning of himself in relationship to periods of modern art in which he compares and contrasts his work to that of modern masters comes out of this environment.

A modern movement that Lichtenstein has rethought at great length is Surrealism. Beginning in 1977 he produced an extensive body of Surrealist-inspired works. His interest in Surrealism is, at first, surprising, given that movement's emphasis on chance, dream states, and irrationality, all of which contrast with Lichtenstein's own very thoughtful and controlled art. Yet the underlying similarities between Lichtenstein's aesthetics and those of the Surrealists are also strong. Surrealism is an art of analogy, visual fantasy, and creativity, just as Lichtenstein's is. In re-creating Surrealism, Lichtenstein empties it of its psychological content; we do not

see its dark, disturbing side, which resulted from the troubled world situation during the interwar years. Instead, Lichtenstein concentrates on its wit, humor, and playfulness. In doing so, he creates an ultimate style of visual transformation, going beyond even the metamorphoses of the Surrealists and by implication showing that their art was also more consciously contrived than they were willing to admit.

Girl with Beach Ball III is one of the earliest and most important of Lichtenstein's Surrealist works. It is based on at least two paintings by Picasso and one of Lichtenstein's own earlier works. Picasso's *Bather with Beach Ball,* at the Museum of Modern Art in New York, is part of a group of such bathers done at Boisgeloup during the summer of 1932. Among Picasso's Surrealist works, they are his most humorous, containing neither the violence nor the overt sexuality of other paintings of those years. Instead, he created comic creatures based on some of the less physically attractive bathers he saw at the beach. *Bather with Beach Ball* is both massive and buoyant, bonelike and as inflated as the ball she catches. Aspects of *Girl with Beach Ball III* also resemble Picasso's *Girl before a Mirror,* 1932, also at the Museum of Modern Art. These include the exposed breasts, extended arm, blonde hair, double face that is both frontal and in profile, and the striped bathing suit. Finally, *Girl with Beach Ball III* recalls Lichtenstein's own *Girl with Ball* of 1961, one of his earliest works derived from a newspaper advertisement.

In *Girl with Beach Ball III,* Lichtenstein created an even more elaborate set of

visual transformations than did Picasso in his two paintings, and he eliminated the vestiges of three-dimensional modeling that remained in Picasso's works. The extended arm of Lichtenstein's bather becomes simultaneously an arm and a high-kicking leg, its outline cleverly designed so as to suggest both types of limbs. The breast adjoining that arm-leg doubles as an entire torso, its nipple serving as the girl's navel. The other breast is simultaneously an arm. The yellow hair of Lichtenstein's girl is at once sun rays, sand, and stone. Amid the fantasy of picture making, the similar yellow hue and analogous shape negate the distinction between these different elements seen in the real world. The undulating stripes of the girl's bathing suit are also waves in the ocean. These are deliberately more oceanlike than the striated ocean and sky as they appear to the right side and in the upper portion of the painting. Instead of giving us a double view of the face as Picasso did, Lichtenstein presents us with a triple view—full-face, profile, and full-face again. In an extremely clever conceit, Lichtenstein merges the head outlines, eyes, eyebrows, lips, and chins of the faces so that we may see them as a single, double, or triple image. In doing so, he also eliminates the psychological implications of Picasso's Girl before a Mirror, which explores an outer presence and a dark, inner psychology seen in the mirror image. The smiles and tears of Lichtenstein's girl are only theatrical gestures. By eliminating some of Picasso's artistic concerns, especially the suggestion of volume in Bather with Beach Ball and the psychological

implications in Girl before a Mirror, Lichtenstein is able to focus on his complex and fantastic form analogies and to extend those farther than Picasso did. In Girl with Beach Ball III, Lichtenstein shows that he can outdo Picasso in the imaginative transformation of shapes. Concerning such a competition, Lichtenstein has said:

I think of him as the central force [in modernism] since he did so much and changed the notion of painting so much and did so many images. So, I think that I confronted him head on and simply painted a Picasso. That liberated me from his influence. Then it is obvious that it isn't a Picasso. You know the source, but it doesn't look as if I were influenced by Picasso.[26]

Girl with Beach Ball III makes it apparent that Lichtenstein's long fascination with Surrealism, and particularly Surrealist Picasso, is based on a degree of analogy and imagination unrivaled by that offered by any other modern art movement.

Razzmatazz (1978) is a late tour de force among Lichtenstein's Surrealist works and is one of his most complex paintings to date. The objects shown all have a surreal air of the miraculous. They differ from those presented in his earlier Surrealist works, however, in that the allusions in almost all of them can be found either in Lichtenstein's own Surrealist paintings or in his other works. For instance, the chair at the center comes from the Office Still Lifes of 1976; the plant forms at the right are from his Cubist Still Lifes; the cylindrical female head combines the female head type found in such works as Girl with Beach Ball III and the

artist's own cylindrical image in Self-Portrait (private collection) of 1978. The jacket with its headlike coat hanger refers to the stiff buttoned-down males from Lichtenstein's romance works of the 1960s. The cheese, which also looks simultaneously like an ancient rock formation and a sculpture by Henry Moore, has already appeared in several of Lichtenstein's Surrealist paintings and has its ultimate source in Cheese (1962; Tod Brassner Collection). Thus, Lichtenstein reveals proto-Surrealist elements in his own works of the 1960s that even he did not realize at the time. The piece of cheese also sprouts as a hand from the right arm of the unoccupied jacket. Razzmatazz is filled with such fantastic and creative metamorphoses. By the late 1970s, Lichtenstein had built up such a complicated and far-reaching vocabulary that he could construct a painting almost entirely through self-references. Like Picasso and Matisse, and more recently Jasper Johns, who have made increasingly frequent references to their own works as their careers progressed, Lichtenstein has created his own body of art history.

Toward the center of Razzmatazz, the blonde reiterates Lichtenstein's stereotypical females who have appeared in his art since the 1960s. Yet she is also a particularly haunting image because her eyes have been isolated and pushed to the outer fringes of her cylindrical head. As discussed earlier, this image may partly account for Jasper Johns's mid-eighties portraits like Untitled (A Dream) and Untitled (M. T. Portrait). (When Lichtenstein saw these works in the Meyerhoff

Collection, he commented, "Jasper got that from me. Let me see what I can get from him." Soon afterward, several of Lichtenstein's Interiors featured his re-creations of Johns's paintings. One of the appropriated works in Lichtenstein's Interiors is a Johns pastel on paper, *Untitled [Holbein Image]* [1989], also in the Meyerhoff Collection. Thus, Lichtenstein made the next move in his game of art-historical chess.)

In *Razzmatazz,* the green form to the right of the blonde refers generally to Surrealist biomorphism and coyly drapes its "arm" over the chair. Despite the fact that it is as much negative as positive form, it is sexier than the more representational blonde. The wooden male "head" has a cutout profile that makes him seem to look with bulging eye and mouth agape beyond the blonde at this biomorphic form. The same wooden "head" acts as a picture frame for the cheese painting. The common folding chair is incongruous in the context of the organic shapes in the painting, and its steel legs are confusing in terms of perspectival illusion. The ball and rope placed on the chair are derived from Lichtenstein's marine still-life paintings of 1973. Although their appearance in those paintings was logical as fishermen's net buoys and lines, they make no sense in this new context. Along the floor, geometric planes, like those that appear in the final canvas of *Cow Triptych (Cow Going Abstract),* are fragmented and chaotically arranged. They suggest some sort of linear perspective system that has gone haywire. On the right side of the painting, the door seemingly has a second knob

at floor level, and it opens to reveal no space. Schematic leaves from an unseen tree appear in the doorway, but they also make their way into the room. The blue floor plane flows into, not out of, the room. In *Razzmatazz,* such humorous readings could be extended almost endlessly. It has been suggested that the stiff males and alluring, but distant, females that appear in the Surrealist works might unintentionally reveal something of Lichtenstein's psychological makeup,[27] but his males and females are too contrived to reveal his unconscious. It might be noted that even in the 1930s and 1940s American artists tried to objectify Surrealism. In fact, the extroverted, artistic vitality of *Razzmatazz* is closest in spirit to the art of Stuart Davis, who absorbed Cubism, Surrealism, and American jazz and gave them a similar mood of humorous, artistic energy.

Lichtenstein has exhibited a tendency through the 1970s and early 1980s to work with modernist styles, increasingly remote from his own temperament, seemingly as challenges to his ability to transform them pictorially. He has moved from Matisse's art, De Stijl, and Synthetic Cubism, with which he had obvious sympathies, to Surrealism, German Expressionism, and Futurism. At the same time, in retrospect he seems to have chosen exactly the historical style he needed for the development of his own art. His interest in German Expressionism during 1979 and 1980 countered perfectly the playful, biomorphic fantasies of his Surrealist works. Lichtenstein's German Expressionist works are tough,

angular, focused paintings, which feature strong black-and-white patterning and forceful color and value gradations.

Although Lichtenstein painted German Expressionist nudes and other subjects, his most successful Expressionist paintings are of heads. *Expressionist Head* (1980) carves up the picture surface into powerful intersecting shapes filled with intensity. From left to right, we begin with an organic black-and-white pattern that reminds us of wood graining and of the trompe-l'oeil wood in Lichtenstein's Surrealist works. The stylized graining is also a reference to the fact that many German Expressionist works were done in the medium of woodblock printing, and the graining of the block would often appear in these works. Lichtenstein's grain is more elegant in its pattern and, of course, is a conceit. Right away, it sets up historic and artistic contrasts in the mind of the viewer. Lichtenstein's wood grain, which locates his work securely in the realm of art references as separate from wood in everyday life, is also different from Jasper Johns's use of imitation wood panels, beginning in such works as *Racing Thoughts.* Johns's imitation wooden surfaces not only ask questions about the relationship between the flat patterns as actually seen on a wall and the veracity of his re-creations, but they contain veiled images that raise the issue of subconscious aspects of vision. These are not issues that concern Lichtenstein.

In *Expressionist Head,* the more organic pattern of the wood grain gives way to angular lines of contrasting values in the left side of the face.

The edge of the face is converted into a single trapezoidal plane, and the yellow patch around the eye socket is used to pull that facial plane forward. The jagged outline of the nose allows it to be seen simultaneously as frontal and in profile. The curves of the chin and forehead are also converted into jutting and intersecting surfaces. Lichtenstein abandons his Benday dots in these works as being insufficiently expressionistic and substitutes for them more dynamic diagonal stripes, which form vector patterns. These mimic the sharp, splintered lines carved with chisels in the woodblocks of the German prints. As we move toward the right side of *Expressionist Head,* we are introduced to increasingly more arbitrary and craggy patterns, and the right side of the face suggests a barely recognizable ear and strands of hair. Further spatial dislocation is evidenced in the tiny, schematic building at the far right.

Prints by the German artists Erich Heckel, Ernst Ludwig Kirchner, and Karl Schmidt-Rottluff come to mind when viewing *Expressionist Head,* and it is particularly reminiscent of Heckel's *Portrait of a Man* (1919; private collection). Yet *Expressionist Head* provides other lessons in art history. It recalls how dependent German Expressionism was on the fractured planes of early Analytic Cubism, as well as how the German movement eventually became a key component in the development of nonobjective art. We are simultaneously reminded of the close-up, abstract views of figures in Lichtenstein's own art. Such a drawing as *Conversation* was done in this mode. *Expressionist Head* also

underscores the differences between its use of the German Expressionist style and the earlier works. In *Expressionist Head,* Lichtenstein turns the raw emotions of German Expressionist art into pictorial excitement. The painting does not try to imitate the powerful passions of German Expressionism, which must remain wedded to the horrible years surrounding World War I. Instead, it creates an intelligent contrast, telling us of Lichtenstein's own late-twentieth-century stylistic concerns and, by implication, about the different forces that motivated German Expressionism. As such, it is distinguished from the attempts in more recent Neo-Expressionist painting to mimic the emotions of the German movement.

Sketches for Lichtenstein's Expressionist works show that he considered including brushstrokes in them. He abandoned this idea because those brushstrokes interrupted the linear angularity of the works. Subsequently, in 1980, Lichtenstein created a second series of Brushstroke paintings. These utilized both stenciled brush marks similar to those of the mid-sixties and a new technique for him, which consisted of wiping paint onto the canvas with a towel. This technique yielded broad swaths of color, which, when applied thickly, produced impasto and, when painted thinly, revealed underlying layers of pigment. His procedure provided nearly the full range of pictorial effects found even in Abstract Expressionism but without the need for rapid and spontaneous execution. Lichtenstein heralded his mastery of this method by creating a

series of de Kooning–like women in 1982 from such "brushstrokes." In 1983 he made a series of works called Two Paintings, also utilizing these new brushstrokes. Most of the Two Paintings compositions consist of a single canvas with two distinct images, each surrounded by trompe-l'oeil frames. The series gave Lichtenstein the opportunity to speculate about different types of art and at the same time to show his mastery of these divergent styles.

The Two Paintings series, which suggests framed art works hung on a studio wall, also looks back to Lichtenstein's Studios, of 1973–74. These paintings show walls on which are displayed real and imagined works by Lichtenstein and other artists. They in turn are connected to a long tradition of paintings of artists' studios, which were mentioned earlier in the context of Jasper Johns's *Perilous Night.* Because of the fragmented and close-up view of the Two Paintings series, it avoids the problem of providing visual interest in the areas around the represented art works, an issue that had concerned other artists who painted studio settings. Also implicit in Lichtenstein's Two Paintings is the fact that we learn by comparison and contrast. The pairing of two images throws each into sharper relief, so that we may better see Lichtenstein's meditations on the roles of image and style in art.

One of the largest and boldest of the Two Paintings is *Painting with Statue of Liberty.* This composition opposes two apparently contradictory styles and subjects. On the left side is

one of the most complicated brush-stroke configurations that Lichtenstein had yet devised. Stenciled strokes, imitation drips, actual rills of paint, and marks applied with towels interweave in a wide variety of painterly activity. The lower section of this half of the composition is anchored by a large red brushstroke created by dragging a paint-soaked cloth through a ground of wet white pigment, creating an extremely rich texture. Ascending from either end of this red brush mark are two vertical white strokes. The left edge of the painting is further reinforced by a long yellow paint stroke, which has rivulets of black pigment running down it. In turn, these vertical marks are crossed by another broad horizontal white stroke. Amid the large brushstrokes is interwoven a variety of curvilinear, stenciled strokes in blue, green, and black. A drawing in the Meyerhoff Collection, *Two Studies for Paintings: Statue of Liberty,* shows that such scaffolding in this seemingly free composition was an intended effect.

To the right of *Painting with Statue of Liberty,* Lichtenstein has created a forceful image of that statue. He has fragmented the form so that we see only a portion of Liberty's head, crown, and hand holding the tablet. The image is viewed as if from below and is so sharply delineated that it has a monumentality that far exceeds its pictorial scale. The face is conceived in only two planes, one white and the other black. The simplified nose and eye socket are directly contrasted, and the head is pinned in place from above by the radiating spikes of Liberty's crown. The almost abstract hand and tablet to the right are a

study in the contrast of curved and straight-edged Euclidean figures. The dramatic interaction of simple geometric forms has a touchstone in Frank Stella's Cones and Pillars series, as seen in such works as *La scienza della fiacca* (see below). While the geometric lines with which Liberty is drawn look somewhat like the Art Deco style, they also resemble those in Lichtenstein's own German Expressionist works. In those slightly earlier paintings, Lichtenstein realized the forcefulness of straight lines meeting in sharp vector patterns and of strong value contrasts. The head of Liberty, which becomes progressively more abstract as one looks from left to right, might be profitably compared to *Expressionist Head.* In *Painting with Statue of Liberty,* the two halves of the painting are bifurcated and thus reveal the artist's willful control over their styles. This bipolar division also resembles the manner in which Jasper Johns has divided some of his recent canvases. On Lichtenstein's visits to the Meyerhoffs' house, he has paid particular attention to Johns's *Perilous Night.* Although *Perilous Night* uses images that are more personal in nature than those in Lichtenstein's works, it employs a division between nearly abstract and more imagistic visual experiences similar to that in *Painting with Statue of Liberty.*

In Lichtenstein's painting, both sections are bordered on their inner edges by portions of trompe-l'oeil frames. These frames clearly show that Lichtenstein is conducting a dialogue within the realm of art. Like so many of his works, *Painting with Statue of Liberty* is art about other artistic styles.

Ironically, the more "advanced" Abstract Expressionist section is bordered by a pink rococo frame of the type that would be an anathema to that movement, while the more traditional Liberty has an undulating white border that looks more modern. As mentioned in the discussion of *Cow Triptych (Cow Going Abstract),* each canvas in Lichtenstein's multicanvas compositions can stand alone, and their sequence usually reveals contrasting approaches to the picture-making process. *Painting with Statue of Liberty* initially seems to be about wildly divergent styles but ultimately gives us a surprising sense of unity. The two halves cannot be separated, and because of their fragmentation would not look right alone. Another common feature is that both parts are framed. In terms of subject matter, both represent an earlier idea of heroism that had become a cliché until revived by Lichtenstein. In fact, each portion of *Painting with Statue of Liberty* shows some surprising similarities to the other. One need only look at the right-hand portion of each section, which is defined by a rising yellow bar. In the left half of the painting, the vertical black-and-white stenciled brushstrokes mimic the facial profile of Liberty, and the gray area on the left edge is like the gray-striped background of the Liberty part. These similarities are successful because they are indirect and function on a subconscious, rather than a conscious, level. The final impression left by *Painting with Statue of Liberty* is one of surprising completion. Lichtenstein has demonstrated his old master–like talent to unify even the most divergent artistic styles.

Having invented a wide variety of brushstrokes and having tested them in relationship to his more usual imagery in the Two Paintings series, Lichtenstein undertook in 1985 a group of large paintings called Landscapes. Inspiration for them came from thumbing through books on Fauvist and German Expressionist landscape painting, looking at so many different images that his canvases would not resemble any particular one. The Landscapes have general affinities to those of André Derain and Maurice de Vlaminck as well as to Alpine scenes by Ernst Ludwig Kirchner. Here, Lichtenstein again uses printed images as source material, as has been his custom since the 1960s. Typically, he prefers to work from reproductions even when the original works are available. Because of his predilection to use reproductions, some critics have labeled his art as Postmodern. They see his appropriation of imagery, often from secondary sources, as his way of undermining creative individuality and the authenticity of the unique art work. There have been specific attempts to relate Lichtenstein's art to Walter Benjamin's seminal essay of 1936, "The Work of Art in the Age of Mechanical Reproduction."[28] These critics ignore the particular historical circumstances of Benjamin's essay as well as Lichtenstein's own artistic attitude. With the rise of the cult of Nazism, Benjamin was desperate to find an alternative to the propagandistic "aura" of genius the Nazis sought to impose on individuals in every field, including the visual arts. He saw the anonymity of mechanical reproduction as a way of avoiding the cult of personality. Lichtenstein's works have very little to do with either Benjamin's original ideas or those of his Postmodern interpreters. Lichtenstein's work does have an "aura" about it: it has an entirely distinctive and recognizable style, and it is not anonymous or mechanical.

The freedom with which Lichtenstein absorbs other art is more akin to André Malraux's idea of the Museum without Walls. According to Malraux, art from every age became available to all artists and viewers through mechanical reproductions. The result is an enlarged creative vocabulary, which resembles Lichtenstein's absorption of nearly all aspects of modernism. Lichtenstein also uses reproductions of art works as a way of distancing himself from the original, to allow more creative latitude for reinvention. Reproductions diminish the power of the originals, for, among other things, they lose their scale, texture, and true color. Therefore, Lichtenstein's creations may prevail over the originals during his transformations. The contest of remaking, updating, and improving these early masterpieces into Lichtenstein's own masterpieces is carried out according to the artist's rules. Beneath his self-effacing humor, the artist is very serious about his attempts to make great art. This attitude is the antithesis of Postmodernism's ironic detachment and disbelief in the power of creativity.

Mountain Village (1985) is one of the largest and most complex paintings in the Landscape series. Up to this time, Lichtenstein's involvement with the subject of landscape had been confined to his flattened Landscapes of 1964–65, which, because of their oversimplification, were among his less successful works of that period. In 1985 his Landscapes took on a new breadth, depth, and variety, and he used them as a way of expanding the range of his recently invented brushstrokes. In *Mountain Village,* Lichtenstein did away with the emphasis on drawn line and the resulting linear scaffolding upon which his work usually depends. For structure, the painting relies only on intersecting brushstrokes, which signify the vertical direction of trees and the horizontal orientation of the fields and hills. Interestingly, Lichtenstein also largely eliminated the horizon line, which was the most important organizational device in his 1964–65 Landscapes.

In *Mountain Village,* Lichtenstein has evoked the rich variety of nature using extremely limited technical means. The painting consists only of stenciled brushstrokes, stripes, and paint marks applied with rags. Yet the heterogeneity of the work and even its enormous size, nine by thirteen feet, rival nature itself. On the right side of *Mountain Village* is a tree. Despite the fact that the tree is a common device in landscape painting to establish scale relationships and to locate the foreground plane, no tree in traditional landscapes has been constructed like this one. It is formed entirely of stenciled and rag-wiped brushstrokes. The heaviness of these strokes and their dark color anchor it in the foreground plane. The alternating black-and-white patterns of the stenciled strokes create the illusion of roundness in the tree trunk, as if

shadows were falling across it. Despite the inherent limitations of stenciled design, each branch of the tree has a different character, ranging from sturdy limbs to frail twigs. At the top of the painting, curved brushstrokes give the illusion of billowing foliage. To the right of the tree, Lichtenstein has composed an entire miniature composition, which includes a pine tree, rocks, and a waterfall, all simply made from patterned paint marks placed at different angles. Below this tree, Lichtenstein renders a convincing illusion of recessional space almost without the use of line. Tan and gray brushstrokes of different thicknesses create the effect.

Generally, the heaviest and thickest brushwork in *Mountain Village* occupies the foreground, while more open strokes form background elements. Also, Lichtenstein's famous reduced palette has been expanded so that differences in color may communicate pictorial depth. Lichtenstein quipped that *Mountain Village* contained twenty-two colors, a new record for his work. The more intense hues are used in the foreground and the paler ones in the background. At the center, the village is created through a cluster of disconnected paint marks. Although we can read the structure of houses in them, no two strokes meet and none are placed at right angles— through completely open brushwork, Lichtenstein manages to communicate the idea of architecture. The sky is as full of atmospheric activity as those of John Constable. Diagonal blue stripes indicate cloudless areas, and partly cloudy conditions are rendered with blue-and-white stenciled patterns.

Darker clouds have black stenciled outlines and gray interiors made with pigment applied with rags. Rain is symbolized by black diagonal lines.

In *Mountain Village,* Lichtenstein has taken such technical means as the stencils, which are rigid in character, and made them perform with suppleness. He has expanded his artistic vocabulary to include effects that he had banned from most of his previous works. Even the concept of foreground and background is new in Lichtenstein's art. Because of its colors and brushstrokes, *Mountain Village* suggests depth in a manner that few other Lichtenstein paintings do. Since the beginning of his career, Lichtenstein has based his art on two-dimensional structure; it has been the very backbone of his work. In *Mountain Village,* experiments with deep space give his art a new appearance. On one level, *Mountain Village* outdoes Impressionist and even Fauve landscapes in the use of suggestive paint marks. In it, no objects are described; rather, they are alluded to through a highly abstract design. Working with an even more limited repertoire of painterly devices than those early modern masters, Lichtenstein is able to create a rich range of effects. The multiplicity of *Mountain Village,* however, extends beyond a competition with those paintings as Lichtenstein tries to rival nature itself and to symbolize the full range of an outdoors experience. In many ways, *Mountain Village* stands outside the main body of Lichtenstein's oeuvre because of its use of depth, natural motifs, and emphasis on variety at the expense of structure. Johns, Rauschen-

berg, and Stella were all shocked when they saw this new work.[29] It remains to be seen if these elements are eccentricities or whether they will be followed up in later paintings.

Ever since the 1960s, the stylistic device most commonly associated with Lichtenstein's art has been the Benday dot. This connection has remained foremost in the public's mind despite the wide range of both stylistic and thematic variations that he has introduced into his art. (*Mountain Village* is just one example of the artistic variety of which he is capable.) In 1987, after the deliberately multiple effects of the recent Landscapes, Lichtenstein created *Painting with Detail.* The work consists of two canvases, one of which is sixty by forty-eight inches and the other a little more than seventeen inches square. Each canvas contains only a field of black Benday dots painted against a white ground. On one level, the work is typical of Lichtenstein's humor in that he willingly parodies his own style. He has been criticized for the pervasiveness and repetitive character of the dots in his work. What better way to answer the critics than to paint only dots? As is also frequent in Lichtenstein's art, there seems to be a more serious intent beneath such a self-effacing gesture. *Painting with Detail* is the first time in Lichtenstein's long and prolific career that he has painted compositions made up solely of uniform fields of dots. By implication, the work points out how varied is the rest of Lichtenstein's art, which uses dots, stripes, solid grounds, patterned brushstrokes, and many other

devices to communicate a wide range of images and styles. Yet *Painting with Detail* does emphasize that the dot is a major discovery by Lichtenstein and a leitmotif of his oeuvre. Just as Lichtenstein has increasingly quoted from his own earlier masterpieces in his art, so *Painting with Detail* underlines the significance of the dot—it is so important that it receives a work of its own.

One of the ways that art masterpieces are traditionally studied is to examine first the whole work and then significant details within it. This method is used frequently in art-history lectures, where details are projected onto the screen next to an image of the entire painting. Lichtenstein undoubtedly saw and employed these very same practices in his early academic career as a graduate student and then as an art teacher at the State University of New York, Oswego, and at Douglass College. The detail in *Painting with Detail* both pokes fun at this procedure and contains its own revelation. We first take humorous note that the detail shows nothing that does not appear in the larger canvas. Yet closer examination indicates that our visual reactions to the two canvases are nearly opposites. If we stand at a viewing distance of about ten feet, the dots in the larger canvas read as a unified field. We do not focus on the character of the individual marks as separate figures. In the smaller painting, the dots have been enlarged to approximately four times the size of those in the larger canvas. As a result, we see the smaller painting as a number of individual dots forming vertical, horizontal, and diagonal

patterns. Here, the dots act as figures, not as ground. Lichtenstein has varied the sizes of the Benday dots in his works over the years so that they sometimes function as figures and sometimes function as grounds, as *Painting with Detail* reminds us. Beneath its seeming simplicity and deadpan humor, *Painting with Detail* alludes to a number of issues that are at the heart of Lichtenstein's art.

Between 1988 and 1990 Lichtenstein painted a series entitled Reflections, an important example of which is *Reflections: Nurse* (1988). In most of the Reflections works, areas of Benday dots in abstract patterns have been painted over re-creations of Lichtenstein's own earlier paintings. These patterns mimic configurations of reflected light that would appear on the surfaces of the works if they were covered with glass. Lichtenstein has also painted illusional frames on the paintings. In his reference to glazing, Lichtenstein comments upon what is commonly seen as a recent and unfortunate practice in the protection of art works. Invariably, light reflections from the glass destroy our ability to see the art works properly. In art circles, this issue has become a complaint that one hears repeated at many exhibition openings. With the sort of wit for which Lichtenstein is now well known, he has found a positive aspect to this practice. For him, the reflections from the glass over the pictures give the works exciting new appearances. They allow him to take an existing work, whether his own or that of another artist, and transform it into a new visual experience. Of course, another

meaning of the word *reflect* is "to reconsider an idea," and Lichtenstein is speculating about changes in his own earlier works as well as those of others. Referring to one of several Reflections based on Picasso's paintings, he commented:

What I've done is to make those paintings appear as though they were framed and had glass on them. The reflections from the glass form another kind of painting. It's an excuse for altering the Picasso and making essentially a different painting, so the Picasso part done by me looks like Picasso, somewhat, but obviously isn't.[30]

With regard to the glazed reflections painted over one of his own works, Lichtenstein's comment might be that the "Lichtenstein part done by me looks like early Lichtenstein, somewhat, but obviously isn't." The viewer is simultaneously aware of a recognizable Lichtenstein and of surprising new inventions that inexorably alter the earlier work. With a further display of inventive wit, Lichtenstein's Reflections combine the most transitory type of visual experience with one of the most permanent. The reflections are ephemeral, constantly changing effects, which are extremely difficult for the eye to capture and study. In contrast, one of the defining characteristics of paintings is that they are permanently fixed images. In the Reflections, Lichtenstein merges these seemingly incompatible visual experiences. The trompe-l'oeil frames and glazing in the Reflections imply the enshrinement of the works. Lichtenstein recognizes the irony in contemporary works of art now receiving the same protective precautions

afforded old-master paintings. Yet here the implication is clearly that Lichtenstein's earlier "masterpieces" also merit such care. Once again, beneath his self-effacing humor, the artist is designating his significant place in the history of art.

The glazed areas in Lichtenstein's Reflections also derive from his own Mirrors series, painted between 1970 and 1972. Self-quotation is an essential feature of Lichtenstein's art, and the artist uses his recent works to remind us of the coherence of his entire oeuvre. The Mirror paintings were seen by many critics as incompatible with Lichtenstein's other art. They are abstract, extremely spare in design and color, and suggest shallow depth through the varying size of the Benday dots.

In the Reflections, Lichtenstein takes on the supposed incompatibility as a test. If the Mirrors are overlaid onto his comic-based paintings, we perceive both the similarities and the differences more clearly. The Reflections also emphatically demonstrate that Lichtenstein's art has always had a strong abstract component and has never been about issues of narrative. The Reflections allowed him great freedom. As Lichtenstein has acknowledged:

That way you can be selective about what you show in the painting. The reflection allows you to do anything at all. It can be any color, any texture so long as it vaguely reminds you of a reflection. It's a way of composing. Then it also refers to painting, although not perhaps in the profound way that the Brushstrokes do. But it rounds it all off. To have glass on it is just another idea that is referential to painting itself.[31]

Reflections: Nurse embodies many of these ideas. The painting re-creates Lichtenstein's own comic-based *Nurse* (1961; private collection). *Nurse,* which dates to the same period as the drawing *Conversation,* is concerned with monumentalizing the comic-book image through a close-up, fragmented view. It employs a simple linear design, which emphasizes the two-dimensional character of the painting and locks the image within the canvas frame. The curves of the nurse's head, cap, and jaw are particularly effective contrasts to the square format of the painting. In *Nurse,* the Benday dots are barely visible. They play a minor role compared to the overall linear design. Lichtenstein's *Nurse* is particularly concerned with parodying and thus draining the superficial emotions from the comic. The nurse's silly and theatrical, anxiety-ridden expression is Lichtenstein's way of indicating that the viewer should look elsewhere for drama, namely to his pictorial construction.

Reflections: Nurse revises Lichtenstein's earlier concerns. He has long since shown that narrative emotion is not a part of his art. Accordingly, the nurse's facial features are largely obliterated. Those that do show are not dramatically wrought. The eye is less heavily outlined and the eyebrow less dramatically arched; the lips do not have the same downward turn. Gone also is the simple structure of *Nurse.* *Reflections: Nurse* is about pictorial complexity and the artist's ability to resolve that intricacy. In it, Lichtenstein has included abstraction and figuration, flatness and three-dimensional illusion, organic and geometric

shapes, picture and frame. His project is to make these diverse features function together. Although the three vertical reflection bars seem at first randomly placed, they actually extend almost exactly to the edges of the nurse's face, and a diagonal bar in the lower section of the painting follows the line of the chin. Just enough of the face—an eye, the nose, and a portion of lips—is shown to create a balance between abstraction and figuration. The reflection bars contain patterns of Benday dots that are more prominent to the left edges and fade away on the right. In this manner, they give the illusion of cylindrical forms. The shallow space they suggest is contrasted to the absolute flatness of the nurse's face.

In *Reflections: Nurse* Lichtenstein creates something flat from a three-dimensional object, the nurse's face, and the illusion of three-dimensional shapes from the flat reflections on glass. Even the illusional frame of the painting is more volumetric than the nurse. This frame is almost identical in appearance to the reflection bars. The individual physical properties of objects in the outside world are almost entirely erased in Lichtenstein's re-creations. Throughout the painting, Lichtenstein uses enlarged Benday dots to emphasize the artificiality and self-contained character of his process. *Reflections: Nurse* and the other Reflections demonstrate Lichtenstein's interest in Analytic Cubism, another modern art movement that he takes on as a challenge. Early Analytic Cubism used fractured planes of light to shatter images and thus to assert both the complexity of modern vision and the artist's right to reorganize

reality as he or she saw fit. In his Reflections, Lichtenstein invents his own version of Analytic Cubism, complete with fragmented imagery and contradictory spatial suggestions. As with Lichtenstein's other historical styles, he does not simply parody Analytic Cubism but revitalizes it and makes it his own. In this process he highlights his own inventiveness and versatility.

Lichtenstein's *Bedroom at Arles* (1992) is a major painting that marks the artist's rethinking of an important source of modernism, Vincent van Gogh's 1888 painting of his room, *Bedroom,* which now hangs in the Art Institute of Chicago. Lichtenstein's painting is partly an amusing parody of Van Gogh's painting. After all, what Van Gogh shows us in this icon of modern painting is simply his room in a cheap nineteenth-century boardinghouse. Since 1990, Lichtenstein has been creating his own series of interiors. They depict bedroom and living-room settings furnished with anonymous Bauhaus-derived furniture of the 1960s. Some of these look like cheap motel rooms. Others are clearly art collectors' homes, filled with such items as Lichtenstein and Johns paintings as well as Alexander Calder sculptures. We can imagine Lichtenstein's delight at the idea of painting Van Gogh's bedroom, which was at once in a boardinghouse and contained art works by the master on its walls. Lichtenstein compounds the pun by replacing certain key items with modern equivalents. For instance, the wooden ladder-back chairs in Van Gogh's painting become bent-metal

modern chairs; the hanging towel in the nineteenth-century painting becomes a neatly folded version on a towel rack such as one might find in a modern hotel. Most of these changes also refer directly back to Lichtenstein's art.

In *Bedroom at Arles,* the dual portraits over the bed humorously become Van Gogh's parents executed in red Benday dots—even Van Gogh hangs Lichtensteins in his bedroom. The two landscape paintings look like Lichtenstein's simplified mid-1960s Landscapes; and the trees, painted with sponges, are similar to some of the devices he used in the expressionist landscapes of the 1980s. The remaining painting on the wall of Van Gogh's room, which cannot be identified clearly in the nineteenth-century work, is turned into a modern abstraction, the type of work for which Van Gogh is often cited as a predecessor. Van Gogh's work shirts hanging on the wall behind his bed become the starched business shirts that Lichtenstein has used as male symbols throughout his career. The mirror on the wall and pitchers on the table, respectively, are like Lichtenstein's Mirrors series and his two-dimensional, painted sculptures of containers that hold liquids such as *Cup and Saucer* (1977) and *Goldfish Bowl* (1978). In these objects, as in others, Lichtenstein continues his investigation of the manner in which simple graphic signs can represent complex physical states. The diagonal blue stripes on the pitcher and one shadow on the vase are sufficient to communicate three-dimensional containers filled with water; in the mirror,

four diagonal lines convey the nature of a reflective surface. With such changes throughout *Bedroom at Arles,* Lichtenstein combines the past and his present, underscores his cleverness, and refers us back to his own art as benchmarks in art history.

Beneath these clever ideas, which are like sophisticated one-line jokes, Lichtenstein is asking what makes the Van Gogh painting special. He answers that the compositional arrangement and especially the spatial dynamics make it exciting. There is not a single right angle in the box Van Gogh created, and the walls are strangely obtuse configurations. At either edge of the painting, doors project outward. The floor slants startlingly upward. All the paintings in the room hang off the wall at odd angles. Every piece of furniture is set at a different slant, and disturbingly, Van Gogh's bed projects directly toward the viewer. This is the spatial dynamism on which Lichtenstein builds in his *Bedroom at Arles.*

Increasingly, Lichtenstein has moved away from the uncompromisingly flat compositions of his early career to investigate different types of spatial illusionism used in art. Examples include the inconsistencies of individual objects in *Razzmatazz,* the experiments in both aerial and linear perspective in *Mountain Village,* and the shallow Cubist depth of the reflection bars in *Reflections: Nurse.* In the context of art history, Van Gogh's reintroduction of depth into painting after the flatness of both Impressionism and Paul Gauguin's Symbolist works is well known. Lichtenstein's *Bedroom at Arles* adopts this idea. His painting is

so large that it fills our entire visual field and thus makes its dizzying spatial effects even more powerful. The rear wall consists of enlarged bright blue Benday dots so that it projects rather than recedes, and the right wall is disassociated from it by its diagonal stripes. Running from lower left to upper right, they push that wall even farther outward. Lichtenstein emphasizes the irregular angles of the doors to either side of the room.

The floor is painted in an intricate pattern of curved lines, which imitate wood graining. Whereas the floor in Van Gogh's painting consists of vertical, linear brushstrokes, which seem to recede rapidly, Lichtenstein's floor forces itself to the surface of the painting. Its undulating, interwoven lines do not resemble anything in Van Gogh's original *Bedroom* as much as they do the coiling spirals in the sky of Van Gogh's *Starry Night* (1889; New York, The Museum of Modern Art). Lichtenstein's undulating lines create an even greater hallucinatory effect than do his dots and diagonals. Their weaving pattern causes optical vibrations, which is a specific physiological condition.[32] Lichtenstein uses this effect to make his painting literally, visually, exciting. The style of *Bedroom at Arles* reminds us of 1960s Op (Optical) art. Although Op art has since been largely discredited because of its lack of content and its use of "trick" visual effects, it was enormously popular at the same time that Pop art emerged and was seen by some critics as a viable alternative to Pop. That celebrity culminated in the large exhibition *The Responsive Eye*,

held at the Museum of Modern Art in 1965. Many of the Pop artists, including Lichtenstein, used some Op elements in their works. Despite the limitations of Op Art, the artists recognized its undeniable visual energy. Lichtenstein borrows that dynamic animation in *Bedroom at Arles* to create one of the most optically vibrant works of his career.

A major distinction should be noted between Van Gogh's and Lichtenstein's paintings, one that involves their emotional tenor. Van Gogh's bedroom is a place of emptiness and haunting loneliness. In it, we keenly feel the lack of human presence and see the irregular geometry of the room as a threat to the security we usually expect to find in small enclosed spaces, particularly our bedrooms. Lichtenstein is not at all concerned with such somber emotions, and, contrasting the Dutch artist to himself, he once commented that Van Gogh "is deadly serious."[33] Lichtenstein converts Van Gogh's bedroom into a place of dizzying visual excitement and buoyant energy. Such a transformation is in keeping with the later artist's optimistic temperament, and Lichtenstein may be thinking humorously that he is "saving" Van Gogh from his own desperate isolation. *Bedroom at Arles* highlights the creative vitality and confident ingenuity that are at the core of Lichtenstein's art.

Lichtenstein's *Bedroom at Arles* is not the final contest in the artist's game of art history; it is another in a series of complex moves, each of which reveals

new strategies. Gamesmanship is certainly an aspect of Lichtenstein's art. The permutations and variations he seems consistently able to discover bear some resemblance to a very complex form of play, and his art does have the light, cheerful mood we associate with games at their best. But the game aspect of his art should not be overemphasized, for Lichtenstein's art is also very serious. Either indirectly or directly, his art demands comparison with the very highest levels of modern art, and the artist is a firm believer in the authority and progress of modernism. Lichtenstein has recast a good deal of modern culture, both high and low, in his own mode, and has shown his ability to revitalize art we once thought either unworthy of our attention or securely locked in a historical framework. In doing so, he invariably reveals the central role that his art plays in that history. Lichtenstein approaches such re-creations of past art, not in the offhanded manner of a humorist, but with the precision and thoughtfulness we most often associate with old-master art. Indeed, someday Lichtenstein may be viewed as a classicist of the late modern period, as Nicolas Poussin is regarded in the context of the seventeenth century, Georges Seurat in the nineteenth, and Fernand Léger in the early twentieth. Almost all of Lichtenstein's art is about the idea that painting is self-referential. He has made us think hard about the nature of picture making, and Lichtenstein might argue that that is the very best an artist can do.

1 "Roy Lichtenstein: 'How Could You Be Much Luckier than I Am?'" an interview with Milton Esterow, *Art News* 90, no. 5 (May 1991), 86.

2 Roy Lichtenstein, interview with the author, October 14, 1991.

3 Ibid.

4 Ibid.

5 Carter Ratcliff, "The Work of Roy Lichtenstein in the Age of Walter Benjamin's and Jean Baudrillard's Popularity," *Art in America* 77 (February 1989), 110–23 and 177.

6 Lichtenstein, interview with the author, October 14, 1991.

7 The notion of challenging rather than paying homage to past art is a central tenet of modernism. In such works as Edouard Manet's *Olympia* (1863; Paris, Musée d'Orsay), the artist so redefines the meaning of the female nude and its social-sexual implications that he asserts his authority over and the validity of his ideas in opposition to past masters who have used the theme.

8 Lichtenstein, interview with the author, October 14, 1991.

9 Ibid.

10 Roy Lichtenstein, "What Is Pop Art?" interview with G. R. Swenson, *Art News* 62, no. 7 (November 1963), reprinted in *Roy Lichtenstein,* ed. John Coplans (New York: Praeger, 1972), 54.

11 Lichtenstein, interview with the author, October 14, 1991.

12 Ibid.

13 Ibid.

14 Ibid.

15 Roy Lichtenstein, interview with Melvyn Bragg during the video *Roy Lichtenstein: Portrait of an Artist* (London: RM Arts, 1991).

16 Lichtenstein, interview with the author, October 14, 1991.

17 Ibid.

18 Ibid.

19 Ibid.

20 Jack Cowart, *Roy Lichtenstein, 1970–1980* (New York: Hudson Hills Press, 1981), 36.

21 Lichtenstein, interview with the author, October, 14, 1991.

22 Ann Hindry, "Conversation with Roy Lichtenstein," *Artstudio* 20 (Spring 1991), 11.

23 Hoyt L. Sherman with collaboration of Ross L. Mooney and Glen A. Fry, *Drawing by Seeing: A New Development in the Teaching of the Visual Arts through the Training of Perception* (New York: Hinds, Hayden, and Eldredge, 1947), 5–6.

24 Hindry, "Conversation," 12.

25 Lichtenstein attended the School of Fine Arts, Ohio State University, as an undergraduate from 1940 until 1943. In 1949 he completed an M.F.A. degree at Ohio State. From 1957 until 1960 he was an assistant professor at the State University of New York, Oswego, and from 1960 until 1964 he was an assistant professor at Douglass College, The State University of New Jersey.

26 Lichtenstein, interview with Bragg.

27 Donald B. Kuspit, "Lichtenstein and the Collective Unconscious of Style," *Art in America* 67 (May–June 1979), 100–105.

28 Ratcliff, "The Work of Lichtenstein in the Age of Benjamin's and Baudrillard's Popularity."

29 Conversation with Jane Meyerhoff, November 3, 1993.

30 Roy Lichtenstein, in "Roy Lichtenstein: 'How Could You Be Much Luckier than I Am?'" 86.

31 Lichtenstein, interview with Bragg.

32 Harvey Richard Shiffman, *Sensation and Perception: An Integrated Approach* (New York: John Wiley and Sons, 1990), chapter 15.

33 Roy Lichtenstein, interview with Lawrence Alloway, February 1983, published in Lawrence Alloway, *Roy Lichtenstein* (New York: Abbeville Press, 1983), 107.

ROY LICHTENSTEIN
Conversation, 1962
Graphite on paper, 10" × 8¼" (25.4 × 21.0)

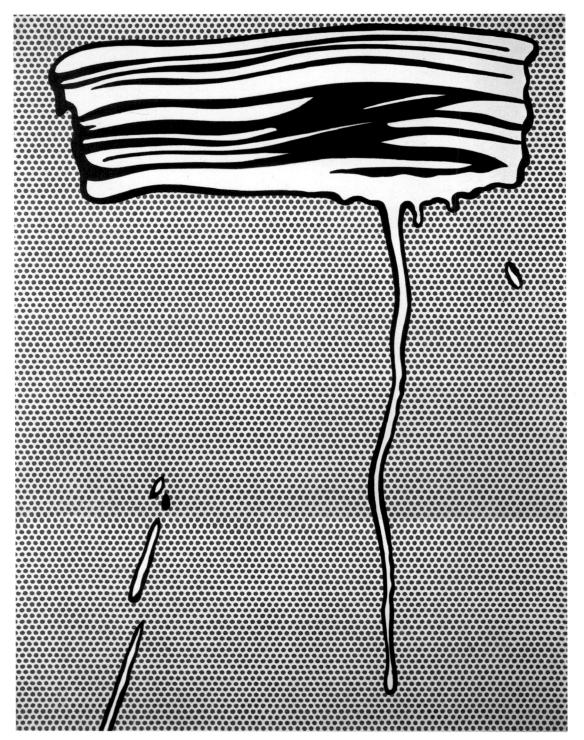

Facing page

ROY LICHTENSTEIN

Fragmented Painting of Lemons and Melon on Table, 1973

Oil and magna on canvas, 36″ × 40″ (91.5 × 101.6)

ROY LICHTENSTEIN

White Brushstroke II, 1965

Oil and magna on canvas, 48″ × 36″ (121.9 × 91.4)

ROY LICHTENSTEIN

Entablature, 1975

Oil, sand, and magna on canvas, 66" × 112" (167.6 × 284.5). National Gallery of Art, Washington, D.C., Robert and Jane Meyerhoff Collection

Facing page

ROY LICHTENSTEIN

Girl with Beach Ball III, 1977

Oil and magna on canvas, 80″ × 66″
(203.2 × 167.6)

ROY LICHTENSTEIN

Razzmatazz, 1978

Oil and magna on canvas, 96″ × 120″
(243.8 × 304.8)

ROY LICHTENSTEIN

Painting with Statue of Liberty,
1983

Oil and magna on canvas, 107″ × 167″
(271.8 × 424.2)

ROY LICHTENSTEIN

Mountain Village, 1985

Oil and magna on canvas, 108″ × 156″
(274.3 × 396.2)

ROY LICHTENSTEIN

Expressionist Head, 1980

Oil and magna on canvas, 70″ × 60″
(177.8 × 152.4)

ROY LICHTENSTEIN

Cow Triptych (Cow Going Abstract), 1974

Oil and magna on canvas, 3 panels,
each 68" × 82" (172.7 × 208.3)

ROY LICHTENSTEIN

Painting with Detail, 1987

Oil and magna on canvas, 2 panels, 60" × 48"
(152.4 × 121.9); 17¼" × 17⅛" (43.8 × 43.5)

ROY LICHTENSTEIN

Reflections: Nurse, 1988

Oil and magna on canvas, 57¼" × 57½"
(145.4 × 146.1)

ROY LICHTENSTEIN

Bedroom at Arles, 1992

Oil and magna on canvas,
126″ × 165″ (320.0 × 419.1)

Robert Rauschenberg

If you are dealing with multiplicity, variation and inclusion as your content, then any feeling of complete consistency or sameness is a violation of that attitude.

ROBERT RAUSCHENBERG[1]

Robert Rauschenberg is one of the most intuitive artists of our age. He has developed creative modes that allow inspiration to dominate his work to an unprecedented degree. The power of his art comes from its basis of instinct and personal feeling. His works capture the surface of thought, rapidly made visual associations, and our innate responses to materials. The immediacy of Rauschenberg's creative process makes him involved with his environment and with the visual information of everyday life to an extent that is greater than that of any other major contemporary artist. In his art, Rauschenberg has always placed enormous emphasis on invention, newness, surprise, and unfettered creativity. Self-consciously, he creates situations in which he can startle himself, improvise, and act spontaneously. In these respects, Rauschenberg's art mirrors the importance of intuition in the daily lives of all of us. Generally, we believe that intuition is reliable, and indeed we act most of the time without analyzing what our reasons for our behavior might be. It is certainly rare to set out an argument for one's actions in elaborate formal terms. It is precisely this latter and more rarified mode of thinking in which Jasper Johns's art encourages us to engage. Despite the frequent analogies drawn between the art of Rauschenberg and Johns, their approaches to artistic thought are actually polar opposites.

The manner in which Rauschenberg encourages intuition in his studio practices parallels the type of thinking today labeled by psychologists as "lateral thinking." The psychologist

Edward de Bono has summarized the differences between vertical and lateral thinking:

> Rightness is what matters in vertical thinking. Richness is what matters in lateral thinking. Vertical thinking selects a pathway by eliminating other pathways. With vertical thinking one selects the most promising approach to a problem, the best way of looking at a situation. With lateral thinking one generates as many alternative approaches as one can.[2]

This is not to propose that Rauschenberg self-consciously uses lateral thinking; rather, I am suggesting that the creative mode Rauschenberg has developed intuitively is a related procedure that might be better understood through reference to that concept. Lateral thinking is now accepted as an important way of generating new and unexpected hypotheses. It presupposes that perception is neither universal nor uniform but is a particular way of looking at some part of the world. It assumes that perception is the grouping together of certain features and the isolation of others; these patterns are only some of the many possible ones that could be formed. Because of the nature of our mind's patterning system, we may be unable to use some modes of thought since we are led in a different direction. Proponents of lateral thinking are concerned with changing perceptions and uncovering insights that we have previously been unable to use. By thinking laterally we can develop habits of mental provocation that move us away from established modes of thought and lead us to discover new ones. Lateral thinking is the opposite of vertical thinking, which depends on logical analysis and categorization. An example of lateral thinking might be, "A child is upsetting its father's writing by playing with a ball. One suggestion is to put the child in a playpen. Another suggestion is to leave the child outside and put the father in the playpen."

Lateral thinking ought to be differentiated from its cousins "free association" and "automatism," which were cultivated as creative methods first by the Surrealists and then by the Abstract Expressionists. While Rauschenberg owes a profound and often-noted debt to Abstract Expressionism, the distinction between lateral thinking and free association tells us of the important differences between his mode of thought and that of his predecessors. Free association is inextricably linked to psychoanalysis. The term became popular when Sigmund Freud claimed in *The Interpretation of Dreams* that unforced remarks made by patients during treatment unwittingly revealed their wishes and motives. Thus, free association by its nature uncovers a relatively narrow range of related themes that define important characteristics of a person's mental state. Free association was also used by Carl Jung in conjunction with his notion of archetypal images. In Abstract Expressionism, free association resulted in the creation of powerful symbolic forms that were repeated almost obsessively with only slight variations. One thinks of Rothko's color fields, Pollock's dripped webs, Motherwell's Elegies, and de Kooning's Women. By contrast, Rauschenberg's lateral thinking is based on variety, change, and inclusiveness, which are among his greatest strengths. His works attempt to capture what vision and thought apprehend of the surface of things rather than to plumb the depths of personality.

Rauschenberg has spoken adamantly about his attempts to negate personal psychology in his work. As an example, when discussing the Black Paintings of 1951, he has said:

Lots of critics shared with the public a certain reaction: they couldn't see the black as pigment. They moved immediately into association with "burned-out," "tearing," "nihilism" and "destruction." That began to bother me. I'm never sure what the impulse is psychologically; I don't mess around with my subconscious. I try to keep wide-awake. If I see any superficial subconscious relationships that I'm familiar with—clichés of associations—I change the picture. I always have a good reason for taking something out but never have one for putting something in. I don't want to because that means that the picture being painted is pre-digested."[3]

One way of understanding Rauschenberg's instinctive way of thinking is to examine his studio methods. They have been among the most completely documented of those of any late-twentieth-century artist. This documentation includes both early and recent articles that discuss Rauchenberg's studio methods, depictions in photographs and film, descriptions by studio assistants, and even the artist's ventures into painting on stage. These reports indicate that Rauschenberg typically begins his works without a specific idea of how the painting or construction will finally appear. He does not make preliminary drawings except to solve technical problems and never works from a predesigned plan. The artist often begins by being motivated by a particular object, image, or material. These elements seem to have been selected with some care. The artist has spoken of his "love" for the articles he uses. The story of Rauschenberg's selection and restoration of the goat in *Monogram* (1955–59; Stockholm, Moderna Museet) marks one extreme of his process, but this attitude seems to apply generally to all his objects. For instance, one system he used during the 1950s was to set a one-block radius around his studio as a limit to his explorations to see what objects he might discover.

The nature of Rauschenberg's studio environment, which allows him to work so spontaneously, was recorded by G. R. Swenson in the early 1960s in his article "Rauschenberg Paints a Picture" and by Mary Lynn Kotz in 1990. Kotz describes books of photographs numbered to coordinate with silkscreens of them that are stored in the studio so that the artist might quickly choose an image and have the screen at hand for inclusion in a particular composition. Such systems, which encourage spontaneous invention, are characteristic of lateral thinking. Reports also indicate that the artist approaches his works with great confidence, deliberateness, and speed. Each step is used to suggest the next one in a chain of associations, and the artist will often be engaged in several related works at once. Rauschenberg must stay closely in touch with the evolving process of the work; if that rhythm is broken, the piece may be ruined.[4] Rauschenberg has spoken about some of the devices he uses to encourage inventive freedom in his art:

I have various tricks to actually reach that solitary point of creativity. One of them is pretending I have an idea. But that trick doesn't survive very long because I don't really trust ideas—especially good ones. Rather, I put my trust in the materials that confront me, because they put me in touch with the unknown. It is then that I begin to work...when I don't have the comfort of sureness and certainty. Sometimes Jack Daniels helps too. Another good trick is fatigue. I like to start working when it's almost too late...when nothing else helps...when my sense of efficiency is exhausted. It's then that I find myself in another state, quite outside myself, and when

that happens there's such a joy! It's an incredible high and things just start flowing and you have no idea of the source.[5]

This discussion of Rauschenberg's studio procedures suggests an approach to interpreting his work. His art is clearly not a random accumulation of materials and data, as has often been stated. But neither does it consist of a deeply worked out iconography or consistent style. Broad tendencies of ideas and moods can be identified. We should be able to perceive aspects of the stream of associations that have gone through Rauschenberg's mind. These associations will take the form of analogies, relationships of both form and content, contrasts, and witty visual puns, but not every item will add up to a unified system. Complexity and variety are at the very heart of Rauschenberg's work, and one should be sensitive to currents of meaning rather than to resolutions. The characteristics of materials are particularly important, both individually and in terms of the manner in which the artist has altered them as well as related them to other materials in the work. Rauschenberg's goal is to make these disjunctive materials look as if they belonged together naturally, but in order to understand his work better, the viewer must examine the artist's procedure to see which decisions were made and which ones avoided. While Rauschenberg's individual works reflect quickly made associations and the captured feelings of the instant, he has a firmly held and evolving vision of overall goals in his art. "My works are like echoes; they are contemporary but also hold the past."[6] Thus, we are not only able to trace specific themes that dominate various series but can also observe the progression of his self-image from modern to national to international artist. Rauschenberg is not concerned with the theoretical problems of picture making that occupy, and sometimes constrain, Jasper Johns and Frank Stella. His art is experiential; it captures the skin of life. Its strength lies in the artist's acceptance of facts in the world around him as well as his optimistic belief that openness and freedom are virtues.

Bypass (1959) exhibits the sorts of associations that mark Rauschenberg's thinking. It also demonstrates the artist's ability to work in a mostly abstract manner. Between 1959 and 1960, Rauschenberg pursued a largely abstract and painterly style, just at the time when that type of art was being discredited by the advent of Pop, for which he had also been an unwitting source. One aspect of Rauschenberg's inventiveness is his tendency to oppose the stylistic trends of a given period. Generally, he has viewed abstraction and figuration as coequal possibilities that vitalize each other. In Bypass, the paint techniques are virtually a compendium of possibilities, as if Rauschenberg were exploring all viable options. The lower area contains a large portion of raw canvas. A flat, opaque section of red in the bottom right quadrant contrasts with the thin, translucent glazes of white directly above it. Thick impasto in pink, black, and red pigment and rills of thin black paint appear throughout the composition. At the center, Rauschenberg has used the brush to create spiral patterns of pink paint, and it appears that he has manipulated an area of red and black pigment with his fingers. In the upper part, a dry brush technique is used to create ragged texture, which, in turn, is contrasted with rich, slip-

pery mottling that results from using oil paint that has been incompletely mixed with thinner. Throughout *Bypass*, pieces of cloth have been glued to the surface, providing further visual and textural variety.

As is common in many of Rauschenberg's works, the paint areas are organized roughly in a grid of horizontal and vertical patches. The grid provides a structure against which Rauschenberg's free paint handling may appear, just as Rauschenberg has invented systems in his studio that allow maximum freedom. The few images used in *Bypass* are collaged onto the surface and thus represent yet another artistic technique. To the upper center is a newspaper photograph of racing greyhounds. Running along a black dirt track, they embody the speed and energy suggested by the rills of black pigment near them. To the left side of the painting, a photograph of a construction crane "supports" the area of black pigment directly above it. The crane, labeled "American Bridge," suggests the national origins of Rauschenberg's works and his positive feelings for the power and authority of modern technology.

Words play an important role in *Bypass*. In the spirit of Rauschenberg's inclusiveness, they should be regarded for both their structural shapes and their content. As with other aspects of the artist's work, their choice is not random but reflects his conscious, but instinctive, decisions. In almost all of the 1959–60 paintings, Rauschenberg's lettering is of the same graphic type, boldface Roman. Obviously, he used his selectively collected examples of this particular typeface so that it might compete visually with the broad rectangular patches of paint around it. The meaning of the letters in *Bypass* are also suggestive. The one complete word, *TITLE*, is placed vertically on the painting's right edge and is partly obscured by a glaze of white pigment. It is followed by *&* and a large patch of red pigment. The question is posed: how do we title such an abstract work, and, more important, are the verbal clues a title provides necessary to understand the work? The actual title of the painting would seem to confirm the irrelevancy of the issue. *Bypass* suggests that we simply detour around the nonissue of titles to get more quickly to a direct confrontation with the painting. The context in which Rauschenberg would most frequently have seen this word was on American highways, especially during the expansion of the national highway system during the 1950s and 1960s. In this framework, *bypass* confirms speed, technology, and modernity as essential features of Rauschenberg's worldview. The title, *Bypass*, then, is simultaneously an element we are told to ignore and one that informs the meaning of the painting. Such multiplicity of information is the essence of Rauschenberg's art.

Brace (1962) is one of Rauschenberg's important early silkscreen paintings, a group of works created between 1962 and 1964. They had been immediately preceded by such transfer drawings as *Tour* (1959; Meyerhoff Collection). As Rauschenberg has pointed out, the silkscreens were important because they allowed him to expand his imagery in scale and thus visual impact. The screens were produced by a professional printer, at first from found photographs and later from both found pictures and Rauschenberg's own photographs. The artist's use of silkscreens, which he discovered at the same time as Andy Warhol did, para-

doxically allowed greater control and greater variety in his work. The control came from a selected repertoire of images that were repeated in many canvases. (Rauschenberg carefully cleaned, preserved, and reused the screens for several years.) Variety resulted from the multiple possibilities inherent in manipulating the images. Rauschenberg has stated that not only did each image appear new and fresh to him when enlarged, but that it appeared different each time its orientation was rotated, painted in another color, or put next to other images.[7] The painterliness and variety of these images are unlike those of Warhol, which appear more as ironic commentaries on mass production.[8] While the surprising diversity of appearances that these images yield is evident to the average viewer, it was particularly apparent to Rauschenberg because, as will be discussed below, his dyslexia prevents him from easily recognizing an image when it is altered in such ways.

The care with which Rauschenberg approached the new medium of silkscreen can be seen in his avoiding complexities of color and executing his first silkscreen paintings, like *Brace*, in black, white, and gray tones. Additionally, *Brace* contains some gold highlights in the upper right corner. It is a sixty-by-sixty-inch composition and contains six partly overlapping silkscreen images—of baseball players and clouds—which have also been over- and under-painted. *Brace* marks an early appearance in Rauschenberg's art of sports imagery. He views sports figures as heroes of society and people of action. The artist has commented, "I used to say art and sports were the only things free from politics."[9] Rauschenberg's rather naive statement about sports (and art) reflects the generally optimistic view that informs most of his art. The sports figures are, to some extent, stand-ins for the artist, who sees himself as a hero and man of action in the modern world. Baseball, the all-American game, has a particular appeal for Rauschenberg, and baseball scenes have appeared in many of his works over the years. The reason for this predilection may be that baseball is a game of strict rules, yet the way to win is to break down that order and to make the unexpected happen. To hit a ground ball between second base and the shortstop, to bunt or to steal a base, is to create moments of freedom, which may allow a player to score and win the game. Rauschenberg sets up similar situations in his studio, where the unexpected and unanticipated might occur.

In this spirit, *Brace* exemplifies freedom and fantasy rather than concrete objectivity. *Brace* suggests that the spectator's viewpoint is that of the ball and induces in the viewer the sensation of flight. The four silkscreen images of ballplayers are seen from a raised point of view, and they are hazy, as if clouded by aerial perspective. We seem to see both the preparation for the pitch and the swing three times—the moment when freedom is created.[10] The forms surrounding the players are clouds made from silkscreen images and from the artist's amorphous paint application. To arrive at this effect, paint was applied directly to the canvas with both a brush and a squeegee (normally used to press pigment through the screens), resulting in thin, soft-edged gray and white shapes that permeate the entire surface of the canvas. The variety of grays is so rich that the lack of other colors is not felt; the small area of gold suggests the sun shining through the clouds, which adds to the romantic aura of the painting. The large

white circle above the central player's head clearly suggests the ball, and it is the image visually closest to the viewer. To its left, the black stripe is like a baseline seen from above, which, because of its slightly trapezoidal shape, appears to recede into space.

In *Brace*, we are amid the clouds, soaring with the ball and looking down on the game. The painting evokes moods of fantasy, reverie, and adventure. It relates to other works by Rauschenberg, which allude to the freedom of space flight, parachuting, sailing, and other such airborne or air-driven activities. In the Rauschenberg literature, so much emphasis has been placed on the materiality of his art that his involvement with fantasy has been neglected. For Rauschenberg, imagination is just as real as the factual character of his materials.

Rauschenberg's mode of creative thinking, which involves intuition, multiplicity, and change, and which motivated the making of *Brace* as well as his other works, has been described as a deliberately cultivated procedure. It is also probable that his way of seeing and thinking is influenced by an innate physiological characteristic—dyslexia. Although the artist's dyslexia is relatively common knowledge, it has never been discussed in the literature on his work. In an interview during which Rauschenberg discussed the visualization of works in reverse during printmaking, he commented:

> Well, that's what happens when you are working with a dyslexic, I already see things backwards! You see in printmaking everything comes out backwards so printing is an absolute natural for me. It is difficult for a lot of artists to do prints because they draw one way and can't imagine it the other way. I always had trouble reading as a child. Every few minutes my mind would shift and I would pick out all the O's then all the letter A's on a page. I still have a struggle reading and so I don't read much.... Probably the only reason I'm a painter is because I couldn't read yet I love to write, but when I'm writing I know what I'm writing; when I'm reading I can't see it because it goes from all sides of the page at once, but that's very good for printmaking.[11]

In all probability, Rauschenberg's dyslexia has profound influences on his perceptions of his environment and his resulting art works. These are hinted at in the above statement but go far beyond it in scope. Dyslexia is a complicated condition, existing in many variations, and is still not fully understood by researchers. Most research on dyslexia concentrates on exercises to correct the condition rather than on investigations of the manners in which the dyslexic person perceives the world. Despite this shortcoming, we may isolate some of the basic characteristics of the condition, but first, some common misconceptions should be addressed. While dyslexia is usually associated with reading difficulties, it affects image perception and the perception of all representational systems, not just the written word.[12] At the outset, one should also note that, according to the most recent research, it is wrong to regard dyslexia as a handicap. It is better thought of as an alternate mode of perception. It has been astutely stated that if modern Western society had not developed its emphasis on writing, which requires placing specific graphic signs in a particular order, dyslexia might not even be noticed and would

certainly not require treatment. Some researchers have even suggested—and this idea is germane to Rauschenberg—that in another type of society, dyslexic individuals would be highly valued. Their alternate modes of perception allow them to see the world differently from other people.

One of the common features of dyslexia that seems to relate to Rauschenberg's paintings is image reversal and rotation. Rauschenberg spoke of this effect in the above statement, and the viewer need not look far in the artist's work to see how many images are altered in this manner, sometimes appearing in several different positions within the same painting. As obvious examples in the Meyerhoff Collection, one might cite the helicopter right side up and on its side in *Archive* (1963) and the upside-down iron railing in the same picture. Other rotated images, such as that of Tutankhamun's sarcophagus, appear in the Meyerhoffs' *Corinthian Covet* (1980).

Related to these rotations is the notion of image retention and identification. For all of us, these reorientations—as well as other changes, such as those of scale and color—make the images look new. This is part of the visual excitement of a work by Rauschenberg, where a familiar object suddenly looks fresh and novel. The ability to identify images when such changes as rotation, scale, and color occur is much more difficult for the dyslexic person.[13] Thus, these rudimentary changes would make each image appear just that much more different and therefore that much more exciting to Rauschenberg. He has spoken about this effect when discussing his silkscreen paintings:

> There's the same quality of surprise and freshness that I have when using objects. When I get the screens back from the manufacturer, the images on them look different from the way they did in the original photographs, because of the change in scale, so that's one surprise right there. Then, they look different again when I transfer them to the canvas, so there's another surprise. And they keep suggesting different things when they're juxtaposed with other images on the canvas, so there's the same kind of interaction that goes on in the combines, and the same possibilities of collaboration and discovery.[14]

At the same time that Rauschenberg clearly courts such visual variety in his works, he also employs designs so that their intricacy does not become overwhelming. In many of Rauschenberg's compositions, the rotated images are organized in a grid. Dyslexic individuals are taught to use horizontal and vertical axes as orientation devices to help them better organize information.

Another common perceptual condition of dyslexia is a lack of figure/ground discrimination. One of the basic properties of vision is the easy ability to separate an object from its surrounding background. Such distinctions are much harder for the dyslexic person to master. Figures often become embedded in and confused with the surrounding ground. In Rauschenberg's work figures and grounds are frequently allowed to merge. One thinks of the hazy, veiled images in *Focus* and the other Hoarfrost compositions. The integration of silkscreen images and the printed fabric in *Fore Season* is so complicated that in certain areas it is impos-

sible to separate them visually. In *Corinthian Covet* the central panel is partly covered with a checkerboard pattern, which effectively obscures the figure/ground reading in that area. Rauschenberg's use of mirrors in a variety of works, including *Rose Condor* and *Corinthian Covet*, further confuses object and spatial readings. It might be noted that one of the most visually difficult forms for the dyslexic person to perceive is the Necker cube, a common illusional cube formed from twelve lines. Although the Necker cube does not appear in any of the Meyerhoff works, it occurs with great frequency in Rauschenberg's oeuvre in such paintings as *Shortstop* (1962; private collection) and *Barge* (1963; Washington, D.C., National Gallery of Art, on loan). Just as Rauschenberg simultaneously encourages visual complexity through image rotation and controls it through grid designs, so he tames figure/ground confusion by the inclusion of actual objects attached to his works. In the early Combines and later constructions, these real objects are easily located spatially by either the dyslexic or the nondyslexic individual.

The dyslexic person often sees things in fragments. He has difficulties with what is called "selective attention"; peripheral stimuli are not easily separated from central stimuli. The great number of Rauschenberg's works that include dozens of images within a single composition partly relate to this condition. Similarly, in Rauschenberg's works, visual hierarchy is avoided. Most objects and images seem to vie with each other for the viewer's attention. Also, short attention spans are common among dyslexic individuals, often coupled with their opposite— obsessive attention to particular details. Records of Rauschenberg's studio practices indicate the speed with which he executes works and his uncanny ability to have several works in progress at the same time, switching his attention from piece to piece.[15] These same reports also mention that the artist can become highly focused, lavishing attention on the smallest details of a work.[16]

While specific testing would be required to determine more exactly the influence of Rauschenberg's dyslexia on his art, empirical reasoning seems to point to the connections outlined above. Far from viewing it as a disability, it appears that Rauschenberg has used his dyslexic condition to create an art form dominated by intuition, change, and multiplicity. It is a type of expression that seems particularly relevant to the modern world. In seeing the world somewhat differently from most of us, Rauschenberg has managed to highlight conditions of change, which many feel are essential parts of modern experience.

Since the beginning of his career, Rauschenberg has been interested in time and personal experience. Such works as the early Combines and even *Bypass* are in one respect records of moments of individual contact between him and his environment. Rauschenberg's silkscreens of 1962–64 mark a change in the artist's concept of time. They are his first works concerned with national experience and even world history from an American perspective, as opposed to his personal experience of time. As such, they signal an important broadening of the artist's viewpoint and ambitions. In these works Rauschenberg asserts his role as an artist who not only is concerned with but records national events. He might even be seen as a history painter, a modern inheritor of the classical tradition of historical painting.

Archive (1963) is a record of national pride and accomplishment. Its dominant colors are red, white, and blue, complemented by patches of bright green and yellow. Once Rauschenberg decided to use colors in his silkscreen paintings, he rapidly fell in love with the intense, joyous tones of silkscreen inks, which influenced his subsequent color choices in oil paint. The shape configurations in *Archive* are open and expansive, freely floating in a loosely constructed grid. At the bottom of the painting is a Boy Scout parade dominated by waving flags, a harmless form of patriotic celebration, which picks up the flag motif of the entire work. To the upper right are several representations of airplane control panels, which celebrate the sophistication and complexity of modern technology. The steering wheel of the plane looks like the curving shape of the raised highway ramp in the upper right, and the circular dials on the panels have a surprising visual congruence with the beach umbrellas—images of America at leisure—shown in the lower middle. A starburst of red at the center further vitalizes the painting. The silkscreen also features an elaborately decorative wrought-iron railing turned upside down, which resembles the flagpoles in the Boy Scout parade below. Along the left edge of *Archive* are two images of Army transport helicopters. Again, these speak of technology but are also somewhat awkward and humorous because of their ungainly shapes. The lower image is rotated by ninety degrees and thus leads us particularly to observe its strange design. The helicopter is reminiscent of the mosquitoes that Rauschenberg remembers so well from his childhood in Port Arthur, Texas (giant versions of them appear in several works).

The upbeat and positive tone embodied by *Archive*, and other works, is a key to understanding Rauschenberg's worldview. The 1960s silkscreens have been seen as antiwar and anti-American statements in light of the anti–Vietnam War movement in this country.[17] This is a misinterpretation of the works and a misunderstanding of Rauschenberg's attitude at the time. *Archive* is not an "archive"—an unbiased collection of documents; it expresses a particular viewpoint. Listing some of the images that recur in the other silkscreen paintings of this period demonstrates the artist's positive stance. They include the Statue of Liberty; the famous, authoritative magazine photograph of President John F. Kennedy; the American bald eagle; a space capsule returning to earth; helicopters; and the Boy Scout parade with flags. Even the helicopter—the most overtly military image—is a transport helicopter, not the more threatening attack helicopters employed during the Vietnam War. If Rauschenberg had wished to show violent war photographs, there was certainly no shortage of images from which to draw during this time, but he deliberately chose not to do so. It has even been asserted that the image of Kennedy, which is used no fewer than nine times in the silkscreens, actually showed him calling the troops home. Rauschenberg's memory of that photograph in the context of his difficult decision to use it even after Kennedy's assassination gives a very different impression of the artist's intent:

> Kennedy and his presidency had merged to become fact. He re-established what a president is supposed to be—somebody special, not somebody you're comfortable with. One of the things that was so shocking about his death was that it was so believable; it wasn't out of scale with the strength and abruptness of all the things he'd done in office.[18]

Rauschenberg's hero worship of Kennedy, which grew for him, as it did for many Americans, in the aftermath of the assassination, is important because the motivations of his art are tied to the political ideology of the Kennedy era. Rauschenberg is a liberal and an optimist about America, whose continuing ideas about the meaning and function of art were formed in the context of the Kennedy era. The Kennedy liberals believed that humanity was in essence good and rational, but that leaders, men of action, were needed to provide opportunities for freedom of expression and openness of thinking. If these chances were provided, the goodness of humankind would manifest itself. For them, democracy was the highest form of government, and it was the duty of America assertively to oppose totalitarianism around the world. America's activist role would result in peace and internationalism. The unspoken credo was that American democracy should be the model for the entire world. The Kennedy ideals were perhaps best summarized by Arthur Schlesinger in his book *The Vital Center*. First published in 1949 and reissued in 1962, it became the Bible of the Kennedy circle. Citing Walt Whitman as a source, Schlesinger wrote:

> Wherein lies the hope? In "the exercise of democracy," Whitman finally answered.... "[T]o work for Democracy is good, the exercise is good—strength it makes and lessons it teaches." The hope for free society lies, in the last resort, in the type of men it creates.... In times past, when freedom has been a fighting faith, producing a "large resolute breed of men," it has acquired its dynamism from communion in action. "The exercise of Democracy" has quickened the sense of value of the individual; and, in that exercise, the individual has found a just and fruitful community. We require today exactly such a redirection to concrete democratic ends; so the exercise of democracy can bring about a reconciliation between individual and community survival of the spirit of democracy, and a resurgence of the democratic faith.[19]

Rauschenberg views himself as an artist-citizen. He believes that all people are responsible for improving society and that his art acts as a model for that improvement. Rauschenberg's American democratic ideals are tied not only to the imagery he uses but, more important, to the very process by which he creates his art and the attitude with which he wishes it to be viewed. As a whole, Rauschenberg's art is about freedom and acceptance. He constantly works to extend his, and subsequently the viewer's, tolerance of a wide variety of artistic experiences. For Rauschenberg, this tolerance is not only a metaphor for societal openness and empathy, but it actually encourages that state of mind among those who experience his art. Civil rights and equality for all—hallmarks of the era—could be stimulated, in the artist's view, by creative freedom.

For many, the beliefs of the early sixties were severely undermined by later history, when the more cynical, Realpolitik attitude of the Nixon-Kissinger era became dominant. Rauschenberg, however, remains committed to a progressive ideal. This attitude is apparent in his art as a whole but was most recently and directly manifest in his Rauschenberg Overseas Culture Interchange. As part of this global project, begun in 1990, Rauchenberg has traveled to twelve countries, making art from the materials and everyday artifacts of other cultures. Subsequently, he has exhibited a selection of ROCI works in each country. This project features

both the strengths and the limitations of 1960s liberal thinking. The program's strength lies in the breadth of its scope and its honest attempt to promote understanding and world-wide communication. Its limitation is that American-type artistic freedom is considered the underlying premise for development and change. Thus, the resulting works look more like Rauschenberg's absorbing other cultures than a true exchange. The project is open to criticisms of cultural imperialism, just as the 1960s' liberals have been seen to be guilty of political and social imperialism as America set out to "save" the world and remake it in her own image.

To say that Rauschenberg has an optimist's faith in American democracy is not to say that he has approved of all American policies. It is well known that during the later 1960s Rauschenberg was one of a number of artists who actively opposed the Vietnam War. One of the few times during which Rauschenberg lost faith in his vision of freedom was 1968–69— a time of crisis for many Americans. With the Vietnam War raging on, race riots in many cities, the assassinations of Martin Luther King, Jr., and Robert Kennedy, and the beating of demonstrators during the Democratic National Convention in Chicago, it seemed as if the entire American society was near collapse and that the "American dream" had been lost. In the face of these events, Rauschenberg, as he himself admits, tried to hide away in Southern California, but ended up creating his Currents, a series of thirty-six large-scale collages made entirely of newspaper headlines. Rauschenberg described the project as "the most serious journalism I have ever attempted."[20] Yet the Currents are also as far from art as Rauschenberg has ever strayed. They contain none of the visual lyricism, variety, and imaginative invention that mark his other works. The Currents are reliable indicators that without his optimistic worldview— his belief—Rauschenberg might be unable to create.

In 1970 Rauschenberg moved his main residence and studio from New York City to Captiva Island, Florida, and his art, which has always responded to his surroundings, was affected by the move. Specifically, Rauschenberg has often been criticized for abandoning the gritty character of his early urban works.[21] What these authors fail to appreciate is the inherent lyricism and the transformative character of all of Rauschenberg's art, even his early urban pieces. In his art of the 1950s, Rauschenberg rescued junk material; the detritus of society received a new life through his creativity. His intent in utilizing worn and discarded materials was never to criticize society but rather to show how those things might positively stimulate the imagination. For instance, Rauschenberg's Magician (1959; Ileana and Michael Sonnabend Collection) shows the artist in the guise of an alchemist, altering the mundane materials of his environment. Rauschenberg recognizes and values this spirit of transformation and hence vehemently rejected the Neo-Dada label when it was attached to his art. From the 1950s, when he began to investigate the nature of Dada, he recognized the antisocietal basis of that movement. In contrast, Rauschenberg insisted, "My art is not anti-anything."[22] This is also the reason that Rauschenberg responded so positively to the art of Kurt Schwitters when he first saw the German's collages. Schwitters's artistic motives have also been historically misunder-

stood. Unlike the socially and politically scathing artists of Berlin Dada, Schwitters was a romantic. His *Blue Bird* (1922; private collection) turns the refuse of Hannover's streets into a tender story about a man and woman, "ER" and "sie." His *Picture with Light Center* (1919; New York, The Museum of Modern Art) changes similar refuse into a meditation on the cosmos; Schwitters's Merz Houses, well known from reproductions, were sensuous and responsive environments, predecessors for Rauschenberg's large-scale, environmental Combines.

Rauschenberg's own statements about discovering Captiva are filled with the life-enhancing feelings that have always been a basis of his art:

> My life was in change then so I was free. It was just me and Sweetie, my pet kinkajou. I started these various trips all down the East Coast.... Every time I got to Captiva, something very beautiful would happen. Some mind-boggling things—like having to throw on my brakes to avoid turtles crossing the road. It's not like that here now. I have the only jungle left on the place because everything else is developed. Before South Seas Plantation developed Captiva, there were perhaps twelve houses from my house on up the island.[23]

Rauschenberg's statement indicates another of his long-held concerns, the environment. For three decades, he has been involved in a variety of ecological movements, on the local, national, and international levels. In 1970 he created the poster for the first Earth Day demonstration. Rauschenberg's environmentalism is strongly reflected in many of the Captiva works.

One of the early series that Rauschenberg created in Captiva was the Jammers (1975–76). The Jammers consist of pieces of Indian silk, some brightly colored and others pale, either loosely tacked to the wall or suspended from poles; they feature no imagery. While the spareness and abstraction of the Jammers surprised some of Rauschenberg's observers, the artist has alternated throughout his career between abstract works and ones filled with images and objects, as a way of keeping all options open. His early black, white, and red paintings, as well as such paintings as *Bypass*, are examples of the former sensibility. Despite their lack of specific imagery, the Jammers have a political and social message. They assert sensuality, flexibility, and softness as positive values. Their gentleness, lack of rigidity, and receptivity—they move with the softest breeze, even that made by a passing viewer—are part of a humanitarian message.

The title *Jammers* refers to jamming, the jazz slang for enlivening a musical composition through impromptu variations, which suits the speed with which Rauschenberg was able to execute these simplified works. The title *Jammers* also has nautical associations. It evokes the type of sailing ship called windjammer and the nautical colloquialism "to jam," which means to sail as close to the wind as possible. The titles of many individual works in the series, like *Frigate* and *Fanfare* in the Meyerhoff Collection as well as *Pilot* (1976; collection of the artist) and *Sea Dog* (1976; private collection), are nautical. Even more to the point, the fabric loosely stretched from poles in the Jammers resembles sails hung from the spars of ships, and the wires in some works even suggest rigging. The use of colored cloth and bamboo or faux bamboo poles is most like simple native crafts with their colorful sails and bamboo masts, which are found in the Caribbean, India, and other exotic locales.

111

It is significant that Rauschenberg has chosen to orient the Jammers around sailing. The artist has expressed his desire to spend as much of his life as possible near the sea, which represents to him not only sensuality but also adventure and freedom. He points out that New York is a port city, and it is noteworthy that his first studio there was near the old South Street Seaport. Images of sailing boats have appeared in Rauschenberg's art with some frequency, including such works as *Frog Tree* of 1964 (private collection) and *Corinthian Covet* (see below). In addition to the sense of freedom, sailing is ecologically sound as a sport and as a means of transportation, an issue relevant to Rauschenberg's intent in these works. The Jammers suggest a particular type of sailing—not that of a blustery day with the excitement of high winds filling the sails, putting tension on the rigging, and driving the boat through the water. Rather, because of the loose and casual relationship between their parts, the Jammers suggest being becalmed. Being becalmed can be frustrating, or it can provide opportunities for the type of prolonged sensual enjoyment of the surrounding environment seldom possible in hectic modern life. It is this latter sensation that the Jammers aim to evoke. They are reminiscent of the rich and colorful works of the French Impressionists, particularly the water-filled paintings done by Claude Monet during the 1870s. Such works as his *Regatta at Argenteuil* (1872; Paris, Musée d'Orsay) depict windless boats in a world of heightened sensuous color. The sheer delight in color provoked by those paintings is close to the spirit of the Jammers.

Fanfare (1976) consists of three silk panels, a bright tangerine one to the left and, to the right, two panels sewn together horizontally, the upper one ivory and the lower, lemon yellow. The two segments of the work are divided by a tan silk sock in which ten paint cans have been inserted. The work is suspended from four tacks along its upper edge. The overt simplicity of *Fanfare* masks its underlying subtlety and sophistication. An elusive visual balance is sought between the left and right halves. The orange cloth is narrower but longer than the ivory-and-yellow one so that the two areas have nearly identical square footage, although this equality is not immediately apparent. While the orange segment on the left is more intense in its hue, this aspect is compensated for by the higher sheen and more reflective cloths used on the right. The orange panel hangs flat to the wall, asserting its two-dimensionality. In contrast, the ivory and yellow panels billow out slightly from the wall, an effect resulting from the construction of the work. (The yellow panel extends up behind the ivory cloth and, with a hidden seam, pulls that cloth slightly out of vertical alignment.) As so often in Rauschenberg's art, what seems effortless is the result of a series of precise, if intuitively made, decisions.

At the center of *Fanfare*, the tan sock looks like a bamboo mast, with the lines between the ten empty one-gallon paint cans substituting for the growth rings of the bamboo and the sockets for the wire handles protruding like budding branches. Underlying this visual pun is the fact that Rauschenberg has recycled these objects in keeping with the theme of environmental conscientiousness. The bright colors of *Fanfare* suggest the ostentatious flourish of its title, and, more specifically, "a fanfare" is nautical terminology for the show of flags made by

a ship when she ceremoniously enters a harbor. *Fanfare* also begs comparison to Minimal sculpture of the early 1970s. While much of that work is hard, geometric, industrial, theoretical, and mechanical, *Fanfare* is soft, playful, sensual, instinctive, and natural.

Frigate (1975), an apparently even more casual work than *Fanfare*, is composed of a bamboo pole covered in linen leaning against the wall. A crinkly wire protrudes through a hole in the top of the pole to support a glass of water. The other end of the wire extends downward, where a torn piece of red cloth is draped over it. The associations are again nautical, a mast, stay, and piece of sail being suggested. But here the parts seem more like ship fragments washed ashore and found by a beachcomber, and the casualness of the work contrasts with the grandeur of its title. *Frigate* particularly benefits from comparisons to Minimal and Conceptual art of the period. The manner in which it lightly and playfully leans against the wall might be contrasted to Richard Serra's *Corner Prop Piece* (1970; New York, The Museum of Modern Art). Serra's steel sculpture is rigid, precise, forceful, and dangerously heavy. *Frigate* espouses the values of being spontaneous, impromptu, gentle, and delicate. *Frigate* also comments on Conceptual art. Its glass of water is a sign for the sea, just as the pole and red cloth represent the concept of an ocean-going vessel. Yet, next to the theoretical aridness of Conceptual art, *Frigate* proclaims its sensuality. In *Frigate* one can touch the water in the glass and hold the wire, and the red cloth actually moves in the breeze.

Shortly before the Jammers, Rauschenberg began another series of works, the Hoarfrosts. That series overlapped with the Jammers, and the example in the Meyerhoff Collection from it, *Focus*, dates to 1975.[24] The overlapping series are related to each other in some respects and antithetical in others. Like the Jammers, the Hoarfrosts consist of pieces of thin cloth and other objects hung loosely from the wall; they evoke all the associations of freedom and pliability contained in the Jammers. The Jammers are hedonistic, warm, and direct; they are tropical in sensibility. In contrast, the Hoarfrosts are elusive, transient, and more somber. For the most part, they are not colorful but depend for their effect on tonality. They contain a plethora of images, yet most of these are vague and difficult to read. The title of the series itself suggests the ambiguity of alternately freezing into focus and melting from view. A hoarfrost, a covering of ice needles formed on objects by the atmosphere at night, gives them a vague, elusive character. Rauschenberg's Hoarfrosts are more difficult and solemn than the Jammers; they represent a more restrained, reflective sensibility.

Part of the mood elicited by the Hoarfrosts relates to the technique with which they were executed. Potent chemicals were applied to torn newspaper and magazine illustrations, and these illustrations were then placed on pieces of silk, cheesecloth, and cotton fabric and run through the powerful electric presses Rauschenberg normally used for printmaking. The combination of chemicals and pressure embedded the images in the fabric. The artist has recalled the laborious and dangerous nature of the process:

> Mostly the restraint and strength of the Hoarfrosts were built of such excesses. The sound of
> the whole process making them is very dramatic. The presses are going on and the paper is
> being crumpled. Magazines are being torn and color is all over, and there are switches. The
> press we make them on has about a nine-foot bed and a loud motor and we use gas masks. It's
> all poisonous too, so we send the dogs out of the room because they don't have gas masks.[25]

The imagery resulting from this technique is by nature indistinct, and Rauschenberg often made it even fainter by overlapping several layers of printing as well as printing on dark or extremely sheer materials. He has commented, "I liked the veiling of the images; they should also move. I like to think that when you open the door, or something like that, they will blow in the breeze."[26]

Focus suggests Rauschenberg struggling to recapture memories from his childhood. The elusive character of the images in the chemical transfer process may have consciously or unconsciously implied such connections to him. The role of autobiography in Rauschenberg's art has been underestimated; a few recent writers have addressed it, but with misunderstandings. Rauschenberg is able to view his own history in a disconnected manner, as a series of interesting facts. He has established an emotional and psychological distance from his autobiography when he uses it in his art, and he does not explore it for hidden clues to explain his personality. Rauschenberg's 1968 print *Autobiography*, which at its center lists key events of his life in a spiral pattern, exemplifies this attitude.[27] It is consistent with someone who thinks laterally and who explores the surface of life, as Rauschenberg does.

The central images of *Focus*, the two cars, are 1938 Packards, just the type of common touring car that Rauschenberg would have remembered from his youth in Port Arthur, Texas. The photographs of the cars are made more uncertain and less concrete by their doubling and by the slight overlap of the images. This placement of imagery, which Rauschenberg selected intuitively but which has been studied scientifically, is called binocular rivalry. In binocular rivalry, the differences between two nearly identical retinal images cannot be resolved so that one is dominant over the other. The result is a state of slight disorientation. In *Focus*, a sense of memory and uncertainty is created by this image configuration.

The fabric on which the two cars are imprinted is attached to a larger charcoal gray piece of cloth. On this have been transferred numerous pictures. All of these are extremely difficult to read because of the very slight value contrasts between them and the ground; this sort of disorientation would be particularly noticed by a dyslexic. Many of these pictures seem to relate to Rauschenberg's childhood, as if seen through the mist of memory. At the lower center of the composition, images of an industrial landscape, swimming ducks, and a coastal scene suggest the character of Port Arthur, and in the left corner there is a can of motor oil, the staple of the economy in that area. Other photographs show housing construction and vegetables of the type that Rauschenberg remembers were grown in his family's truck garden. Photographs of beer and liquor glasses, always elements in Rauschenberg's life, are also present. Throughout the lower area, segments from the comics are included. Along the right edge appears a cartoon

strip, *The Family Circus*, depicting a young boy at the dinner table. Again, the general theme of youth and family is brought to mind. Attached to *Focus* is an old shipping box whose label reads, "Caution sealed package" and "If the seal has been tampered with, do not give clear receipt." In fact, the box has been opened, and extending from it is an old rubber cord—stretching one's memory—which leads the eye down past all the pictorial images to the base of the work.

This description makes Rauschenberg's decisions to use such objects and images appear too programmatically conceived. The actual process was much more informal and subconscious. As the artist rapidly selected and joined the specific objects and images from the wide range he had assembled around him in the studio—and because of the chemical application, the whole process had to proceed with great haste—certain associations were made, and from them general themes and accompanying moods evolved. Rauschenberg does not judge his past; rather, he presents it as a series of interesting, fragmented memories. Rauschenberg commented, "*Focus* probably relates to my childhood, but I don't want to go back!"[28]

The nature of Rauschenberg's thought process may be more clearly understood by contrasting *Focus* with a work such as Jasper Johns's *Untitled* (1987). Both works utilize the idea of a piece of fabric with an image on it suspended before a ground. In fact, one of the sources for Johns's use of trompe-l'oeil cloths may have been Rauschenberg, who has been attaching paper and cloth as well as a variety of other objects to the surface of his works since the 1950s. Johns's work, however, is finally both more specific and more allusive than Rauschenberg's. By contrast, Rauschenberg's *Focus* invites us to join with him in experiencing his feelings for particular materials and to follow the chain of instinctive associations and connections that he has made. His use of overlapping pieces of fabric is real and physical, not illusional. The three-dimensional packing carton is actually attached to the surface. Even Rauschenberg's use of the chemically transferred photographs does not so much question the relative reality and illusionism of the photographic medium as accept it as a common feature in our lives. The theme of *Focus* is the way that images of childhood pop in and out of our consciousness. Rauschenberg does not further analyze that phenomenon either psychologically or perceptually but, rather, simply expresses it as one of life's experiences.

Because of Rauschenberg's involvement with the totality of his environment, his relationship to other art works—particularly those from earlier periods—is often neglected in the literature on him. In fact, Rauschenberg has responded emotionally and powerfully to certain exhibitions he has viewed, and objects from these exhibitions have influenced his subsequent works. *Rose Condor* (1977) is one of several works that was done in response to the exhibition *Tutankhamun: His Tomb and Its Treasures*. Rauschenberg has said:

> The main influence on these new pieces came from my having seen the Tutankhamun show in Washington. I was so moved by it that I was afraid I'd never be able to paint again—so I went to Florida and started right in. My emotional response to the Tut things was so intense that a

lot of works of art I'd always thought of as masterpieces were blanched by it. I saw a da Vinci that had always been one of my favorite paintings in the National Gallery in Washington, and I thought, God, how clumsy! How simpleminded! Now, if that doesn't scare the hell out of an artist! Seeing the Tut show was very close, for me, to the surprise of walking down a New York street. The Egyptian stuff was organized, of course, but to me it was as foreign and titillating as walking in New York and seeing the changes—the marvelous catalogue of trash.[29]

Rauschenberg's statement makes clear both the power of his response to the Tutankhamun exhibition and the reasons for that reaction. On the one hand, the exhibition presented an accumulation of life's objects, a concept that had long been part of the artist's work, but on the other, these objects were filled with a transcendent and mysterious splendor. In *Rose Condor*, Rauschenberg uses everyday materials to create one of his most exotic and mysterious works. The title probably refers to the famous breastplate from the Tutankhamun tomb that represents the composite god Ra-Harakhty. It consists of a spread-winged falcon with a rose-colored orb representing the sun over its head and rose-colored symbols of infinity and life in each claw. They are identical in color to the rose pillow Rauschenberg used in *Rose Condor*. Rauschenberg translated the falcon into its American relative, the condor—there is no such creature as a rose condor—mixing Egyptian exoticism with a native American association.

In *Rose Condor*, flight is indicated by the ladder. It represents escape to a wondrous realm. The ladder has been used with some frequency in literature and painting as a symbol of imaginative flight as, for instance, in Joan Miró's *Dog Barking at the Moon* (1927; Philadelphia Museum of Art). In *Rose Condor*, the ladder leans strangely on a richly colored pillow; firm contact with the wall is avoided and a gentle, yielding relationship is substituted. The pillow, of course, reminds us of sleeping and dreaming, and pillows play a similar, although perhaps more ironic, role in such Rauschenberg works as *Bed* (1955; New York, The Museum of Modern Art) and *Odalisk* (1955–58; Cologne, Ludwig Museum). The rose pillow, in turn, rests on a rich and reflective silk fabric with silver and white stripes. It appears simultaneously old and precious, and it reminds one of clouds in the sky.

Extending from the lower part of *Rose Condor* are two platforms. Neither touches the other nor, as in flight, do they make contact with the ground. The upper platform contains transfer images on its top and bottom faces. The lower platform is covered with three Mylar panels, from left to right, in tones of tan-bronze, blue, and green and has four lightbulbs attached to it. The lower section of the wall panel is also covered with Mylar, this time, clear. The Mylar may be associated with mirrors, which have often appeared in Rauschenberg's art. Two of his favorite images to use as collage elements are Rubens's *Toilet of Venus* (ca. 1613; Vaduz, Liechtenstein Collection) and Velázquez's *Toilet of Venus (Rokeby Venus)* (ca. 1650; London, National Gallery); both figures study their reflections in mirrors. Rauschenberg also used actual mirrors in several early works. In the history of art, the mirror has had an exceptionally wide variety of meanings, ranging from truth to falsehood; art itself has been called "the mirror of nature." Rauschenberg's mirrors, however, do not deal with these meanings; rather, they extol

the adventure of seeing and through the inclusion of the viewers' images seek their greater involvement in the work. Rauschenberg's interactive use of mirrors is the opposite of Roy Lichtenstein's Mirror paintings of 1970–72. Lichtenstein takes up the idea that art is the mirror of nature and totally undoes it. After all, his Mirrors are not real, and they do not reflect the image of the viewer or of anything else. In Lichtenstein's work, the mirror becomes an excuse for some of the artist's most elegant and refined abstract painting. Unlike Rauschenberg's connection between the art work and its environment, Lichtenstein's mirrors comment on the separation between art and life. In the case of *Rose Condor*, the viewer must bend down to see her image as well as to see properly what else the Mylar sheets reflect. As early as the 1960s Rauschenberg recognized the interesting aspects of this particular view when he considered placing a mirror at the base of one of his Combines. He said, "Up there the mirror image is conventional—just your head and shoulders. Yes, kneeling we see a more complicated image of ourselves."[30] In *Rose Condor*, peering at the panels while on one's knees is somewhat akin to going on an archaeological dig or crawling into Tutankhamun's tomb.

Rose Condor's lights relate to lightbulbs that Rauschenberg used in his work as far back as the early Combine *Charlene* (1954; Amsterdam, Stedelijk Museum); electric lights are incorporated in numerous other works, including *Corinthian Covet* (see below). Although Rauschenberg's lights elicit a wide variety of reactions, from the tacky carnival atmosphere of *Charlene* to the elegant sensuality of *Corinthian Covet*, they generally contribute to the expansive sensibility of the work, because they interact with the surrounding environment, which not only lights the art work but is illuminated by it. When asked about the most important inventions in his art, Rauschenberg once mused, "I don't know—screwing lightbulbs into a painting maybe. Trying to make the light come from the painting. Adding luminosity from the painting to match the environment. That is the first evidence I had of wanting the work to *be* the room itself."[31] In *Rose Condor*, the white glowing orbs have a sense of exoticism appropriate to the entire piece.

In keeping with *Rose Condor*'s inspiration in the Tutankhamun artifacts, the three Mylar sheets on the lower platform—tan, blue, and green—probably refer to the region underground, water, and landscape. The most prominent images that appear on each sheet seem to confirm this reading. The tan panel contains several gritty, unspecific images that look earthen. The other dominant design in this section is an archaeological drawing of a circular burial mound, shown in both plan and elevation. The representation of this tumulus is appropriate to the work's inspiration in art from an Egyptian tomb. The primary pictures in the central blue panel are two fossilized fish—a primal watery theme. The images in the right segment resemble foliage, shown blowing in the breeze. The upper panel features colorful mixtures and more vitalistic images, as if suggesting the world's energy as opposed to the elemental divisions below. Above, the dominant motif is circularity. Oranges, motorcycle wheels, a rose, fruit, a scientific chart with radial divisions, six golf balls, and a turtleshell all vie for attention in a mixture typical of Rauschenberg's raucous combinations. The overall mood of *Rose Condor*,

however, is one of exoticism and mystery. In this work, Rauschenberg combines his love of modernity with an admiration for the ancient and ineffable art of Egypt.

Rauschenberg first employed the technique of solvent transfer onto cloth in the Hoarfrosts. As seen in *Focus*, the use of image transfer onto thin pieces of fabric allowed the artist to overlap images; he was thus provided with a metaphor for the manner in which ideas overlap and slip one into another. In the Hoarfrosts, the cloth ground was usually neutral; in Rauschenberg's 1979 series, the Slides, the transfer of images takes place in more layers and on patterned fabric, so that he could create many more levels of interwoven images. Another characteristic of the Slides is their vertical orientation. Almost all the works in the series feature dominant vertical strips of fabric; they suggested to the artist the playful idea of the eye sliding down through the works. This vertical structure has the advantage of reorienting the way we see. As members of a culture based primarily on the written word, we tend to read art work horizontally, from left to right, as we might read a text. Being dyslexic, Rauschenberg does not exhibit this trait and would easily realize the fresh possibilities of vision in encouraging the eye to move in different directions. There are two other sources for the vertical design of the Slides. One is Asian calligraphy, which is read vertically rather than horizontally. Around this time, Rauschenberg was intensively examining the art of Eastern cultures. The second is photography. When photographic negatives are hung to dry, they are first looked at sideways, in the vertical position. In 1979 Rauschenberg began taking his own photographs again rather than using previously published images, and this experience in the darkroom, looking at images one on top of another, would be common for him.[32]

Fore Season (1979) is one of Rauschenberg's Slides. The collage contains four overlapping layers of images: photographic transfers have been applied to the background paper using solvents; a translucent cloth with a small floral pattern, upon which images have been transferred, has been laid over the paper; over the cloth have been applied three vertical strips of fabric with different designs; and further transfers have been applied to each of these strips. The collage intimates a loose categorization of the images. In keeping with the title, there are four types of images—as well as four layers of transfers—the machine, nature, popular culture, and exotic places. The left-hand section features a cluster of people and human-made objects. There appear to be calipers and a number of electric batteries, and most prominently, a steel-link chain and canned tomatoes—nature processed by humans—in the bottom corner. These images are applied to the geometrically designed, plaid fabric. This subject extends to the top of the second strip, which shows a mechanical drawing of a gear-driven winch. The winch overlaps a scene of people dancing at a disco—a popular-culture ritual practiced in the Western hemisphere.

The second strip, with its less rigid pattern of thin vertical bands, is dominated by images of the natural world—animals, cliffs, fruit, and a bird. One of the many visual puns here is the relationship between the seeded skin of the strawberry and the poppy seeds of a popular-culture cheeseburger bun. The exotic bird, a cockatoo, at the bottom of this strip leads us to

the third portion of the collage. This piece of fabric has a lush floral pattern on it. Among the photographs transferred to it are those of a young boy in a loincloth with freshly caught fish in each hand (a South Seas image), women accompanied by servants holding large umbrellas to shade them from the sun (an Indian scene), the dramatic photograph of a figure emerging from an ancient walled monument, and an antique amphora, perhaps from the Minoan culture. The title of the collage, *Fore Season*, is a wordplay that indicates that the categories just outlined are neither restrictive nor rigid. Rather than adhering even to one of the most basic divisions in organizing the natural world, the four seasons, the collage suggests that it is (be)fore the seasons. As in most of Rauschenberg's work, the profound and mysterious connections between images and ideas take place beyond the realm of intellectual categorization. In this regard, *Fore Season* might be contrasted with Jasper Johns's more intellectually and iconographically deliberate Seasons of 1985–86.

Two subjects that appear in *Fore Season*, machines and foreign locales, merit additional comments. In *Fore Season*, machines and machine-made objects, like almost all of Rauschenberg's depictions of technology, are shown in a positive light. They exhibit the artist's fascination with the wonders of technological design. Rauschenberg's extensive involvement with technology and art has included his cofounding of the Experiments in Art and Technology of 1966—a program intended to involve artists and engineers in cooperative projects—and his intense interest in the American space program. Rauschenberg has incorporated advanced engineering designs in such pieces as *Soundings* (Cologne, Museum Ludwig) and *Solstice* (Osaka, The National Museum of Art), both from 1968. Rauschenberg's mode of viewing the machine, which explores few of its negative aspects, is typical of his positive outlook. At times, the artist has been castigated for not adopting a more critical attitude toward the military use of technology, its environmental hazards and dehumanizing characteristics.[33] For Rauschenberg, however, technology is "contemporary nature." Many of his works clearly depict humans interacting with machines. Problems of the environment or the industrial-military complex cannot be solved, he believes, by returning to a simpler form of life. He maintains that the interaction between art and technology will lead to a richer, more humane world. He has said, "It's hard for me not to build in a lesson, because I care so much about it [technology and the environment]. We're really going to be lost if we don't come to terms."[34] With this attitude, Rauschenberg avoids both the utopian worship of technology that predominated in Purism, De Stijl, and other early-twentieth-century art movements and the rejection of technology that characterized Dada, Surrealism, and even Abstract Expressionism. Like his political views, the course that he charts is optimistic and progressive.

Rauschenberg's interest in foreign and often industrially less-developed cultures and early human history, scenes from which appear in *Rose Condor*, *Fore Season*, *Corinthian Covet*, and many other works, would seem to be at odds with his interest in technology. Instead, it is a product of his confident belief that the interaction between different cultures and experiences

will be of mutual benefit to all. His conscious attempt to assimilate a worldwide viewpoint into his art is a phenomenon that dates from around 1976. Before that time, Rauschenberg's art had been primarily American-based. It has already been mentioned that in his 1962–64 silk-screen paintings he self-consciously took on a more national stance. Rauschenberg's use of globally based subjects is linked to his 1976 retrospective at the National Collection of Fine Arts, in Washington, D.C. That retrospective, the first the museum gave to a living American artist, established Rauschenberg in the eyes of many people as the country's preeminent living artist. At the same time, Rauschenberg's art was criticized for having become too limited and predictable—that it had lost the capacity to surprise found in his early creations. This combination of national importance and the perceived need to expand to new areas led to Rauschenberg's world considerations. From this date, international imagery begins to appear more insistently in his art. He arranged trips to China and Japan to execute works in 1982 and to Thailand and Sri Lanka in 1983. These interests culminated in his enormous overseas project, the Rauschenberg Overseas Culture Interchange, begun in 1984.

Rauschenberg's *Corinthian Covet* (1980) suits such a broadened perspective. It contains a wealth of images—domestic and foreign, terrestrial and celestial, historic and contemporary, rare and common, luxurious and plain. What holds the work together is its sense of utter splendor, sensual abandon, and physical beauty. Rauschenberg is often incorrectly thought of as an artist of excess. In fact, his art is marked by some frugality. He has traditionally reused materials discarded by society, saving objects that would otherwise be lost. He has, for instance, always been restrictive in his use of color for fear of seeming excessively decorative. Concerning color, Rauschenberg once mused, "I think Matisse was just beginning to investigate beautiful colors in the early Nice paintings. He probably had the same problem that I did —that if the color was too clear and too immediate with its brilliance, well, then it couldn't be taken too seriously because it hasn't been 'chewed' by the brain."[35] This attitude is typical of a certain type of restraint in his work, which is largely abandoned in *Corinthian Covet*.

Corinthian Covet is one of fifty-two works called Spreads that Rauschenberg created between 1975 and 1981 in one of his most prolific periods. The Spreads are all large in scale and contain bright colors as well as a dense array of imagery; many are also electrified. One Spread, *Sea Cow Treaty* (1978; private collection), even contains plumbing. Rauschenberg joked that the buckets attached to that work were "to contain the excess."[36] Generally, Rauschenberg considered the Spreads well-earned indulgences and called them "my present to me. . . . I can indulge as eccentrically as I please, and be perfectly right—being as how it is my work."[37] Whereas he used color freely in the Jammers, he carefully limited their simple formal design. Although the Hoarfrosts were filled with imagery and attached objects, their color was severely circumscribed. In the Slides, Rauschenberg indulged in rich and colorful imagery but on a modest scale. In the Spreads, however, the artist wanted it all. The title *Corinthian Covet* refers to Corinth, the ancient city famous for its luxury and licentiousness. The verb *covet*, or to desire inordinately, has been turned into a noun.

Corinthian Covet is a large work, seven feet tall and over fifteen feet long. In addition, it projects nineteen inches from the wall. It is simultaneously painting, sculpture, and architecture, or better, it dissolves these boundaries. In this respect, *Corinthian Covet* is much like Frank Stella's large constructions beginning with the Exotic Birds. *Corinthian Covet* fills the visual field, and the central recessed area draws one close to the work. Because of its wealth of images, colored lights, and mirrors to either side, *Corinthian Covet* creates an almost funhouse effect. Rauschenberg deliberately contrived playful spatial ambiguities. For instance, the right-hand panel contains a green Mylar mirror on its inner edge, which adjoins the blue painted trapezoid on the central panel and the green trapezoid on the outer panel. Standing in the recess at the center, we have difficulty telling whether we are looking at a two- or a three-dimensional object. The Mylar strip appears to be the color of whichever painted trapezoid we focus on. In addition, of course, we see our own image, which adds to the visual complexity. In ways like this, the lights and mirrors allow the work to affect the surrounding environment; *Corinthian Covet* reaches out to the world around it.

In essence, *Corinthian Covet* becomes its own room. The colors are Gulf blue, palm green, and tropical orange. The photographic images spread throughout the surface and the objects attached to it are largely of two types. One category contains much more luxurious and "classy" items than is usual in Rauschenberg's art. These include silverware, fields of flowers, fireworks surrounding the Statue of Liberty, Tutankhamun's gold sarcophagus, a windjammer, Mercedes-Benz motorcars, and Louis Armstrong playing his trumpet. The second type of objects demonstrates Rauschenberg's ability to transform even refuse into beauty. Unlike their appearance in many Rauschenberg works, in which he redeems objects to make them interesting, here he is making them overtly gorgeous. Most notable are the three life preservers. One can hardly imagine the life preserver as an elegant form. Rauschenberg has said, "I never take the meaning out of the object. Although I free it from its previous responsibility, I do not abstract it."[38] These life preservers are stained, torn, and have lost some of their buoyancy pads, yet Rauschenberg has attached them to the work in such a manner as to make out of them graceful shapes, and he has accented their orange color with such a richly painted orange pigment that they seem positively sumptuous. Rauschenberg may have thought that by adding these beat-up life preservers he was really "going overboard." The preservers also relate to the artist's longtime love of the sea as well as to the idea of freely drifting along amid the currents of artistic thought, a concept of which he is a master. They are a nautical equivalent of another favorite image, the parachute, which allows one to drift in the air. Rauschenberg has implied parachutes in such works as *First Landing Jump* (1961; New York, The Museum of Modern Art) and actually wore a parachute and roller skates in *Pelican*, the first dance choreographed by Rauschenberg, which was performed in 1963 at the Pop Art Festival in Washington, D.C.

Corinthian Covet, like many of the Spreads, is also a witty commentary on Rauschenberg's past works. In his search for fresh discoveries, Rauschenberg has usually avoided this type of self-conscious commentary on his own art—it is just this self-referential attitude that is so important to Jasper Johns's art. Rauschenberg has commented that he "gave himself permis-

sion to use again" such conscious echoes of earlier work. In *Corinthian Covet* Rauschenberg shows a dog running on a treadmill, which refers to the racing dogs—emblems of his own speedy modes of creation—that occur in many earlier works, including *Bypass*. The windjammer in the right panel playfully refers to the Jammers, as does the image of Louis Armstrong jamming nearby, and the Tutankhamun sarcophagus refers to *Rose Condor*. The fireworks shown in several areas are perhaps signs for the more spontaneous paint splatters in earlier works. On the whole, *Corinthian Covet* resembles one of Rauschenberg's most important early Combines, *Charlene*, because of its scale and colors as well as the carnival-like density of artistic events on its surface. *Charlene* has a gritty character, however, which is quite different from the more refined elegance of *Corinthian Covet*.

One important aspect of the polished appearance of *Corinthian Covet* is the precision with which it is constructed. Rauschenberg's ability to make solid, durable art works has often been underestimated. Even his seemingly casual and haphazard works are assembled with a great deal of structural integrity. Over the years his works have demonstrated a durability that surpasses that of many other modern works. Rauschenberg has often made efforts to hide the care that has gone into the manufacture of his works, precisely so that they seem effortless—as if his surprising combinations were somehow always meant to be. In *Corinthian Covet*, the precision of construction is revealed and is part of the work's overall elegance. Exactly joined mahogany plywood panels have been overlaid with sharply cut Mylar sheets. In other areas, thin pieces of fabric, with their solvent transfer images, have been glued in grids. Order and intuition engage in a fine balancing act. *Corinthian Covet* embodies luxury as surely as do Henri Matisse's most sensual canvases; its particular vision is of a world full of beautiful things waiting to be experienced. It invites us to apprehend the wonders and splendors that surround us. Rauschenberg has stated, "In *Corinthian Covet*, I tried to get as much information, as richly as possible."[39]

Robert Rauschenberg is not generally thought of as an expressionist artist. His work is dominated by continual discoveries of new and exciting aspects of life and an optimistic belief that not only artistic problems but world problems can, with the right attitude, be solved. In response to the overly emotional character of later Abstract Expressionism, Rauschenberg determined early in his career to avoid high emotion in his work. Both the intellectual and the physical struggle sometimes necessary to arrive at his ever-changing vocabulary of forms are hidden. Rauschenberg strives to make his art seem easy and natural, as if his unexpected invention took place of its own accord. There is also a darker, less optimistic side to Rauschenberg's personality, although he seldom allows it to be revealed in his work. Rauschenberg exposed elements of this other aspect of his character in his book-length interview with the art critic Barbara Rose. During their discussion about the late 1960s, he commented:

> I was beginning to feel that so many of my friends, and you are one of them, were having
> so many problems with happiness that perhaps I was responsible for some sort of evil spirit.

I got so depressed that I went to an astrologer. . . . I went to him when everybody I knew was breaking up. Everything was falling apart. There was such an abundance of bad news that eventually I began thinking that maybe it was my spirit, or lack of spirit, that was doing it.[40]

Rauschenberg's Kabal American Zephyr series of 1981–82 suggests some of the emotionalism and mysticism to be found in this statement, although the expressionism of this series is filtered through art and thus made general rather than personal. The series originally was inspired by an exhibition of works by the nineteenth-century Japanese printmaker Tsukioka Yoshitoshi, which Rauschenberg saw at the Los Angeles County Museum of Art in 1980.[41] Yoshitoshi is an eccentric figure in the history of Japanese art. He is known for his particularly brutal, erotic, and bizarre imagery. During our discussions, Rauschenberg called Yoshitoshi's works "fantasy-macabre." Yoshitoshi frequently counterbalanced scenes of beauty and delicacy with such gruesome events as disembowelments and decapitations. He had a strong interest in the supernatural but, as an important Japanese newspaper illustrator, was simultaneously part of a more factual world. Rauschenberg found in Yoshitoshi's work an inspiration for a release of more expressionist tendencies as well as a belief in the supernatural.

The Ghost of the Melted Bell (1981) is one of the rougher works in the Kabal American Zephyr series. It is tentative and aggressive at the same time, two characteristics not usually found in Rauschenberg's work. The sculpture's aggressiveness comes from the unabashed roughness of its materials. A marred and beaten wooden board with its edges chewed away is hung by an old rope from two vertical supports and a horizontal board that are irregularly bolted together. Nailed to the board in a haphazard fashion is a painted pillow and two broken beams with further nails protruding threateningly from them. Little of the magical reconciliation of different materials apparent even in Rauschenberg's coarse, early Combines is here, and one might consider the differences between the comical use of pillow as base in *Odalisk*, the exotic rose pillow with its connotations of dreaming in *Rose Condor*, and this cruder example nailed brutally to the rugged board. Most of the Kabal American Zephyrs are sculptural, and Rauschenberg exploits the more aggressive, space-occupying character of sculpture. *The Ghost of the Melted Bell* has affinities with the Post-Minimalist, expressive works of Eva Hesse and Jackie Winsor, and it also relates to the sculpture of Mark di Suvero.

The Ghost of the Melted Bell is also tentative, another possible characteristic of sculpture, because it often supports materials in a vertical configuration, defying the laws of gravity. *The Ghost of the Melted Bell* is propped up only by two legs, which are stabilized by a single crosspiece. The old rope holds the board platform at a slight angle; it appears ready to slip at any moment. As one walks around the sculpture, one worries about tripping over its legs or over the rope extending from it and toppling the piece. Both the aggressiveness and awkwardness of the sculpture lead to uncomfortable feelings and a certain uneasiness not usually associated with Rauschenberg's work. In this spirit, Rauschenberg has commented, "I'm not an elegant artist; I have never let crudeness down!"[42]

The title for *The Ghost of the Melted Bell* is taken specifically from Yoshitoshi's series One Hundred Ghost Tales from China and Japan. The story was recorded in the tenth century by the Emperor Gokomatsu and was the basis for a Noh play. In it, an innkeeper's daughter falls in love with a priest. The priest retreats to a temple and hides in the temple bell. She turns herself into a snake, wraps around the bell, and with the heat of her passion and anger melts it, killing him. Rauschenberg has incorporated some of the violence and mystery of the tale in the sculpture. Although it does not resemble any of Yoshitoshi's prints, its various parts nonetheless take on aspects of the story. The flat board serves as the hanging bell. The bell rope extends from the work while the pillow and beam play the roles of melted clapper and clapper arm. Such visual references, which also exist in the other Kabal American Zephyr pieces, reinforce the influence of these stories on Rauschenberg. Even the title of the series is mysterious and bizarre. *Kabal* hints at a secret conspiracy; *American* refers to the artist's own roots; and *Zephyr* suggests the elusive character of the wind. The darker mood suggested in *The Ghost of the Melted Bell* has found a more recent expression in Rauschenberg's Gluts, a continuing series begun in 1986, and his Night Shades of 1991. The Glut sculptures, made of parts collected from salvage yards, suggest to the world the hazards of excessive quantities of obsolete machinery. Rauschenberg commented about them, "Greed is rampant. I'm just exposing it, trying to wake people up. I simply want to present people with their ruins."[43] The Night Shades, executed in black acrylic and tarnishes on aluminum panels, similarly yield a dark threatening vision of urban decay and danger.

Rauschenberg's interest in Japanese culture has been long-standing. He first traveled there in 1964 as the set designer for Merce Cunningham's dance company. While in Japan, the artist executed a major work, *Gold Standard* (1964; Hiroshi Teshigahara Collection), onstage from materials discovered in Japan. Since that time, a number of works, including the Kabal American Zephyr series, have reflected Rauschenberg's interest in Japanese culture. What fascinates him about Japan is that it can be so thoroughly modern—in fact, the nation seems to be able to match the West at its own capitalist, technological, industrial game—and at the same time maintain its traditional cultural values.

In 1982 Rauschenberg traveled to the Otsuka Chemical Company in Shigaraki in order to make a series of ceramic compositions, his Japanese Clay Works. These include two very large examples, one of which is *Gates: South* (1982). The Otsuka company had perfected a technique for making large-scale ceramic tiles that would not warp during firing and that, according to the company, would last three thousand years. They had also developed a process of transferring imagery onto the tiles using photoceramic decals derived from silkscreens. The chance to combine new techniques with silkscreening, which he had used extensively, and clay, which he had used in his Tampa Clay Pieces of 1972–73, was attractive to Rauschenberg, as was the opportunity to work in Japan. There, he experienced fully Japan's cultural dichotomy. The factory was located in Potter's Valley, renowned for its special powdery peach-blossom red clay.

For seven hundred years Japan's finest potters have worked there. Rauschenberg lived in a traditional bamboo-roofed house, slept on tatami mats laid on the floor, and bathed in a steaming cast-iron tub. He would bicycle to the factory each day to collaborate with the Japanese technicians. In contrast to this aura of tradition, while the clay was being fired, he commuted to the industrialized and international city of Osaka, to take the photographs (Rauschenberg calls them "my palette") that would be incorporated in the works.[44]

Gates: South, which is nearly fourteen feet long, is composed of five separate ceramic panels butted one against the other; all except the left panel are divided horizontally and hinged. The four hinged platforms extend out from the wall nearly four feet, and they are supported at different angles by faux bamboo poles and have faux gold foil–wrapped bricks on them. The entire work, including the faux poles and even the hinges, is made of ceramic. Photographic images and painting cover most of the surfaces. In addition, Rauschenberg manipulated the glazes, creating painterly effects throughout.[45] *Gates: South* is a commentary on traditional and modern Japan; it juxtaposes the old and the new, the East and the West. Its theme is both the integration of and the incongruity between disparate cultures. The hinged, folding panels braced by bamboo poles are found in Japanese temples to support portable altars and in markets, where commercial goods are sold. The photoceramic decals of circles in a vertical row on the left panel, which look like modernist Western abstraction, are traditional designs used on wedding kimonos. Near these is another vertical arrangement of photographs that show primarily discarded industrial objects. The circular motif is picked up by the shape of a protective cover from an electric fan and by the double golden arches on a McDonald's fast-food wrapper. The back of a junked pickup truck is shown, and one thinks of Japan's domination in the automotive industry as well as the obsolescence of such machines and the environmental problems their disposal creates. At the top of this panel, the seemingly abstract pattern is actually a photograph of the traditional carved birds that used to be placed on bamboo poles as signs of good luck; in contemporary times they have been put on utility poles. Next to these images are two mannequins used to advertise wigs. Both the facial features of the mannequins and the hairstyles of the wigs have a distinctly Western look. Below these are metal pans filled with elegant white muscadine grapes, a grape widely culti- vated in America and considered a delicacy in Japan.

The viewer must move around *Gates: South* and peer at it from different angles to see all the imagery. On top of the first panel is an enlarged photograph of an American Beauty rose. It refers to Japanese flower culture in the context of a non-Asian flower. A rusted, round gaso- line sign sits on a pole, as the rose sits on its stem. A rocky landscape is shown above the third panel. Its colors and patterns resemble those on prized Shino stoneware from the sixteenth century; near this beautiful pattern is a crude dump truck used to move earth. The burgundy- and-white striped canvas next to the dump truck looks like a contemporary abstract painting, perhaps an early Brice Marden work, but it is actually a traditional funerary tent. A photo- graph of a wall on the hinged panel below has graffiti in which Japanese teenagers tried

awkwardly to write English words. Next to this, Rauschenberg has signed *Gates: South* in perfectly made Japanese characters.

On the one hand, the simulated gold bricks on each of the panels refer to Japan's economic acumen and its strict maintenance of a gold standard like those developed in the West. (These items also harken back to Rauschenberg's first work created in Japan, *Gold Standard*.) On the other hand, the bricks, which seem wrapped in foil rather than being solid, comment on the traditional Japanese craft of wrapping objects in such natural materials as tree bark.

In *Gates: South*, Rauschenberg's choices of materials and images allowed the artist to capture the dichotomies he saw all around him in Japanese society. Rauschenberg does not favor one culture over another, nor does he prefer the past to the present. He neither praises nor condemns the mixtures that take place in Japan. Rather, he presents the visual and intellectual excitement of constant change and incongruity in the modern world. Rauschenberg's trip to Japan, together with his trip to China, was a warm-up for the Rauschenberg Overseas Culture Interchange, which occupied the artist's attention for the next decade. In point of fact, the Japanese Clay Works are among the most successful of his overseas projects, first because the large-scale clay process introduced him to a truly new technique. Second, there is little sense of the artist's appropriating, or colonizing, a foreign culture with his Westernized style, because that admixture—one to which Rauschenberg is especially attuned—had already occurred. *Gates: South* reflects the particular world involvement to which Rauschenberg aspires. He has said, "If I couldn't respond with open honesty to that culture, then I should not have tried ROCI. That was one of the spices, that I could indulge in another country as a generalist."[46]

Some of Robert Rauschenberg's best aspects are present in *Gates: South*. His quickness of eye and mind allows him to take in the salient features of an environment or culture at a glance. His interests are catholic, and he embraces variety and does not shy away from exploring almost any new options in content, form, and material. These abilities are carefully cultivated; they result from his general personality, as well as, very probably, from the physiological condition of his dyslexia. Rauschenberg's art embodies the multivalence of the modern world. As we have seen, Rauschenberg follows general thematic patterns in his work, but, at the same time, he dares not explore any of his themes too deeply. To do so would be to limit his options, to force him to decide *for* something and *against* something else. In such a case, he would have to resolve or at least limit the multiplicity that is essential to his art. In these features, he differs from Lichtenstein's confident ability to assimilate and control completely, from Johns's determination to make us face the specific contradictions and questions of his every visual decision, and from Stella's focused exploration of particular high adventures in picture making. None of these would be viable options for an artist who believes that freedom and instinct are primary virtues in art and life.

1 Robert Rauschenberg, in "The Artist Speaks: Robert Rauschenberg," interview with Dorothy Gees Seckler, *Art in America* 54 (May–June 1966), 81.

2 Edward de Bono, *Lateral Thinking: A Textbook of Creativity* (London: Ward Lock Educational Limited, 1970), 39.

3 Rauschenberg, in Seckler, "The Artist Speaks: Robert Rauschenberg," 76.

4 G. R. Swenson, "Rauschenberg Paints a Picture," *Art News* 62 (April 1963), 45–46.

5 Robert Rauschenberg, "Robert Rauschenberg: An Audience of One," interview with John Gruen, *Art News* 29 (February 1977), 48.

6 Robert Rauschenberg, interview with the author, February 4, 1994.

7 Calvin Tomkins, "Profiles: Robert Rauschenberg," *The New Yorker*, February 22, 1964, 101.

8 Roni Feinstein speculates that this is one reason Rauschenberg's works received relatively little notice when they were first exhibited. Roni Feinstein, *Robert Rauschenberg: The Silkscreen Paintings, 1962–1964* (New York: Whitney Museum of American Art, 1990), 21.

9 Sam Hunter, "Artist, Tramp (Robert Rauschenberg's Cultural Exchange: A Travelling International Art Project)," *Elle*, March 1989, 50.

10 The three swinging images are actually players warming up in the batter's box.

11 Maxime de la Falaise McKendry, "Robert Rauschenberg Talks to Maxime de la Falaise McKendry," *Interview* 6 (May 1976), 34.

12 Macdonald Critchley and Eileen A. Critchley, *Dyslexia Defined* (London: William Heinmann Medical Books, 1978). T. J. Wheeler and E. J. Watkins, "Dyslexia: A Review of Symptomology," *Dyslexia Review* 2, no. 1 (1979), 12–14.

13 William H. Berdine and A. Edward Blackhurst, eds. *An Introduction to Special Education* (Boston: Little, Brown and Company, 1981), 414–23.

14 Tomkins, "Profiles: Robert Rauschenberg," 101.

15 Swenson, "Rauschenberg Paints a Picture," 45–46, 65–67.

16 Calvin Tomkins, *The Bride and the Bachelors* (Middlesex: Penguin Books, 1962), 234.

17 Feinstein, *Robert Rauschenberg: The Silkscreen Paintings*, 82.

18 Calvin Tomkins, *Off the Wall: Robert Rauschenberg and the Art World of Our Times* (New York: Penguin Books, 1980) 214.

19 Arthur M. Schlesinger, Jr., *The Vital Center: The Politics of Freedom* (1949; Boston: Houghton Mifflin Company, 1962), 21.

20 Mary Lynn Kotz, *Robert Rauschenberg: Art and Life* (New York: Harry N. Abrams, 1990), 180.

21 For example, Jeff Perrone, "Robert Rauschenberg," *Artforum* 15 (Summer 1977), 29; and Roger Cranshaw and Adrian Lewis, "Rereading Rauschenberg," *Artscribe* (U.K.) 29 (June 1981), 49.

22 Robert Rauschenberg, interview with the author, February 5, 1994.

23 Barbara Rose, *Rauschenberg* (New York: Vintage Books, 1987), 86–87.

24 The title originally used by the Meyerhoffs for this work was *Two Cars*. When Rauschenberg read a draft of the present essay on July 28, 1993, he decided that the title should be *Focus*. Rauschenberg's title confirms the theme of focusing on the artist's past.

25 Arthur Perry, "A Conversation between Robert Rauschenberg and Arthur Perry," *artmagazine* (Canada) 10 (November–December 1978), 34.

26 Rauschenberg, interview with the author, February 5, 1994.

27 In a recent article, the critic Jill Johnston (*Art in America* 80 [April 1992], 114–19) pressed the artist hard for connections between his use of the Kennedy image and his father. Johnston suspects that the artist's father was authoritarian and "abusive." Her suspicion is unsubstantiated, and this mode of thinking, to my mind, is irrelevant to Rauschenberg.

28 Rauschenberg, interview with the author, February 5, 1994.

29 Tomkins, "Profiles: Robert Rauschenberg," 31.

30 Swenson, "Rauschenberg Paints a Picture," 66.

31 Rose, *Rauschenberg*, 56.

32 In 1979 Rauschenberg used his own photographs in the set design and costumes for the Trisha Brown Dance Company's *Glacial Decoy*. Subsequently, he

made a photographic trip down the East Coast, which resulted in the publication of two books of his photographs.

33 Max Kozloff, "American Painting during the Cold War," reprinted in *Pollock and After*, ed. Francis Francina (New York: Harper and Row Publishers, 1985), 120.

34 Kotz, *Rauschenberg: Art and Life*, 138.

35 Rose, *Rauschenberg*, 109–10.

36 Kotz, *Rauschenberg: Art and Life*, 214.

37 Ibid., 215 and 218.

38 Rauschenberg, interview with the author, February 4, 1994.

39 Ibid.

40 Rose, *Rauschenberg*, 86.

41 Roger Keyes, *The Bizarre Imagery of Yoshitoshi: The Herbert Cole Collection* (Los Angeles: Los Angeles County Museum of Art, 1980).

42 Rauschenberg, interview with the author, February 5, 1994.

43 Kotz, *Rauschenberg: Art and Life*, 246.

44 Rauschenberg, interview with the author, February 5, 1994.

45 Ibid.

46 Ibid.

ROBERT RAUSCHENBERG

Bypass, 1959

Oil, paper, metal, and fabric on canvas,
59½″ × 53¼″ (151.1 × 135.3)

ROBERT RAUSCHENBERG

Brace, 1962

Oil and silkscreen ink on canvas,
60" × 60" (152.4 × 152.4)

ROBERT RAUSCHENBERG

Archive, 1963

Oil and silkscreen ink on canvas, 84″ × 60″
(213.4 × 152.4)

ROBERT RAUSCHENBERG

Frigate (Jammer), 1975

Wall-leaning assemblage: fabric-covered
rattan pole, wire, fabric, and plastic
drinking glass with water, 92″ × 16″ × 30″
(233.7 × 40.6 × 76.2)

ROBERT RAUSCHENBERG
Fanfare (Jammer), 1976
Mixed media: ten one-gallon metal
cans and silk, 89″ × 83″ × 17″
(226.1 × 210.8 × 43.2)

Facing page
ROBERT RAUSCHENBERG
Rose Condor (Scale), 1977
Mixed media: Mylar, silk, transfer
images on fabric, four electric lightbulbs,
ladder, and pillow, 94¾″ × 72¾″ × 15⅜″
(240.7 × 184.8 × 39.1)

ROBERT RAUSCHENBERG
Focus (Hoarfrost), 1976
Transfer images on fabric, paper,
cardboard, rubber, and metal, 86¾″ × 49″
(220.4 × 124.5)

133

Facing page

ROBERT RAUSCHENBERG

Corinthian Covet (Spread), 1980

Transfer images, paint, and collage on plywood panels with objects, 84″ × 185″ × 19″ (213.4 × 469.9 × 48.3)

ROBERT RAUSCHENBERG

Gates: South (Japanese Clay Work), 1982

High-fired ceramic, 96¼″ × 167¼″ × 43″ (244.5 × 424.8 × 109.2)

ROBERT RAUSCHENBERG

Fore Season (Slide), 1979

Transfer images on fabric and paper collage, 60″ × 40″ (152.4 × 101.6)

134

ROBERT RAUSCHENBERG

*The Ghost of the Melted Bell
(Kabal American Zephyr)*, 1981

Mixed-media construction: wood,
rope, and pillow, 48¾″ × 51½″ × 66¾″
(123.8 × 130.8 × 169.5)

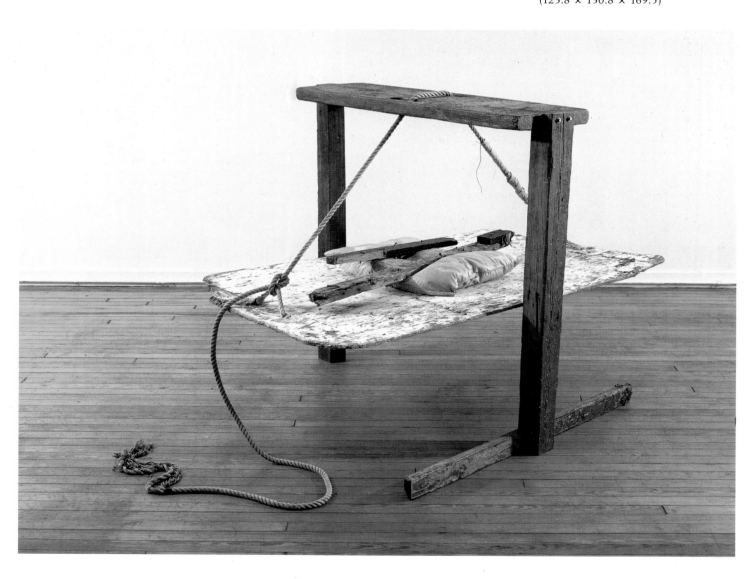

Ellsworth Kelly

Since birth we get accustomed to
seeing and thinking at the same time. But
I think that if you can turn off the mind
and look at things only with your eyes,
ultimately everything becomes abstract.

ELLSWORTH KELLY[1]

Seeing is the content of Kelly's art, and his constant concern is the power and concision of vision. It might seem unusual to remark that Kelly is concerned exclusively with vision, but most artists, by contrast, mix their ocular interests with a variety of other preoccupations. These might include some mixture of theoretical positions, social and political beliefs, autobiography, history and art history, and emotional states. Other artists would contend that these elements enrich their art; Kelly believes that they dilute and diminish the concentration of his work. The nonpersonal look of Kelly's art expresses a moral position: "Everything is so personal today. I am worried that man is destroying the world. My art does not deal with personality but with nature and a larger vision of the world."[2] Kelly thinks that the functioning of the eye can be separated from the mind. He has commented, "I want to let the eye speak instead of the mind."[3] By this statement he does not mean superficial looking. For him, all vision is conditioned by experience, knowledge, and concentration. He wants to encourage visual intelligence, unconnected to preconceived theories. Kelly's work is both experimental and experiential. It is, in his words, "sparked by visual discoveries," and the artist constantly refers to his works as "intuitive problem solving."[4] Kelly is not concerned with the relationship between seeing and understanding that occupies Jasper Johns or the optical ambiguities that preoccupy Frank Stella. Kelly has commented, "I have carefully decided which of many visual experiments I wish to show. I hope there is a clarity and rightness about each one."[5] For Kelly, seeing is knowledge.

Surprisingly, this single uniting feature of Kelly's art has not been sufficiently discussed in the critical writings about him. The artist noted recently, "The structure in my work has not really been discussed."[6] This deficiency in the Kelly literature has to do with the history of Kelly criticism and the state of art history during the period in which the first lengthy studies of the artist began to appear. Public interest in Kelly's art began during the late 1950s and early 1960s. At that time he was linked by many critics, who were only superficially familiar with his art, to Color Field, hard-edge, and Minimal art, which were then in vogue. In fact, Kelly's use of flattened, clarified visual forms and often single-color canvases preceded hard-edge painting and Minimalism by two decades. Kelly also completely rejected what he considered to be excessive theorizing that often limited the visual investigations of artists associated with those movements. Later, in the early 1970s, the first monographs and one-person exhibition catalogues on Kelly were at pains to point out these distinctions.[7] Their authors had also become disenchanted with the

formalist critical vocabulary used to discuss Minimalism, in which descriptions of art had become obtuse and mired in jargon. Worst of all, criticism of Minimal art increasingly seemed to refer to itself rather than to elucidate the art. Yet, in rejecting out-of-hand this mode of criticism, the writers on Kelly failed to see that what was needed in his case were precisely clear discussions of the structure and visual effects of specific paintings.

In the Kelly literature, one particular aspect has been used to differentiate him from other abstract artists of the 1970s. This aspect was the fact that, since his early years in Paris, 1948–54, Kelly had derived many of his painting motifs from observation of the natural world. Although the origins of his forms were rarely apparent in the final works, Kelly had kept his sketchbooks and made photographic records of the subjects that eventually were transformed in his art. The artist progressively, although sometimes reluctantly, made this material available to curators and writers.[8] As a result, many of the studies on Kelly have focused largely on discovering the "sources" for groups of paintings, and there is an unfortunate sense in these texts that finding that source is a solution to the art. The accompanying implication is that Kelly is a sort of modern naturalist before the motif. Paradoxically, this approach has resulted in less careful scrutiny of Kelly's actual art. His paintings and sculptures have been considered as groups rather than studied as individual examples, in which a change of line, angle, or color may alter the whole character of the work. In contrast to this approach, the artist unpretentiously has commented, "I like to leave the viewer to finish the work visually. The art is not complete until the viewer sees it."[9] It is precisely such study that must be done to understand Kelly's art.

Kelly's use of natural motifs is important but must be understood in the overall context of his art. He began using fragmented forms from the world around him during his early sojourn in Paris, and his discovery of such motifs may be partly related to the visual excitement of being in a foreign city. He has recalled:

The subject was there already made, and I could take from everything. It all belonged to me: a glass roof of a factory with its broken and patched panels, lines on a road map, a corner of a Braque painting, paper fragments in the street. It was all the same; anything goes.[10]

Kelly would sketch random patterns—bits of architecture, accidental markings on the stones of the city, shadows and reflections—in notebooks, roughly recording their design. As a clearly distinct second stage, he would return to one of these sketches, sometimes many years later. (He would not return to the original motif.) He then transformed the sketch, altering its design, scale, outline, and color and eliminating suggestions of volume, in order to relate it to painting problems he was working on at that time. Kelly has indicated, "I never work directly from my photographs or drawings. They are a jumping-off place, an aide-mémoire."[11] Two separate events occur; vision is a twofold procedure, although the dual processes are neither as contradictory as some authors claim nor as closely related as others state. Kelly uses his acute vision once to select a motif and then a second time to make all the alterations that turn his initial, and often chance, observations into a profound and immediately compelling visual experience. Kelly's final art work is invariably so far removed from the original motif that it urges us to concentrate on it as the primary experience and only secondarily, if at all, to seek its source.

By beginning with a discovered shape, Kelly guarantees greater variety in his art and a certain impersonality. Habits of creating and using repetitive forms that can become limited and mundane, if guided by theory alone, are avoided by chance discoveries in the surrounding world. Kelly is a pragmatist. He trusts the facts of objects, both things in the world and art objects, and relies on his direct sensual experiences to guide his art.

At the same time, because Kelly's art imposes a thoroughgoing metamorphosis on all forms, his work is remarkably self-referential. The visual decisions that he makes in a work are often best understood in terms of his other works and their solutions or the questions they ask about particular artistic problems. It is not uncommon for him to refer back decades in his own oeuvre to an idea or a sketch that he will revise, refine, and bring to completion in a major painting. Through careful comparisons to his other works, we can observe both subtle changes and the overall flow of his ideas—problems that he has worked on throughout his career. The self-referential character of Kelly's art is in distinct opposition to Rauschenberg's work. Rauschenberg constantly relies on outside objects and images to vitalize his art, and he often makes minimal changes in those things so that his original experience of the object or image remains in the forefront of the art work. The internalizing traits of Kelly's paintings and sculpture resemble those of Jasper Johns, who almost obsessively repeats certain images and ideas. While Johns's repetitions make us see questions and problems from different viewpoints, Kelly's variations propose clear-cut solutions, although the artist often demonstrates in his next painting that none of these solutions is final. Johns is also much more autobiographical, if guardedly so. He attempts to give the personal events of his life universal significance, whereas Kelly's works resist a personal reading. Because of the high degree of abstraction, as well as the nonpersonalized execution, they seem like the works of a disembodied eye or intelligence studying particular visual phenomena.

Overall, two features dominate Kelly's oeuvre: originality and clarity. Kelly seeks to add new objects to the world—paintings, drawings, and sculptures—that will contribute significantly to the visual environment and provide profound insights into the manner in which we see. He has long expressed his interest in how his art relates to the world around it. Although these statements are often taken to refer to the shape of a particular canvas on a given wall, they have much broader philosophical implications. Kelly intends to influence the viewers' understanding of their entire visual environment through the optical analyses carried on in his paintings. The artist has commented, "Most people don't learn how to see. They 'think' what they see. I try to separate the mind, and to see with the mind at rest."[12] Kelly relies on clarity as a primary feature of his art. Many works, such as *Orange Green* (1966), engender a classical balance between elements, although always with an original and unexpected twist. Even in works like *Dark Gray and White Panels* (1977), where Kelly is exploring irregularity as a visual phenomenon, he frames the investigation in the most concise terms possible. Early in his career, Kelly instinctively understood the three initial steps that take place in vision. These stages have been more recently confirmed by scientific testing. The first is separating shape from surrounding ground; the second is identifying that shape primarily through its contour; and the third is responding to color. Kelly emphasizes certain features in his paintings and sculptures that promote the clarity of his visual investigations, fea-
tures that appeal to these fundamental stages of vision. They are frontality, edge, singularity of form, single saturated color, and anonymous surface. All of these principles are so broadly conceived that they do not inhibit the variety and freedom of Kelly's explorations, which may be seen through careful examination of individual works.

Blue Yellow Red V (1954/1987) is an ideal example of the internal dialogue that Kelly carries on with his work as well as his use of previous discoveries. The painting, which Kelly created in 1987, is directly based on a small collage that he made in 1954. It is remarkable to think of an artist looking back thirty-three years in his own career to a study that he probably intended to make into a painting but, because of either time or economic restrictions, was unable to execute. In reviewing this collage many years later, Kelly realized that it was so significant in terms of the overall direction of his art that it now demanded execution as a full-scale painting.[13] It is also indicative of the consistency of Kelly's art that this very early design, re-created as a painting, seems fresh today. One of the few artists one can imagine engaging in a similar endeavor is Jasper Johns. In fact, as a somewhat analogous situation, the Meyerhoff Collection contains Johns's *Two Maps* (1989), in which the artist re-created his *Double White Maps* of 1965, both because the original was damaged and because he "wondered what it would be like to do" it again.

Kelly's 1954 collage, *Red Yellow Blue*, which he made in New York shortly after his return from Paris, is small in scale (8½ × 11 in.) and consists of three strips of colored paper—the primary colors are used—that are equal in length but unequal in width. The three strips are placed one above another, to form a vertical rectangle. One of Kelly's primary messages is that the

work consists of three individual elements, not a single rectangle, as close observation will tell. It is a point that he makes more obviously in the painting *Blue Yellow Red V* and still more conspicuously in such works as *Chatham III: Black Blue* (1971), in which vertical and horizontal panels are opposed rather than aligned. The notion of three separate strips of paper, and later the three panels of the painting, arranged in a rectangular configuration undermines the Renaissance idea of the painting as a framed window opening onto space. Kelly negates the mimesis and illusionism connected with traditional picture making. He also nullifies the more modern concept of the rectangular painting as a single indivisible object. This aspect of the work is more apparent in the painting *Blue Yellow Red V* because one can see the division between the three panels in it much more clearly than between the three strips of paper. In the painting, pigment extends around the sides of the work so that, if one looks at the work obliquely, one sees the separation between the three panels, rather than a continuous framing edge. To aid in this distinction, the stretchers of *Blue Yellow Red V* are over one inch thick, and the hanging supports for the painting have been designed so that it is suspended a full inch away from the wall, asserting the independence of the three panels from their background surface.

When creating the painting *Blue Yellow Red V* from the collage, Kelly duplicated the proportional relationship between the horizontal bands and scaled up the entire work by a factor of ten. The correlation between the bands in both the collage and the painting is, mathematically speaking, irregular —the blue band is approximately 9.8 percent of the total area of the work; yellow, 61.5 percent; and red, 27.8 percent. Although these numbers are close to a 10–60–30 relationship, they vary from it slightly. An important aspect of Kelly's works is that they can seldom be measured in terms of simple round numbers. This indicates that the artist does not work by any preconceived mathematical formula, but proceeds by intuition, determining which visual relationships "feel" right. His work is experiential rather than theoretical. The color areas of *Blue Yellow Red V* do, however, have an intuitive logic. Blue, the most highly saturated of the colors, occupies the smallest surface area, while yellow, the least saturated, takes up the largest area. Thus, the three panels appear to be visually balanced. Of course, this type of effect cannot be determined scientifically but relies for its perception on our innate sensitivity to color. It might also be noted that traditional gravitational weighting—we tend to think of dark things as being heavy —is undone by placing the deepest, most intense color at the top.

The question still has not been fully answered as to why Kelly would find the collage *Red Yellow Blue* so compelling decades later that he would feel driven to "finish" it in a large-scale painting. First, the collage partly solves some problems concerning the interaction between color and form that Kelly had been working on in some much better-known paintings of the period. Between 1951 and 1952, he introduced vibrant and varied colors into his works in *Sixty-four Panels: Colors for a Large Wall* (1951; New York, The Museum of Modern Art) and *Sanary* (1952; collection of the artist). In these paintings, the choice of color has no connection to its placement on the canvas. The different colors are all contained in equal-size squares, which form a grid. The size and location of the color squares are unconnected to the specific character of a color. In *Sanary*, Kelly partly rethought this problem by arranging the colors to form alternating vertical bands of brighter and paler tones. In *Red*

Yellow Blue, the different-size surface areas of colors, which vary according to their intensity, carry this correlation much further.

The collage *Red Yellow Blue*, as well as collages from Kelly's Sanary period (1949–52), introduced a solution to the use of simplified horizontal panels that emphasized the integrity of each colored form as a separate visual object, rejecting the notion of the rectangular picture as a window onto space. In addition, *Red Yellow Blue* suggested an interaction between color and the shape/size of the color areas. As such, the collage was an essential complement to the work that may be the most important of Kelly's very early creations, *Window, Museum of Modern Art, Paris* (1949; collection of the artist). This painted relief construction uses architecture as a source; it features a vertical and horizontal grid and value changes, not color. *Red Yellow Blue* might be seen as a pendant to the relief. Recently, Kelly commented about the collage, "It was a work ahead of its time; it had a future that wasn't realized."[14] In this light, it is understandable that Kelly would feel compelled to resolve that collage as the painting *Blue Yellow Red V*.[15]

A forceful argument might be made for regarding Ellsworth Kelly as a classicist. His innate sense of harmony, refinement, and precision is in the spirit of classicism, and his art often features the balance and sure proportions that characterize classicizing art. Yet Kelly's high regard for artistic freedom argues against relating him too closely to the classicizing tradition. He refuses to adhere to overriding rules that would control his art, since his paintings and sculptures are based on experience and are open to new discoveries. Nevertheless, *Orange Green* (1966) is one of Kelly's most classical works. Order, stasis, and absolute rightness of proportions are its salient features.

Orange Green is an eighty-eight-by-sixty-five-inch canvas on which is painted an orange shape surrounded by a green ground. The shape has straight upper and lower edges whose ends terminate in broadly sweeping arcs—segments of ovals—that closely approach, but do not quite reach, the sides of the canvas. In the same way, the bottom of the shape comes within a hair's breadth of the lower edge of the canvas. Kelly initially considered executing the ovals with a compass, but he felt that the curves would meet the straight edge too directly, so he chose to draw them by hand so that they would merge imperceptibly into the upper and lower edges of the form.[16] The resulting shape does not have an easily classifiable geometric name, and our inability to identify it quickly accents the inventiveness of Kelly's art. The form, straight along its sides and elliptical at its ends, might be called a rounded rectangle—a term recently used for similar shapes in computer graphics programs. This shape appealed to Kelly because it mediates the dichotomy between the strictly geometric forms he favored during his Paris years and the more irregular, organic shapes he employed during 1954–60, his first years back in New York.

The first works that Kelly created with rounded rectangles were *Peru* (private collection) and *Inca* (private collection) of 1959, and this compositional type continued during the 1960s with ten other examples. The last use of this form was *Stele I* and *Stele II*, two sculptures of 1973. In *Orange Green*, the width of the rounded rectangle equals one-half the height of the canvas. Thus, it occupies nearly one-half of the canvas surface, and it rests at the bottom of the work. Because it does not visually extend to the canvas's edges, it is not constrained by the ground's rectangular shape. Rather, there is a symbiotic relationship between the shape and the ground.

Historically, Kelly has used two dominant modes of dealing with the competitive demands of figure and ground. In his words, one has been to "squeeze" out the ground by using very large shapes, which he has noted is exactly the effect he sought to avoid in *Orange Green*.[17] More recently, he has used a shaped canvas, which turns the entire wall on which it hangs into the ground. By contrast, in *Orange Green*, he arrived at a flawless relationship between figure and ground so that, in a classical spirit, neither element eclipses the other. *Orange Green* evokes consonance and harmony in its parts.

The colors of *Orange Green* are also in a state of equilibrium. The intensity and value of the hues are equal. Although clearly separated on the color wheel, they are not opposites, so that they do not set up the acute retinal vibrations that orange and blue or red and green would yield. Again, the effect is clear but restful. Although it is seldom noted in the literature, Kelly, like Roy Lichtenstein, has great admiration for Georges Seurat. Kelly recently wrote, "With a profound understanding of the elusiveness of color, Seurat atomized color to map out and stabilize the chromatic complexities of vision."[18] The color relationship of *Orange Green* parallels that of one of Seurat's most classical and stable paintings, *Les Poseuses* (1886–88; Merion, Pa., the Barnes Foundation). Like Seurat's masterpiece, Kelly's *Orange Green* exhibits perfect balance and counterpoint.

A visual source for *Orange Green* may be identified in the clear window of a postal envelope, which features a shape somewhat similar to the rounded rectangle set within a rectangular ground. Kelly seems to have first noticed this configuration while working at the post office in New York in 1954–55. At that time, he did a series of five small sketches of rounded rectangles contained within larger rectangles.[19] In his

paintings, however, Kelly's sophisticated meditations on this form demonstrate how far removed from his initial and peculiar observation the form has become. The effect of *Orange Green* is closest to Kelly's Stele sculptures of the 1970s.[20] These rounded steel rectangles set amid green landscapes have the stability, breadth, and classical composure that characterize *Orange Green*. This similarity indicates the importance of recurring themes in Kelly's art over decades and in different media. It confirms that a classical sensibility, combined with inventive freedom, is one of the leitmotifs of his art.

Chatham III: Black Blue (1971) is one of a series of works Kelly created between 1971 and 1972, immediately after he moved his studio and residence from New York City to the small town of Chatham in upstate New York. The Chatham paintings consist of two rectangular canvases of different dimensions—each panel is a single color, and the two colors are never the same. One canvas is hung vertically and the second horizontally, so that they abut and their left edges align. The resulting configuration resembles an inverted L. The Chatham series is significant as one of Kelly's most important assertions up to that time of the independence of the shape of the canvas from its background and thus the freedom embodied in his works as creative endeavors. In these works, he insists that each colored panel has a clarity and measure of its own, which is to be seen in relation to the other parts. Each panel is a separate object, establishing its own association with the space around it.

For much of his career, Kelly had been interested in authenticating the canvas as a discrete visual object. Such a distinction asserts the artist's role as creator of independent objects, not as imitator of already existing things. He first achieved this goal in

his Parisian works, in which each color is carried on a different panel. (The painting *Blue Yellow Red V* provided another solution to this problem.) Yet for all their radical innovations, the Parisian paintings do not fully distinguish themselves from their surroundings. The viewing public is accustomed to the rectangle as a neutral container of pictorial imagery and thus does not easily see it as an independent configuration. This is especially true because the Parisian works were arrayed horizontally, as individual paintings would be in a traditional museum arrangement.

In the mid 1960s, Kelly again took up this issue in a series of multipanel paintings, such as *Thirteen Panels: Spectrum II* (1967; Saint Louis Art Museum). In these works, Kelly aimed at promoting his ideas about the self-sufficiency of his works by literally filling the room with them. To some extent, however, they still suggested a familiar museum arrangement. During this same period, Kelly also experimented with more radically shaped canvases. These included parallelograms and trapezoids, sometimes consisting of single panels or of several interlocking canvas stretchers. Kelly developed the concept for these paintings when he saw a reproduction of *Thirteen Panels: Spectrum II* photographed at an angle so that the painting looked like a trapezoid. Kelly liked the shape of the work but wanted to "take the space out of the shape."[21] Thus he began to create his shaped canvases, which are frontal, not perspectival. These paintings divorce themselves both from the rectilinearity of the wall and from the rectilinear form of traditional representational painting. The artist believes that they are a very important step leading to his later work.

Chatham III: Black Blue retains the absolute planarity of its surface and the clarity of its forms. There is no suggestion of illusional space. Its rectangles continue

Kelly's self-conscious commentary on the distinctions between his work and traditional rectangular painting. Yet, by the simple gesture of placing one canvas above another in the inverted L design, Kelly forces us to see the panels in an entirely new manner. Because the vertical arrangement of the canvases is unexpected, we read them as specific shapes, not as neutral containers for imagery. The L design further leads us to see the wall around the panels as ground, since we instinctively attempt to turn the open L into a closed rectangle, but cannot. We thus focus simultaneously on the wall as an expansive shape separate from, but related to, the canvases. *Chatham III: Black Blue* provides a brilliantly simple solution to the complex figure/ground problem that Kelly had been contemplating for decades. He has said that it provided "a new sense of space" for him.[22]

In *Chatham III: Black Blue*, the particular shapes and colors reinforce the visual innovations of the entire series. The lengths of the two panels are clearly different; the lower one is sixty-eight inches long while the upper is ninety-six inches long. In width, by contrast, they are nearly identical, thirty-nine versus forty-one inches. Both obvious and very subtle visual distinctions are present. Although the panels are arranged so the left edges align, the upper panel projects dramatically to the right. Because of the length of the upper canvas, the lower one falls short of its center line, or fulcrum point. Therefore, the reach of the black panel across the wall surface is that much more striking: the upper panel extends from, but is not supported by, the lower one.

The vertical and horizontal arrangement of *Chatham III: Black Blue*, a type of nonstructural post and lintel, raises the issue of Kelly's longtime interest in architecture. At the beginning of his career in Paris, Kelly studied and sketched building facades, and their

designs became the sources for several paintings. In 1953 he traveled to Marseilles to see Le Corbusier's renowned Unité d'Habitation and wrote in his notebook: "The wide slabs of primary color on the balconies surprised me, but I thought that Le Corbusier was using color in a decorative way. I wanted to use color in this way, over an entire wall, but I didn't want it to be decorative."[23] Later, for a 1957 exhibition at the Betty Parsons Gallery, Kelly uncharacteristically wrote an extended introduction:

For a long time painting and architecture have remained separated. Today there is very little collaboration of the plastic art with architecture producing anything of real value. Perhaps the reason is that most contemporary painting is too personal for large spaces; the easel-painting artist is more involved with his painting as an end in itself rather than relating it to building.... The glass and steel reinforced concrete structures have created a new form and a new space to work upon. The artist has new materials to work with. The monochrome buildings demand color, and the spaces demand an image on a large scale—powerful statements which are very much alive.[24]

Kelly's statements indicate his interest in the scale, flat surfaces, and simplified geometric structures of modern architecture. Yet he rejects the notion that painting is subsidiary to architecture and thus decorative, as he found the colored wall slabs on the Unité d'Habitation to be. Kelly also shows no interest in the structural aspects of architecture. His paintings are conceived in a purely visual fashion without abiding by the physical laws that necessarily govern large three-dimensional objects. He is concerned with establishing a harmonious, although independent, means of expression so that painting and architecture can reinforce one another. Kelly's use of an architectural vocabulary, which is neither decorative nor architectonic, relates his work to that of Frank Stella, particularly to

such works as *Chodorow I* (see below). Despite Stella's interest in visual complexity and ambiguity as opposed to the simplicity and clarity essential to Kelly, both artists create works that utilize similar principles of scale, planarity, and personalized geometry, which are compatible with some principles of modern architecture.

Generally, few attempts have been made in the Kelly literature to locate the philosophical underpinnings for his art. Kelly's approach to creativity is closest to American pragmatism. Pragmatism, which was conceived by the philosophers C. S. Peirce and William James during the 1870s, was so prevalent in American thought and in our educational system around midcentury that Kelly need not have read specific texts in order to have it influence his ideas. Pragmatism's aim is to make thought clearer and to determine as accurately as possible the meanings of intellectual concepts. It posits, first, that none of our formulations has meaning unless it has been derived from some elementary sensory experience. Here, one thinks of Kelly beginning his visual investigations with objects in his environment. Even more important for pragmatism is the insistence that ideas have a practical outcome. They must lead to results that are clear and intelligible. In fact, the value of an idea is measured by its results. This aspect of pragmatism relates not only to the legibility of Kelly's compositions but also to their physical presences as objects. Like the pragmatists, Kelly attempts to arrive at the most explicit representation of his visual ideas. For him, seeing succinctly is understanding.

The drive for specificity in pragmatism does not eliminate freedom of invention, but rather encourages it. This aspect of the philosophy was most fully explored by John Dewey during the 1930s in his extremely popular book *Art as Experience*. According

145

to Dewey, we can know only through experience. The specific experiences with which he is concerned are those of perception and creation; they are a heightened form of everyday occurrences. Again according to Dewey, our experiences are so wide and varied that our creative potential must be equally expansive. We must be constantly open to new encounters and not constrained by theoretical prohibitions. Dewey wrote:

Experience in the degree in which it *is* experience is heightened vitality. Instead of signifying being shut up within own's own private feelings and sensations, it signifies active and alert commerce with the world; at its height it signifies complete interpenetration of self and the world of objects and events.[25]

At the same time, Dewey recognized the special character of artistic transformation in a manner that suggests the thoughtful process of refinement that takes place in Kelly's works. Dewey continued:

Fortunately for variety in experience, terms are made in many ways—ways ultimately decided by selective interest. Pleasures may come about through chance contact and stimulation; such pleasures are not to be despised in a world full of pain. But happiness and delight are a different sort of thing. They come to be through a fulfillment that reaches the depths of our being —one that is an adjustment of our whole being with the conditions of existence. In the process of living, attainment of a period of equilibrium is at the same time the initiation of a new relation to the environment, one that brings with it potency of new adjustments to be made through struggle.[26]

For Dewey and the other pragmatists, as for Kelly, these beliefs are not only intellectual; they have a moral component. Openness to experience, combined with logical thought and clarity of creation, is a model for informed, humanist behavior. Ellsworth Kelly's work stimulates us to see and think with independence and lucidity.

Kelly's pragmatist interest in both the freedom and factualism of the art work can be traced in *Green Curve III* (1972). *Green Curve III* is one of the first works in which Kelly used curved lines after largely abandoning them for straight-edged shapes around 1965. These works utilizing curves were begun shortly after Kelly moved from the city to the country, and they are undoubtedly influenced by his environment. These expansive curves remind us of gently rolling hillsides and the undulations of the nearby Berkshire Hills, and Kelly took confirming photographs of the landscape around him. (These photographs were often taken in winter so that only the basic shapes of the landscape stand out.) The paintings, which incorporate such sweeping arcs, seem even more closely related to a larger vision of the curvature of the earth seen at a great distance or to the phases of the moon. Kelly has mentioned his special interest in photographs of Earth taken from NASA spaceships.[27] The overall mood provoked by these curved works is one of astonishment at their amplitude and the expansiveness of their forms. Although the shapes depicted appear to be perfectly controlled, they suggest enlargement outside of their boundaries to such enormous forms that they are nearly beyond comprehension. The curves are related, although perhaps not obviously, to the Chatham paintings. Because of its open configuration, *Chatham III: Blue Black* suggests an expansive vision and includes as part of its visual experience the surrounding environment. *Green Curve III* extends that idea.

Kelly had first used arcs in his art during his Paris years, most notably in *White Plaque: Bridge Arch and Reflection* (1951–55; private collection); his equally well-known *Kilometer Marker* (1949; collection of the artist) also approximates a semicircle. By the time Kelly had returned to New York from Paris in 1954, he had abandoned arcs

for hand-drawn and deliberately irregular curves. Circular shapes were of little interest to him because of their regularity. "I don't like circles; they are complete. In the fragment what is interesting is what is hidden."[28] The more biomorphic forms, done in New York, were indebted both to his study of fragments of the surrounding world and to the influence of Jean Arp, whose studio in Meudon Kelly had visited in 1950. Although Kelly's biomorphic shapes were less irregular than Arp's, they still had a meandering organic character that called to mind the botanical world. The major problem that Kelly had with those shapes, despite their often large scale, is that they read as insular, contained forms—figures enclosed within the ground of the rectangular frame of the canvas. In fact, when perceptual psychologists wish to demonstrate the most basic figure/ground distinctions that humans make, they use compositions —unspecific organic patterns drawn within rectangular fields—that are similar to Kelly's works of the late fifties and early sixties. The last device that Kelly tried (1963–65), before temporarily abandoning curved forms, was extending the curve and the color area it enclosed to the edges of the canvas, as if it were a small fragment of a much larger entity. He thus attempted to give the form an expansive character that is connected to his later curved paintings.

These later works by Kelly signal a new type of engagement with the natural world in that he is looking at the macrocosm, not the microcosm, external space rather than inner shape. Earlier, Kelly had discovered that the closer one looks at things the less regular they appear; later, he realized that the environment seen at a distance has a commanding, even awe-inspiring, regularity. Simultaneously, the curved works mark a new use of geometry. Previously, Kelly had avoided geometric regularity, which he associated with rigidity of thought.[29] The

curved works, however, feature arcs, segments of circles. They are portions of the most regular of all geometric forms. In these paintings, Kelly discovered that regularity need not imply closure and predictability but may instead inspire an imaginative sense of expansiveness. In order to create this visual experience, Kelly used a very simple version of projective geometry—that is, the concept that a geometric figure is unaltered by projection into space. Therefore, we may imagine an infinite continuation from a small segment of a regular geometric form. Since its discovery in the early nineteenth century, projective geometry has been admired for the straightforwardness and simplicity with which it solved a number of problems in Euclidean geometry. Kelly's projecting arcs provided him with the clarity he prizes in his art as well as an imaginative sense of vast possibility.

Like many of Kelly's early paintings containing curves, *Green Curve III* consists of an arc drawn within a parallelogram so that either end of the arc coincides with the corners of the parallelogram. The arc is large. If completed, it would circumscribe a circle over thirty-five feet in diameter. (Some of Kelly's later arcs project a circle well over one hundred feet in diameter.) Kelly's integration of the arc and the parallelogram is derived from his method of making such large curves. One of the best ways to plot their curvature is through a grid formed within a parallelogram. Kelly must have quickly realized that the parallelogram was not only a practical device with which to construct the arc, but that it complemented its form. The two very different shapes—one curved and the other straight-edged—seem inseparably fused. Neither contour dominates the other. The arc and the parallelogram together create a strong unified diagonal thrust from lower left to upper right. At the same time, the

arc holds the parallelogram to the surface and keeps it from reading as a form receding into space. One might imagine the arc running in the opposite direction, terminating at the obtuse angles of the parallelogram. In this case, the relationship could not be symbiotic. The arc would visually divide the parallelogram into two parts rather than directionally uniting with it. Both the arc and the parallelogram in *Green Curve III* are ample forms. The arc has a distinctive curve, and the acute angles of the parallelogram are relatively broad (78 degrees). The white upper area of the parallelogram in *Green Curve III* implies the merging of that zone into the wall, yet that area of the canvas also provides an essential contrast to the green portion. Kelly has observed that the difference between the painted edge and real edges in the work is crucial to it. *Green Curve III*, thus, looks forward to Kelly's later works in which the canvas itself takes on a curved shape.

A group of dark gray and white panel paintings that Kelly created in the late 1970s acts as a foil for his paintings containing arcs. Whereas the arcs rely on imaginative extensions of geometrically perfect forms, these gray and white paintings explore such visual phenomena as irregular, fragmentary, and distorted forms in the surrounding world. They are among the toughest and most recalcitrant works of Kelly's career, because they resist easy visual organization and classification. In Kelly's recent oeuvre, these paintings mark the greatest degree to which the artist is willing to accept the notion of things that do not fit, the idea that visual experiences can be incongruous and abnormal. Paradoxically, they emphasize the importance of perception by accentuating its tentativeness. Yet, as is typical of his modes of thinking, Kelly investigates these ideas about irregularity with self-conscious, intellectual control.

Dark Gray and White Panels of 1977 consists of two panels that abut along a common side. The two panels form a closed order, demanding comparison to each other. One of our primary methods of gathering information is through pairing objects. In this case, nothing about these two is exactly the same and nothing is precisely the opposite. The two canvases have no two sides that are the same length. The white panel measures 61 by 57 by 68 by 40 inches and the gray one, 78 by 80 by 77 by 66 inches. The angles are equally irregular. In the gray panel, for instance, they measure 105, 77, 94, and 87 degrees respectively. Several of these angles are close enough to 90 degrees so that they test and then frustrate our natural inclination to see easily resolved right angles. Likewise, in both panels three of the sides are relatively close in dimension while one is considerably shorter. As we know from experimental psychology, the eye seeks to normalize visual irregularity so as to order experience, although we almost never see Euclidean shapes in everyday experience. We commonly see objects along orthogonal lines, and they appear irregular to us before being corrected by the mind. Kelly has noted, "I like to see shapes in space and then draw them as frontal or parallel to the viewer. You don't really see anything as a rectangle."[30] *Dark Gray and White Panels* resists resolution into any common Euclidean shapes, and it leads us logically and relentlessly into irrational pictorial situations. The shape of each panel in *Dark Gray and White Panels* is a trapezium—a quadrilateral plane figure in which no two sides are parallel. In this group of paintings, Kelly avoids both the parallelograms and trapezoids that had been featured in earlier paintings. There are two reasons for Kelly's use of trapeziums. First, their irregular surface geometries represent the visual liberty that Kelly prizes in his art. Second, the

forms do not encourage the illusion of recessional space the way that angled parallel or converging lines do. Kelly has further precluded any chance of illusional effects by placing the larger angles and longer sides of the panels at the top, the points most distant from the viewer's eye. Despite our inability to label the shapes in *Dark Gray and White Panels*, it is nonetheless a forceful, concrete object that we must confront.

In addition to the asymmetry of the individual canvases in *Dark Gray and White Panels*, the panels have neither vertical nor horizontal edges, so that they undermine our innate desire for balance. The dark gray panel rises at a 30-degree angle from the horizontal on its left side and at a 45-degree angle on its right. Our ability to measure the world accurately is predicated on our vertical stance and the horizontal extension of our arms; *Dark Gray and White Panels* does not allow such easy measurement to occur. Equally, architecture is normally an extension of this vertical and horizontal grid created by our anatomy. The gray and white paintings are combative with the architecture around them: they insist on their separation from their architectural surroundings. The stretchers of the two panels are unusually deep, about two inches. This simultaneously enhances the physicality of the work and causes it to cast shadows, which provide further variables as we try to resolve the erratic shapes. The relationship between the two panels is essential to the theme of deliberate incongruity. Although the white panel is smaller than the gray one, it is not so diminutive as to be of secondary importance, especially since the dark panel also may be read as a base holding it aloft. The two canvases do not gracefully align as do those in many other works by Kelly; rather, they seem to collide. At their upper edges, they are strikingly disparate. At their lower borders, the

effect is more subtle, but no less disturbing. The canvases almost, but not quite, form a continuous line. Such a slight irregularity—the angle between them is 174 as opposed to 180 degrees—tests the eye's ability to perceive minute directional changes. It is similar to a standard test of visual acuity, called "vernier acuity." Every line in *Dark Gray and White Panels* puts us slightly off balance and creates subtle sensory irritation. Even the color association between the two panels is not straightforward. While the white panel is pure titanium white, the other is not black but mixed to gray using a variety of colors. In this respect, as in others, *Dark Gray and White Panels* is not as clear as black and white, but a complex indeterminate work.

Dark Gray and White Panels begs comparison to two artists whom Kelly admires, Piet Mondrian and Kasimir Malevich. Between 1916 and his death in 1944, Mondrian created a series of diamond-shape compositions that appear similar to the canted planes of *Dark Gray and White Panels*. Although the abstraction and concrete physical presence of these works are related, as is Mondrian's innate sensitivity to such features as the thickness of his lines, Kelly rejects the theoretical rigidity that limited Mondrian to strictly vertical and horizontal lines and to positioning the bottom edge of the canvas only at a 90- or 45-degree angle to the vertical. These aspects undermine Kelly's belief in freedom and intuition as primary artistic qualities. Unlike Mondrian's works, Malevich's Suprematist compositions are derived from feeling rather than geometry. The forms in his paintings are seldom Euclidean but instead feature subtle irregularities in form, position, and texture, which give them their humanist content. Yet Malevich incorporates in his works a spatial illusionism that Kelly cannot accept. Malevich's Suprematist shapes float in a

mystical and undefined space, which is quite apart from Kelly's belief in concrete facts and thus his conviction that the modern painter "has always to return to the planarity of the surface of the canvas."[31] The most important connection among Mondrian, Malevich, and Kelly, however, runs deeper than these contrasts. Kelly, like these earlier masters, believes that painting has not only a formal purpose but an ethical role in suggesting an entire worldview. Kelly has stated: "The challenge for the artist is to encourage the viewers to see in a new way, to lead them beyond television, pop culture, and advertising. If the art accomplishes this, it is profound and revolutionary."[32]

Sources in the everyday environment for *Dark Gray and White Panels* are the old homes and barns in the region of Kelly's studio. Kelly photographed details from these old buildings. The photographs highlight such features as the irregular geometry of a sagging roof or a door hanging on only one hinge. These photographs also clearly show the distinctions between Kelly's sources and his artistic investigations. The photographs have a sense of particular place, time, and environment—a nostalgic character—that is entirely missing from the paintings. In this respect, Kelly's approach is diametrically opposed to that of Robert Rauschenberg, who deliberately preserves the nostalgic character of his photographic images and objects in the final works. Kelly has noted about his photographs: "I take photographs to document shapes I see that are like my paintings."[33] In his paintings, Kelly has conceived of the idea of irregularity as a pictorial problem. Paradoxically, through generalization he can arrive at the particular nature of the problem and is able to carry on his impersonal and factual observation of forms. Kelly has commented that by using the photograph the objects depicted are "flattened out and become a

metaphor for something else, something the eye sees but does not usually grapple with."[34]

Kelly's sculpture is one of the most distinctive aspects of his oeuvre. In none of his sculptural work has he shown the slightest interest in either the traditional tactile or volumetric aspects of the medium, which are thought by many sculptors to be its essence. In terms of tactility, Kelly carefully painted his early sculptures so that each panel had an unmarked monochrome surface. Later, in his Corten works, he has allowed the chance markings on the surfaces to remain and the natural weathering of the metal to progress unmodified. Both these methods avoid the individual touch prized by so many sculptors. As in his paintings, Kelly aims at a universal rather than a personal mode of expression. He finds notions of sculptural volume to be particularly misleading and confusing. For him the outer skins of conventionally modeled, cast, and carved sculptures mask and obfuscate the space within. He believes that his sculptures, which consist of flat, shaped planes placed in space, reveal the true interaction of the object with space. In his words, "all the material and all the space are apparent."[35]

The planar character of Kelly's sculptures relates them closely to his paintings. Some of his most innovative work in the 1950s in Paris were his painted relief panels, which negated both the illusionism of painting and the volumetric concerns of sculpture. Throughout his career, Kelly's paintings are most fruitfully regarded, as they have been discussed in this essay, as shaped and colored panels placed on the wall surface. Since the 1970s, Kelly has attached his cutout metal panels to the wall as frequently as he has created freestanding examples. In these ways Kelly, more than any artist since David Smith, breaks down

the traditional boundaries between sculpture and painting; he allows the two media to cross-fertilize and through them creates a unified vision of form in space. For Kelly, the clarity of form and space in his sculptures does not eliminate their imaginative content. In fact, he feels that his open planar constructions do much more to encourage imaginative extension by the viewer than closed, volumetric sculptures do. In his words, "I have always been against volume. I feel that volume is a finished product. I want the works to exist between being and non-being, metaphors for spatial extension. My works go so far and then stop; they allow various imaginative completions. I am not attracted to work that is an obvious finished statement."[36] One essential respect in which Kelly's sculptures encourage imaginative completion is viewer position; they change appreciably when one moves relative to them.[37] In fact, it may be argued that the sculpture is calculated to make such movement visually significant. It is the viewer's movement that, in a manner of speaking, provides the third dimension in Kelly's sculpture—the dimension that has been eliminated from the sculptures themselves.

Concorde Angle (1982) is an important example of the monumental freestanding sculptures in weathering steel that Kelly has produced since 1973. It consists of two flat metal plates bolted together at a 90-degree angle. The horizontal plate is a square 91 inches on each side. The vertical plate is a trapezoid, 91 inches at the bottom, 108 inches on its left edge, 109 inches along the top, and 112 inches on its right edge. Its left side is set at a 90-degree angle to the lower plate, while the cant of the right side is 100 degrees.

Kelly has stated that he considers the horizontal plates essential parts of his sculptures. Besides providing actual physical support, the most important aspect of the horizontal plane in Concorde Angle is that it controls where the viewer stands and thus how she perceives the piece. Standing directly in front of the sculpture at the edge of the horizontal plate, at a distance of 91 inches, one reads the vertical plane of Concorde Angle as perpendicular on its left side and angled slightly outward on the right. But, if the viewer stands at the left corner of the horizontal plate, the right edge appears perpendicular, like the left one. If one moves to the right corner, the angle of the right vertical edge is accentuated and the left side is visually pulled out of plumb. It appears to slope in a direction parallel to the right-side angle. In Concorde Angle, viewer movement has provided the third dimension for the work, one in which we measure our varying optical perceptions against the physical presence of the sculpture. Our understanding of the sculpture through these movements may be the reason Kelly chose Concorde Angle as its title. The French word concorde may be translated as "good understanding."

This aspect of viewer position is reinforced by references that the work makes to other sculptures by the artist. Concorde Angle alludes to Kelly's White Angle (New York, The Solomon R. Guggenheim Museum) and Blue White Angle (private collection), both of 1966.[38] Each of these works features two rectangular panels attached at a right angle. We are urged to consider them from two radically different positions, from directly in front and from the side, which give two entirely different appearances to the sculptures—they yield an abstract version of the dramatic differences between full-face and profile views in traditional sculpture. The variations in Concorde Angle that arise as one moves to different positions are more subtle, which befits the stance of an artist rethinking an idea decades later. Concorde Angle may also

be linked to a painting of 1958, *Concorde* (private collection), and to the relief construction *Concorde Relief* (1958; private collection). Each of these works features a shape closely associated with the vertical surface of *Concorde Angle*; Kelly even retained the French spelling of *concord* so that the connection to the early relief could be made by informed viewers. Seeing the sculpture from different angles changes the look of the work in a manner that does not happen with the painting and the relief. In this comparison, Kelly has underscored a major distinction between his sculpture and work in other media.

Kelly desires his outdoor sculptures to harmonize with the landscape while retaining their distinct identities, and he prefers his sculpture to be set against a wall of foliage. His attitude is akin to his thoughts about architecture in relation to his paintings. Kelly has stated, "In sculpture the work itself is form and the ground is the space around it."[39] The scale of *Concorde Angle* connects it with small trees. At a distance, it holds its own against the expansive natural backdrop. Close up, it is not so large as to obscure its surroundings. The design of the upright panel also harmonizes with the environment in that it features both strict verticality and angular projection, like that we find in trees. The weathering steel surface of *Concorde Angle* has a natural look. Although Kelly's use of weathering steel initially derived from his frustration with the deterioration of his painted surfaces placed outdoors for any extended period of time, he has come to appreciate the irregular, natural-seeming look of the material, which results from the metal's sealing itself with a thin layer of rust. In these works, Kelly has even retained the accidental surface marks and scratches that often occur during manufacture, which give them an organic appearance. The harmonious alliance that

Kelly's sculpture establishes with its setting might be contrasted with the work of Richard Serra. In emphasizing strict geometry and massiveness, Serra's sculptures are overwhelming and sometimes threatening. They exemplify the force and willfulness of the artist as he imposes himself upon nature rather than existing in a symbiotic relationship with the natural world as does *Concorde Angle*.

The sculpture *Phoenix* (1984) was commissioned by the Meyerhoffs for the central courtyard of the gallery wing of their home. Its design is based on one of Kelly's best-known and most frequently exhibited sculptures, *Blue Red Rocker* (1963; Amsterdam, Stedelijk Museum), and it is also related to Kelly's first freestanding sculpture, *Pony* (1959; Shirley and Miles Fiterman Collection, on permanent loan to the Minneapolis Institute of Arts). *Phoenix* consists of two attached plate-metal forms. A hand-drawn ellipse has been sliced in two, and the sections have been welded together along the resulting straight sides at a fifty-degree angle, to create a self-supporting sculpture. The appearance is that of a single planar ellipse that has been bent. In fact *Pony* was actually conceived when the artist bent and cut the flat lid of a coffee container.[40] Even more than *Concorde Angle*, *Phoenix* achieves a fully three-dimensional expression without being volumetric or tactile—it neither encloses nor contains space. Instead, *Phoenix* gains its spatial character by urging us to move around it, and each view is distinctive. From its side, the sculpture is strictly planar, and our eye follows the graceful curve of its upward arching edge. Facing the sculpture's straight edge, one is struck by its sharpness and brevity. The curves are all but invisible, and we focus on the razor edge at which the two planes join. From this viewpoint, the sculpture seems almost ballistic in char-

acter. On the opposite side, the two elliptical planes of *Phoenix*, like arms, embrace the viewer. One can easily step into the ample, five-foot-wide space between them. Here, security and containment are the primary experiences.

On the whole, *Phoenix* has a buoyant and even playful quality. The joyousness and life-affirming nature of Kelly's art is often overlooked in the literature on him. The massive steel plates of *Phoenix* seem quite light. The work balances on the arcs of the ellipses, and it barely touches the ground. Its shape is dominated by the gracefully soaring ellipses and the shooting straight edge. The title of the sculpture is a wordplay both on the township of Phoenix, Maryland, where the Meyerhoffs live, and on the myth of the phoenix rising from the ashes. True to its namesake, *Phoenix* seems winged and about to soar. Its gray steel surface is reminiscent of the ashes, reinforcing the allusion. In terms of the lyrical character of *Phoenix*, Kelly has noted that *Blue Red Rocker*, its closest source, was partly inspired by both a child's rocking horse and the ubiquitous furniture of American leisure, the rocking chair. Yet *Phoenix* is simultaneously more monumental and expansive than *Blue Red Rocker*. *Phoenix* also owes a general debt to the sculpture of Alexander Calder, particularly his Stabiles. Kelly met Calder in France during the 1950s and has admired his work since that time. At least once, he identified Calder as among his most important influences.[41] Like Calder, Kelly's formative years were spent in France, and also like Calder, he identified the artistic concerns that would define his career at an early date. In the mode of Calder, Kelly is a stubborn individualist who stands somewhat outside artistic trends. Calder's flat color planes, which transform organic subject matter through a clarifying sensibility, may have influenced, or at least confirmed, Kelly's

mode of thinking. But Calder's art is earthier and simpler than Kelly's. In his Mobiles and Stabiles, Calder's direct visual analogies to such creatures as whales and lobsters differ from Kelly's more conceptual thinking. In contrast to Calder's visual puns, Kelly's wit is directed toward the processes of creation and perception. Calder's interest in engineering as a form of tinkering is also distinct from Kelly's concerns, which extend only to using technical means to solve particular artistic problems. *Phoenix* undoes the sculptural conventions of volume, tactility, closure of form, pedestal, and gravitational weighting. It is both lively and monumental, and it reflects Kelly's exhilaration at discovering new forms in the process of redefining traditional sculptural expectations.

Near the beginning of his career, Kelly planned to write an instructional book about basic artistic elements. His notes for that book still exist; the components that he planned to use to organize the book were, in order of development, vertical and horizontal bands, squares, triangles, and circles. The planned book is prophetic in that Kelly's actual artistic investigations have roughly followed this course, and many of his more recent works have focused on portions of the circle. Starting in 1980, Kelly used curved stretchers so that the actual shape of his paintings and relief sculptures contained arcs. Such a development was already implicit in *Green Curve III*, in which the white upper area of the parallelogram nearly merges with the wall behind it. Like Kelly's sculptures, his arc canvases are assertive shapes that establish the walls themselves as their grounds.

The circular shape has a long tradition in the history of art. One origin may be traced to the interaction between art and architecture. In ancient Roman architecture, decorative motifs were sometimes carved or painted under structural arches.

Fragments of this type of work may still be found in such monuments as the Colosseum. In the great Romanesque churches of Western Europe, this practice underwent a significant revival as relief carvings on their exteriors became one of the most important devices with which to instruct the faithful about religious doctrines. The curved tympanums over the great entrance doors were a favorite place for these carvings. In the Renaissance, the circular format, or tondo, became a notable subcategory for paintings. It was particularly favored for depictions of the Virgin and Christ Child, and one thinks of such famous examples as Raphael's *Alba Madonna* (c. 1510; Washington, D.C., National Gallery of Art) and Michelangelo's *Doni Madonna* (c. 1503; Florence, Uffizi Gallery). It has been suggested that the perfection of the circle was a fitting symbol for the purity of the Virgin Mary and also that the format was suited to such tightly knit groupings of figures. One aspect of these paintings is certain. Artists considered it a particular challenge to contort the human figures subtly so as to accommodate them to that format. (In medieval churches the issue of how to fit the scenes under the arches was also a pressing concern.) The curved format for painting continued to appear sporadically after the Renaissance. In the nineteenth century, Jean-Auguste-Dominique Ingres was noted for his willingness to distort and abstract the human form to fit that shape. During the twentieth century, examples can be found in the round Cubist compositions by Picasso and Georges Braque, Robert Delaunay's Sun Disks, and Frank Stella's Protractors. What links all of these examples, even such contemporary works as Stella's Protractors, is the artists' attempt to relate the interior forms, be they figurative or abstract, to the shapes of the works. It is precisely this concern that Kelly eliminates. His arcs exist as

single indivisible shapes with no internal relations. In his works, the shape of the canvas embodies wholly the expression and meaning of the art work.

Each of Kelly's curved works has a distinctive character. *Blue Violet Curve I* (1982) is one of the most forceful and physical of his curved compositions. The left side of the painting is a vertical edge 80 inches tall. That edge acts as a neutral starting point for two dynamic angular thrusts that move from left to right, the direction vision in the West normally travels because we are accustomed to reading that way. The lower, straight edge rises 30 degrees from the horizontal and hurtles a distance of 120 inches. Its elevation is such that it does not so much soar skyward as suggest lateral projection across a great distance. The upper edge curves in a powerful arc; the circle of which it is a segment would be 320 inches (more than 26 feet) in diameter if completed. The arc of its trajectory is thus pronounced and intimates the sweep of vision across a vast expanse. The right corner of the arc, its terminus point, is slightly closer to the floor than its beginning at the left (88 versus 90 inches). The visual result is that the directional thrust of the arc is brought back to earth. The panel's blue-violet color suits the character of its shape. The hue has a weightiness about it, more like deep water than sky. It complements the forcefulness and physicality of the entire painting.

As noted with *Green Curve III*, Kelly's arc paintings are partly indebted to his appreciation of large and powerful elements in nature. *Blue Violet Curve I* particularly brings to mind two Kelly drawings that reveal these natural origins. *Sluice Gates* (1947; collection of the artist) is one of Kelly's very first preserved works. This small drawing shows the artist pictorially interpreting the power of flowing water by flattening and shaping it as a series of vigorous arcing tra-

jectories set off by straight lines, like the shape that appears decades later in *Blue Violet Curve I*. In 1970 Kelly drew *Study for a Lake* (collection of the artist). In more specific terms than we are accustomed to seeing in his art, this drawing shows the artist's concern with the projection of vision across a vista and his ability to conceptualize that experience as two-dimensional shapes. During our discussions, Kelly said of this drawing: "I was on a hill looking across a body of water. The part of the lake that I saw made a shape that has real torque. I made a complicated shape into a flat shape. The angles make the work; they give the measure a sense of mystery. The shape starts as vertical and becomes horizontal." *Blue Violet Curve I* conceptualizes such an extended vista and by implication comments on the power of sight to take in the world in a glance. Kelly has expressed his admiration for Paul Cézanne, who also used a sort of visual torque to twist spatial forms into two-dimensional painted shapes. Kelly has written of the French master, "Cézanne tackled and conceptualized the three-dimensional world in terms of underlying structures."[42] Kelly's drawing and, more important, his painting *Blue Violet Curve I* owe a debt to such works by Cézanne as *The Bay from L'Estaque* (c. 1886; The Art Institute of Chicago). In the spirit of Cézanne, *Blue Violet Curve I* transforms visual experience into a powerful pictorial dynamic.

The ardent physicality of *Blue Violet Curve I* is unusual for Kelly's curved paintings. A number of them, like *Red Curve* (1986), are more ethereal and transcendent than physical. What are the features that give *Red Curve* this sensibility? *Red Curve* is one of the most elongated works that Kelly has created to date. It is 205½ inches long and only 41½ inches wide at its widest point; the work fills the width of our visual field.

Its arc is based on a circle that is 1,500 inches (125 feet) in diameter, a size that strains the limits of imagination if we try to complete it as a Euclidean form. At the same time, *Red Curve* seems to have no mass because it is so narrow, and its surface area, relative to its length, is so minimal. It is such a small segment of such a huge circle that its lower edges meet at an expansive 160-degree angle. Thus, despite its size, *Red Curve* seems to float before us, disembodied, like an apparition. Unlike *Blue Violet Curve I*, *Red Curve* is absolutely symmetrical; it does not have a predominant directional force. This feature contributes to its sense of otherworldly perfection. This painting does not have the irregularities or dynamics we expect of things associated with our biological world. It appears absolute and hieratic and seems reduced to a state of ultimate simplicity. The color of *Red Curve* contributes to this feeling. Red is a hue that is relatively rare in the natural world and one that is sometimes associated with spirituality. (For instance, Christian archangels are said to be red.) Kelly has noted that *Red Curve* utilizes a "red-orange that tends to be warmer than pure red," and he added that he never uses pure color, employing a new and unique color solution for every canvas.[43] The red in *Red Curve* glows in a manner that induces in the viewer an almost hypnotic state.

Despite the pictorial logic as well as the physicality of most of Kelly's art works, they have always contained a latent spirituality. This aspect of his art results from its ahistorical traits. Kelly's art has often appeared unhinged from specific moments in time. His pictorial investigations are finally so far removed from the observations of the everyday world that inspired them that they seem universal. They are strongly conceptualized rather than particularized. This sense of removal from daily circumstances has an inherently spiritual component. Kelly,

himself, has recently begun to speak about his art in such terms and to consider early sources for this attitude. Several years ago, he commented:

While visiting Brancusi in Paris in 1950, I was impressed by the purified nature of his abstraction and by his creation of often simple, solitary forms. For me, his art was an affirmation; it strengthened my intention to make an art that was spiritual in content.[44]

Early in his career, Kelly was attracted to artistic sources that often suggested spiritual issues, and several of these contain the arc configuration of *Red Curve*. In Paris, he made many visits to the museum of ethnographic art, the Musée de l'Homme. While there in 1949, he drew *North-West Coast Indian Ceremonial Plaque* (collection of the artist), based on a copper plaque from the Haida Indians. That mysterious ceremonial object has a sweeping arc at its top and features an absolute symmetry similar to that of *Red Curve*. (Kelly simplified the plaque so that its outline is dominant.) Even closer to the shape of *Red Curve* are drawings that Kelly made in 1949 of the vaults of Notre Dame cathedral. Kelly chose not to draw the sculpture-filled tympanums probably because their profusion of imagery conflicted with the straightforwardness of the architectural structure. In the soaring vaults of Europe's great medieval churches, Kelly found an inspiring combination of structural simplicity and mystery. The quadripartite vaults he depicted at Notre Dame, seen at an angle from the nave below, look like *Red Curve*. During his first year in Paris, Kelly also obtained permission to draw at the Byzantine Institute, a Harvard University extension. A notebook page that contains images from several twelfth-century manuscripts is perhaps closest of all to *Red Curve*. The page juxtaposes a standing

angel with wings outspread and a bent-over human figure. The angel's wings, in their rounded horizontal spread and balance, are analogous to the design of *Red Curve*. In fact, one might contrast the spiritual symmetry of *Red Curve* with a more irregular and physical work like *Blue Violet Curve I* in a manner similar to the contrast between the angel and the human in this drawing. Such a contrast both emphasizes the different tenors of Kelly's various works and illustrates the way that the artist mines his earlier work for ideas. It might also be noted that Kelly has collected anthropological objects that have a simplicity similar to that of his art and whose uses are unknown and probably ritualistic. These objects include American Indian banner stones and Chinese bi forms. In discussing these objects, Kelly has stated that when form in one of them is reduced to a minimum, "something else happens; it becomes a mysterious object."[45] Kelly's personal collection of objects hints at a metaphysical intent, which is one aspect of his work.

Kelly's paintings, reliefs, and sculptures are not simply about seeing and making objects. His art has an ethical content that is not dependent on theory but is part of the works themselves. Kelly has observed: "All the solutions are so subtle that people often take them as givens. The discoveries that I make in the paintings are actually very difficult for me."[46] Kelly's work exemplifies the value systems of the artist and reflects his desire to remake the world around him in a way that is compatible with his beliefs. In the last analysis, Ellsworth Kelly's art advocates the following values: the universal rather than the particular; harmony rather than disruption; clarity rather than obscurity; unity rather than chaos; contrast rather than repetition; and rationality rather than irrationality.

1 Paul Taylor, "Interview with Ellsworth Kelly," *Interview Enterprises* (July 1991), 102.

2 Ellsworth Kelly, interview with the author, February 26, 1994.

3 Robin Cembalest, "Ellsworth Kelly: 'Everything Becomes Abstract,'" *Art News* 91 (December 1992), 102.

4 Kelly, interview with the author, February 26, 1994.

5 Ibid.

6 Ibid.

7 John Coplans, *Ellsworth Kelly* (New York: Harry N. Abrams, 1971); E. G. Goosen, *Ellsworth Kelly* (New York: The Museum of Modern Art, 1973); Diane Waldman, *Ellsworth Kelly: Drawings, Collages, Prints* (Greenwich, Conn.: New York Graphic Society, 1973).

8 Diane Upright, *Ellsworth Kelly: Works on Paper* (New York: Harry N. Abrams, in association with the Fort Worth Art Museum, 1987), 7.

9 Kelly, interview with the author, February 26, 1994.

10 Ellsworth Kelly, "Notes from 1969," in Barbara Rose et al., *Ellsworth Kelly: Schilderijen en beelden 1963–1979/Paintings and Sculptures, 1963–1979* (Amsterdam: Stedelijk Museum, 1979), 32.

11 Kelly, interview with the author, February 26, 1994.

12 Ibid.

13 Kelly indicated that his realizing the importance of the collage led him to suggest it as a frontispiece for Upright's *Ellsworth Kelly: Works on Paper.* He added that seeing the work in the context of that book may have finalized his desire to make the painting *Blue Yellow Red V.*

14 Kelly, interview with the author, February 26, 1994.

15 Kelly has said that the painting brought about a sense of liberation for him. "I finally said that I can make paintings now from these earlier experiments. Before this I needed a validation." Interview with the author, February 26, 1994.

16 Ibid.

17 Ibid.

18 Ellsworth Kelly, "Fragmentation and the Single Form," in *Artist's Choice: Ellsworth Kelly* (New York: The Museum of Modern Art, 1990), n.p.

19 Diane Upright, *Ellsworth Kelly: Works on Paper,* 32.

20 See *Stele I* (1973; private collection) and *Stele II* (1973; private collection). A 1964 drawing on a postcard, *Château d'Angers,* shows Kelly contemplating such ovoids in a landscape setting (Upright, *Ellsworth Kelly: Works on Paper,* 93). A drawing for one of the Stele sculptures shows it within and tangent to a rectangle (ibid., 107).

21 Kelly, letter to the author, March 12, 1995.

22 Kelly, interview with the author, February 26, 1994.

23 Bois, *Ellsworth Kelly: The Years in France,* 192.

24 Kelly's statement, which was mimeographed for his second exhibition at the Betty Parsons Gallery in 1957, is reprinted in Patterson Sims and Emily Rauh Pulitzer, *Ellsworth Kelly: Sculpture* (New York: Whitney Museum of American Art, 1982), 18.

25 John Dewey, *Art as Experience* (1934; New York: G. P. Putnam's Sons, 1979), 19.

26 Ibid., 17.

27 Sims and Pulitzer, *Ellsworth Kelly: Sculpture,* 27.

28 Kelly, interview with the author, February 26, 1994.

29 Kelly has recalled his early meeting in Paris with Georges Vantongerloo, who asked him to explain the underlying theory of his art. From that time, Kelly resolved that he would not let theory restrain his visual investigations. Ibid.

30 Ibid.

31 Kelly, "Fragmentation and the Single Form."

32 Kelly, interview with the author, February 26, 1994.

33 Ibid.

34 Ibid.

35 Ibid.

36 Ibid.

37 Although the effect of relative viewer position is somewhat more evident in the free-standing sculptures than it is in either the relief sculptures or the paintings, viewer location also alters our perception of those works. Kelly intends the varying appearances of all his works from different positions to be an essential part of their content.

38 For more information on these sculptures, see Roberta Bernstein, *Ellsworth Kelly, At Right Angles, 1964–1966* (Los Angeles: Margo Leavin Gallery, 1991).

39 Kelly, "Fragmentation and the Single Form."

40 Sims and Pulitzer, *Ellsworth Kelly: Sculpture,* 75.

41 Richard H. Axsom, *The Prints of Ellsworth Kelly: A Catalogue Raisonné, 1949–1985* (New York: Hudson Hills Press, 1987), 14.

42 Kelly, ""Fragmentation and the Single Form."

43 Kelly, interview with the author, February 26, 1994.

44 Kelly, "Fragmentation and the Single Form."

45 Axsom, *The Prints of Ellsworth Kelly,* 32.

46 Kelly, interview with the author, February 26, 1994.

Ellsworth Kelly

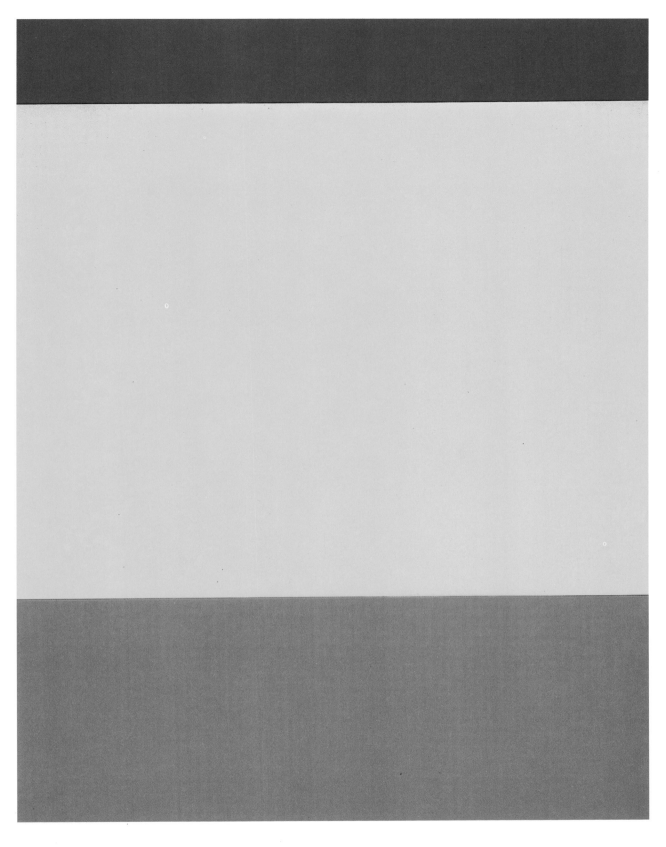

ELLSWORTH KELLY
Blue Yellow Red V (EK 764), 1954/1987
Oil on canvas, 3 joined panels, overall: 97½″ × 75″
(247.7 × 190.5)

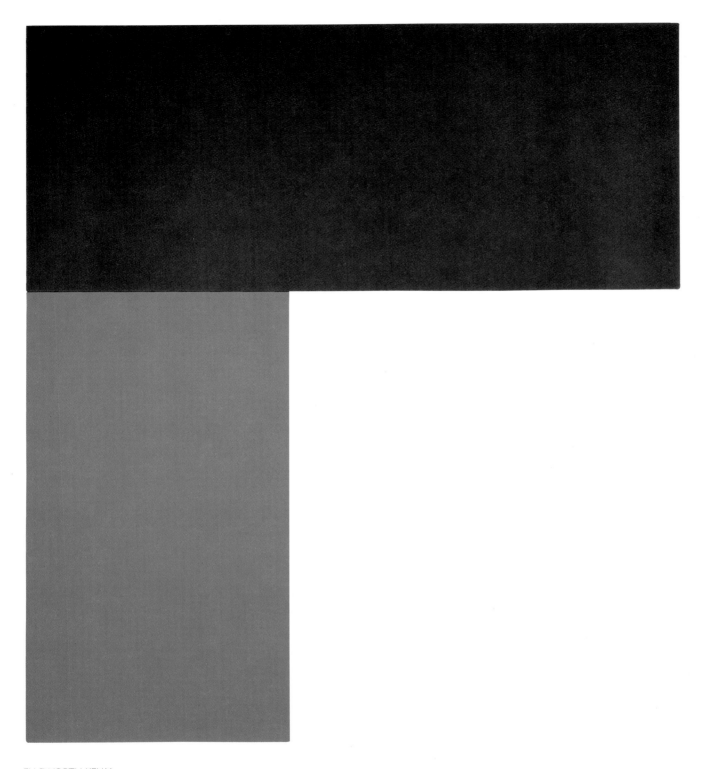

ELLSWORTH KELLY

Chatham III: Black Blue (EK 454), 1971

Oil on canvas, 2 joined panels, overall: 108″ × 96″
(274.3 × 243.8)

Facing page

ELLSWORTH KELLY

Orange Green (EK 352), 1966

Acrylic on canvas, 88″ × 65″ (223.5 × 165.1)

ELLSWORTH KELLY

Green Curve III (EK 488), 1972

Oil on canvas, 91⅝″ × 116″ (232.7 × 294.6)

ELLSWORTH KELLY

Dark Gray and White Panels (EK 551), 1977

Oil on canvas, 2 joined panels, overall: 110″ × 151″
(279.4 × 383.5)

ELLSWORTH KELLY

Concorde Angle (EK 654), 1982

Weathering steel, 108″ × 109″ × 91¼″ × 1¼″
(274.3 × 276.9 × 231.8 × 3.2)

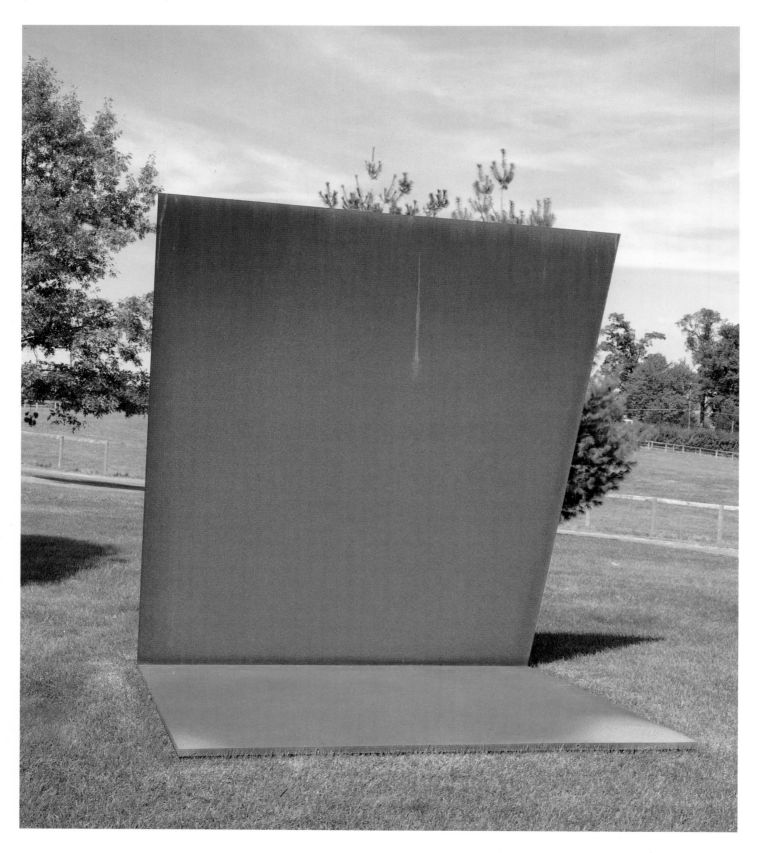

ELLSWORTH KELLY

Phoenix (EK 707), 1984

Stainless steel, 94″ × 66″ × 96″ × ¾″
(238.7 × 167.6 × 243.8 × 1.9)

ELLSWORTH KELLY
Red Curve (EK 732), 1986
Oil on canvas, 41½″ × 205½″
(105.4 × 522.0)

ELLSWORTH KELLY
Blue Violet Curve I (EK 639), 1982
Oil on canvas, 80″ × 120¼″
(203.2 × 305.4)

Frank Stella

People thought my painting was narrow and focused, but it didn't seem that way to me. I thought it was inclusive.... I'm driven by anxiety, but not by doubt. Anxiety to do something and to do it well, but never doubt as to whether to do it in the first place. The answer is always yes.

FRABK STELLA[1]

Frank Stella's art is based on intuition and speculation, and it embraces contradiction and ambiguity as it reflects the complexity of modern life. In this respect, Stella's artistic attitude resembles the adventuresome and speculative character of Robert Rauschenberg. Of course, a critical difference is that Stella's art is based on investigations of space through abstract forms while Rauschenberg's work is imagistic. The idiosyncratic and individualistic nature of Stella's works has been underestimated in the critical literature on him, which usually sees him in the sim-

plistic model of a "problem solver" and creator of "deductive structures." He is a risk taker who is filled with new ideas and willing to experiment on a monumental scale. Stella has said of the formalist discussions of his work, "The main assumption is that you've done it and you know what it's about, and that's simply not true."[2] Also, far from being emotionless or containing mere emblems of emotion, as is often asserted, his works explore the wide gamut of feelings and experiences evoked by abstract forms. The formalist critics would have us believe that in order to be serious Stella must isolate artistic

concerns from other aspects of life. In fact, his work is given its vitality by simultaneous involvement in art and life. This commitment does not diminish the effect of his paintings but increases their resonance. Stella pushes himself and the viewer to the experimental fringes of seeing.

Early in his career, Stella himself encouraged a strictly materialist reading of his art with such often-quoted statements as, "What you see is what you see."[3] Today, with greater historical distance, what we see is that Stella's statements were a reaction to the sloppy emotionalism of later Abstract Expressionism.

He actually identifies closely with the originators of that movement, including Pollock and de Kooning, Gottlieb and Motherwell. More important, what we see is that Stella's work provides a deliberately complex and multifarious artistic experience. The paintings embody intuition as well as logic, illusionism as well as materiality, and feelings as well as structure. At the time, they were new and exploratory. Stella has commented, "It's not clear that they were paintings or that that was a possible way to paint. The whole situation was very problematic."[4] His work before 1970—the year of his first Museum of

Modern Art retrospective—is typically viewed as the antithesis of his later artistic explorations. In actuality, these paintings are not antithetical but contain the seeds of his later art. Ideas pioneered in the early paintings became the foundations of his later career.

The basis of our knowledge of the world is vision. Stella's paintings and later constructions reach out to the viewer and ask her to question the visual world and the processes by which information is collected from it. It is worth noting that the root of the word *abstract* means "to take from," and Stella's art embodies visions and ideas taken from the world around him. He is concerned with the issue of "real" vision versus "pictorial" vision. That is, how the multiperspectival, motion-filled, and boundaryless nature of everyday vision conflicts with "pictorial" vision, which traditionally is static, centrally focused with a single perspective, and contained by framing edges. Stella also brings endeavors outside of painting to bear on his artistic problems. He uses ideas and techniques from such fields as engineering, architecture, and mathematics, in addition to a wide array of unusual methods from the visual arts.

His investigation of the expressive powers of new materials is an important aspect of his experimental thinking. He began with explorations in metallic paint and constructed stretchers in the 1960s and continues today. Recently, he has utilized gravity-denying honeycomb aluminum constructions and etched magnesium painted in crayon, caustic solutions, lacquer, and silkscreen inks. He acts as an amateur chemist, engineer, and inventor. Stella's material experiments are not gratuitous gestures but attempt to solve certain emotional and visual problems. The future will see him in this regard as a successor to such artists as Edgar Degas and Thomas Eakins, whose art was partly driven by material inventiveness and who reflected the experimental sciences of their age.

Stella is also interested in old-master painting, especially the transitional times in art history. This preoccupation reflects the fact that he sees our own age as one of change. His attention is not directed to such periods of synthesis as the High Renaissance or High Baroque, but the times between two eras. Such artists as Correggio, Annibale Carracci, and, above all, Caravaggio—artists who broke the existing order—fascinate him. Similarly, Manet's nineteenth-century conflicts between realism and abstraction, illusionism and the two-dimensional surface obsess him. Stella's intellectual analysis of these artists is balanced by an immediate, passionate, and sensual identification with their works.

Stella's art also reflects other types of experiences. If these interests are viewed conceptually, as he does, they may be seen to play a role in his art. Thus, for instance, fragmented and multifocus vision as one might experience it from a racing automobile is connected with the complex overlapping and interlaced patterns of Stella's Circuit series, the paintings of which are named after the racetracks he visited while traveling on the formula race circuit. Stella has stated, "I think, for everybody, it's the things that you come across in lived life that get translated into the work that you do, and that's something that happens pretty fast and pretty automatically."[5] In this light, Stella's art is not "pure" but "impure"; its very impurity gives it vitality and energy.

Another debate concerning Stella's recent works has centered on whether the later constructions should be called paintings or sculptures. Stella has insisted that these works deal with issues of illusionism that place them unequivocally in the realm of painting. Many critics have asserted that the works' tactility and use of projecting forms and planes make them sculpture. In truth, these constructions have both the three-dimensionality of sculpture and the illusionism of painting. Stella has broken down the barrier between the two media and incorporated essential aspects of both in his works. They are constructed and painted; they feature real and imaginary space. Traditional rules are shattered and radical solutions invented.

The *Marquis de Portago* is one of Stella's twelve seminal Aluminum Paintings created in 1960.[6] The series introduced Stella's first shaped canvases, a leitmotif for his career, and it also contains his first consistent use of metallic paint. In developing the shaped canvas Stella dramatically discarded the Renaissance idea of the picture frame as a window onto space and later notions of it as a neutral boundary for the imagery within the work. Despite some precedents for his idea, Stella's works are a radical departure in the history of painting. For the first time, a painter regularly united the shape of his work with its design. The modest notching in the Aluminum Paintings became the generative idea for the more radical shapes of his later paintings, and his idea has been utilized in a variety of forms by many painters and sculptors of his and succeeding generations.

Initially, the critical discourse on Stella's Aluminum

Paintings was diverse and briefly hinted at the varied ideas in his art. The reviewer for *Art News*, discussing Stella's 1960 exhibition at the Leo Castelli Gallery, wrote that Stella "tendered a homage to Aristotle," and that his paintings were a "sophisticated flirtation with conundrums" which "invoked the protection of a mystagogy."[7] Eventually, the discussion of Stella's early art became dominated by two figures, Michael Fried and William Rubin.[8] Despite minor differences in approach, both saw Stella as a highly successful artistic problem-solver. For them, he was a model of logical process—an artist who reduced painting to its primary function, design on a two-dimensional support. In their view, Stella's success in the Aluminum Paintings was to create undeniably two-dimensional works that totally united design configuration with their overall shapes, and thus reduced the art to a single clearly articulated premise.

Upon initial inspection, *Marquis de Portago* would seem to fit this model. It is a vertical composition of approximately eight by six feet executed in aluminum paint on canvas. It contains twenty-four vertical stripes. Each of the stripes contains two right-angle jogs, the first diverting the course of the stripe and the second return-ing it to its original direction. At the outer edges of the canvas, these jogs terminate in four notches constructed in the canvas stretcher, the wider ones being on the taller, vertical edges and the narrower ones on the horizontal edges.

When *Marquis de Portago* and the other Aluminum Paintings are considered from a different point of view, they ask more questions than they answer. The shape of Stella's canvas, itself, suggests not a two-dimensional but a three-dimensional presence. We read it as a form clearly distinguished from the rectangular wall upon which it hangs. The depth of Stella's stretchers, here slightly greater than the width of one stripe, further contributes to the segregation of the painting from the wall.

In addition, the repeated jogs in such an additive configuration create the illusion of projecting and receding shapes as opposed to either the three-dimensionality of the stretcher or the two-dimensionality of the canvas surface. While the straight sections of the stripes read two dimensionally, the angled areas suggest the corners and edges of raised surfaces. Their repetition only serves to increase this effect. Stella would seek a similar look with two and four parallel lines in his Irregular Polygons (1965–67) and later in his Polish Villages (1971–73); the latter series culminated in three-dimensional shapes that actually project from the surface of the works. In *Marquis de Portago* the pattern made by the jogs runs at a forty-five-degree angle to the direction of the stripes, forming an incomplete diamond configuration—an elusive secondary image—within the composition. If the pattern of the jogs is projected beyond the edges of the canvas, the diamond that is formed is a regular shape (equal on all sides), as opposed to the irregular dimensions of the work as a whole. These two motifs, one a physical presence and the other a mental construct, compete with each other for the viewer's attention. Stella has said:

But the other point is that it is a shaped canvas and the jogs are shaped. Those things are interesting—to have illusionism and to shape the perimeter. The reality of the painting itself, and what it actually did then and still does now is—I think the word is problematic. Things happen in the stripe paintings that are different. I mean, they do something, but maybe they don't do it. I don't think I've gone beyond them, or anyone else has gone beyond them.[9]

The manner in which the stripes are painted creates further ambiguity. Although they are relatively precise, Stella has carefully preserved a handmade and individual touch. When painting the work, he was concerned to tape his lines in such a way that the paint bled into the raw canvas between the stripes, adding a strong note of irregularity and imperfection. In fact, because we clearly see the canvas between the stripes we do not know whether to read the stripes as lines or as edges of thin planes. This preservation of irregular touch—one sign of individuality and personality—is constant in Stella's art and after 1970 exploded in lush, painterly works. The striped design of the Aluminum Paintings also encourages a complex and intricate rather than a simplistic and holistic perception. Most of Stella's Black Paintings of 1958–60 feature a central shape as the source for their biaxial symmetry. As in Renaissance art, the focal point of those paintings is the center of the composition. In the Aluminum Paintings the additive pattern no longer provides a single focal point, forcing the eye to move constantly along the surface; peripheral vision is used as much as central vision. Stella described this latent movement of the stripes as "travelling" bands and likened them to a "force field."[10]

The color of the Aluminum Paintings is both spatially ambiguous and evocative. Although the metallic paint

prevents the atmospheric associations that traditional oil paint can encourage, its reflective character promotes illusional projection into the viewer's space. The enameled surfaces of such later constructions as *The Ramadan* (1988) yield a similar, although more exaggerated, effect (see below). Stella's particular color choice also has associative implications. On the one hand, the silver metallic paint reminds us of the precision of industry. On the other, the particular tone chosen, which is steely rather than bright, gives the works a somber moodiness. When asked about the melancholic character of the Black and Aluminum Paintings, Stella has remarked, "I think the Black Paintings are certainly meant to be that way, and I think the metal paintings were meant to be that way, too. I mean you can be very emotional without slick emotions." He continued, adding that he was concerned that the painting carry the emotion, rather than that the act of painting, in the mode of later Abstract Expressionism, be considered an emotional or even a noteworthy performance.[11]

The titles of Stella's works generally have received little attention, a surprising occurrence since they are often exotic and evocative. Most critics have either ignored them entirely or oddly claimed that their allusive-

ness is intended to prevent our deciphering them. The single thorough investigation of this subject has been Brenda Richardson's catalogue for the Baltimore Museum's 1976 exhibition of the Black Paintings.[12] She discovered that in nearly every case, the titles refer to such conditions as death and urban decay. Although Richardson suggested that those titles might relate to Stella's overall mood during a difficult time in his life, she hesitated to connect the emotions suggested by the titles directly to the feelings generated by the paintings themselves.

Since the 1950s Stella has created lists of titles for his paintings. These lists are sometimes assembled before the works are executed and at other times at the same time or afterward. Each of the lists has thematic consistency. In Stella's early years, the connections between individual titles were indirect and required research such as Richardson's to unravel. Later, the relationships between titles became more obvious. Individual titles in the Exotic Bird series, for instance, were taken from a single book on endangered and extinct birds of the world.

Generally, the unusual character of Stella's titles prods us to further investigation rather than impedes our thoughts about their relationship to the works. If the latter were

Stella's desire, a numerical system would have been adequate. The titles encourage, as do the paintings, prolonged investigation and speculative thought. There are no indications that individual titles within Stella's series are wedded to particular paintings. But there is evidence that the visual appearance, content, and mood of the entire series are closely related to the titles used.

Marquis de Portago is an example of this relationship. The title refers to the young Spanish aristocrat Alfonso de Portago, who was a flamboyant sportsman—jockey, boxer, and flyer. He challenged the professional sports establishment when, through his raw daring, he became an overnight success in automobile racing. The marquis was featured in a *Life* magazine story in April 1956. In May 1957 *Life* did a second photo-essay about de Portago's death. At the age of twenty-eight, he, along with four adults and five children, was killed when his Ferrari crashed at 150 miles per hour in the Italian cross-country race Mille Miglia.

The story of the marquis suits the mood of the Aluminum Paintings and is indicative of Stella's romantic self-image during this period. The Aluminum Paintings concern daring innovation through the exciting invention of the notched canvas and the

use of metallic paint. Stella has particularly associated the four notches and metallic color of *Marquis de Portago* with the fenders of the marquis's racing car. At the same time, the painting's dark tone and hierarchal patterning lend it a constrained, somber sensibility—melancholy seems mixed with adventure. Stella viewed himself as a young outsider challenging the art establishment and perhaps doomed to failure because of his daring. Even recently, after years of success, he refers to himself as nearly alone in his pursuit of new abstract painting modes. Stella's self-image is distinctly romantic, and his interest in the marquis de Portago is prophetic of his later passion for automobile racing, the speed and daring of which play a role in his art.

In the summer of 1967, Stella was commissioned to design a stage set for a new dance, *Scramble*, being created by the Merce Cunningham Dance Company.[13] The Stella set consisted of six horizontal bands of colored canvas—yellow, orange, red, green, blue, and purple—ranging from four to twenty-four feet in length. The canvases were supported on movable metal frames that were suspended above the floor at heights varying from one to eighteen feet. Six dancers were dressed in bodysuits,

each the color of one of the canvases. Merce Cunningham and Carolyn Brown, Cunningham's premier dancer, dressed in black and white costumes respectively. *Scramble* premiered at the Ravinia Music Festival in Chicago on July 25, 1967. During the performance the dancers moved in front of and behind the canvases, so that their bodies were often partially obscured by one or more of them. In addition, the canvases, whose frames were mounted on casters, were moved around the stage during the performance. The effect was one of spatial vibrancy and the activation of fields of color. Cunningham and Brown acted as controlling forces amid the seemingly more random movements of the dance team in their colored costumes.

Stella's experience with *Scramble* is related to *Gray Scramble* (1969). Whereas for the dance the stage set involved real movement, the seemingly restricted design of the painting is activated spatially through the suggested movement of color. Color is one of the most complicated variables with which an artist works. Even today, modern science does not understand all of its properties, and scientific investigations are still conducted to determine the manner in which reflected light leads to the properties of perceived color. Because of its

complexity, color has traditionally been the domain of more romantic and intuitive artists. Until 1962, Stella had deliberately restricted color in his works to no more than two tones. At that time his interest in color exploded in *Jasper's Dilemma* (1962–63; Alan Power Collection) and the following Concentric Squares and Mitered Mazes. Prompted by a discussion of *Jasper's Dilemma,* Stella commented:

The thing that is so overwhelming about Jasper's paintings is how they're constructed, and I don't think people are as aware of it as they should be. But more than any other painter I've been with, Jasper's paintings give you the feeling that you're participating and that you're making the painting. You're drawn into it and you participate in the ideas, and the building up, and the making of the painting. And it's a wonderful feeling and a wonderful experience. And, you know, it's hard for a painting to do that![14]

Stella's statement not only reveals his emphasis on pictorial questioning rather than easy formalist resolutions, but it also shows the important role that Jasper Johns's art played in affirming those ideas.

Stella returned to the issues explored in *Jasper's Dilemma* in *Gray Scramble*. As in the earlier Concentric Squares, Stella chose as a foil for his color exploration a composition of twelve concentric bands. In the Concentric

Squares and Mitered Mazes the bands had either been colored or executed in different values. In works such as *Jasper's Dilemma*, the painting was divided into two sections, one featuring adjoining bands of color and the other bands of value. For the first time, in *Gray Scramble* color and value bands alternate within the same design. Despite the seemingly simple square composition, Stella is playing with combinations of pure value change, value change in color, differences between the warm and cool ends of the spectrum, and the advancing and receding properties of color.

Gray Scramble offers no easy resolution of these different elements. The lack of resolution in the earlier Mitered Mazes led William Rubin to conclude that Stella had "failed to solve the problem of uniting a variety of color juxtapositions with his most complicated of design structures."[15] In fact, the lack of integration between various systems in the painting is not a failure but the meaning of the work. Stella shows that color cannot be measured in the manner that surface design can. In addition, the relationships between different colors are not as readily perceived as those between light and dark tones. The relationship of colors is more theoretical than the units of a gray scale, and thus, for the

artist, color tends to be a matter of intuition. The alternating color and value changes of *Gray Scramble* make its spatial illusionism among the strongest in Stella's works until that time. Yet the illusionism is deliberately inconsistent. The design sequence of concentric bands could suggest either an advancing or a receding motif —either a ziggurat or a bellows seen from the inside. The gray bands progress consistently from higher to lower value from the outer to inner area of the canvas and thus suggest recessional space.

As one reads from the outer edges toward the center, the colored bands are more ambiguous. They proceed from higher to lower values as far as the green band and then reverse—the blue and purple bands are higher in value. In this respect the shapes seem to recede and then advance again. In addition, the property of hot colors to advance and of cool ones to recede is used nonprogrammatically. The colors only generally follow the spectrum. If properly aligned, the red and yellow bands would be switched. From the spectral point of view, the result is that the work seems to project until the red band and to recede after that. Consequently, the visual messages are deliberately conflicting. In *Gray Scramble* Stella is exploring the ambi-

guity and complexity of the spatial properties of value and color, and reminding us of the imprecise, personal, and variable nature of vision.

Flin Flon IV (1969) is part of the Saskatchewan series, which Stella began while teaching advanced painting students at the summer extension session of the University of Saskatchewan in 1967. The paintings in the series, like *Flin Flon IV*, were named after places in the area. The muted colors of *Flin Flon IV*—tan, gray, light green, and slate blue, which are different from the colors that Stella had used up to that point—might derive from the tonality of that northern landscape during its brief summer.

The forms of the Saskatchewan series, however, derive from Stella's Protractors begun earlier that summer, and they are a variation on that larger series. The Protractor series is marked by Stella's use of a protractor shape in a multitude of variations as the central feature of the composition. By selecting the protractor Stella wanted to use a design tool as a device to increase the intuitive nature of his creative process. He could easily move the protractor around a piece of graph paper, tracing its shape in overlapping patterns, erasing selected areas, and thus generating ideas with great

speed and fluidity. The fact that the Protractor series is based on a tool, an object not meant to be seen in the final product, links Stella's work to modern art's long interest in revealing process. His art suggests the adventure and open-ended nature of creative invention.

In the Protractors, Stella deliberately used the precision device of geometers and engineers in a conjectural and not-easily-quantified manner. Stella's art has often been linked to mathematics by the simple fact of the careful measurements he makes to construct his paintings. But Stella's art has a more profound affinity to the complex and speculative developments in pure mathematics of the twentieth century, such as abstract algebra, topology, and vector spaces. The so-called new mathematics of the post–World War II era attempts to substitute ideas for calculations.[16] It opens avenues of exploration, as opposed to the arid formalism that characterized the discipline in the decades before the war. The new mathematicians viewed paradoxes as sure signs of the vitality of the field rather than as threats to neat solutions. In the tradition of Henri Poincaré, who dominated mathematical thought during the beginning of the century, new mathematics encourages intuitive and imaginative

solutions, ones that cross over into other areas of intellectual endeavor. In fact, Stella's Protractor paintings most resemble complex knots, which relate to the recent mathematic fascination with knot theory, an engagement in intriguing, insoluble puzzles. These enigmas parallel the speculative side of Stella's thinking.

Flin Flon is a series of seven works that present visual conundrums of growing complexity. All are painted on either eight- or nine-foot-square canvases. The Saskatchewan series differs from the other Protractors in that the former is not executed on shaped canvases. While this aspect of the works might seem a retreat to traditional pictorial forms, it actually causes the viewer to speculate about figure/ground relationships, an issue that Stella had eliminated from the early shaped canvases. The Flin Flons are all designed around quatrefoils. These were created by placing the bases of four protractor shapes at the sides of the canvas and having their arcs meet at the center. This would seem to be an easy design to analyze, but the fragmentation and overlap of these shapes vary in each composition. There is a system at work here, but it is as difficult to grasp as it is arbitrary. The bases of the four protractors are fragmented so that the

ground overlaps them, yet that ground is not continuous, as is emphasized by the use of different colors. In two of the diagonally opposed quadrants the interlacing patterns are mirror images, although in different colors. In the other two quadrants the mirror image is altered by a diamond pattern created through an extra overlap adjoining the center. In addition, of course, the colors vary in each work, and Stella rotated the canvases in the series so all four orientations are used. In different members of the series, he also added between one and four additional arcs in the areas between the lobes of the quatrefoil. *Flin Flon IV* is oriented so the lower left and upper right quadrants mirror each other, and two additional arcs have been added to the composition in the top half.

Stella communicates the message that his system is arbitrary and idiosyncratic. It obeys no outside logic, only the rules he creates. Thus, visual analysis is extremely difficult and slippery. We feel a harmony in the individual canvases and a relationship between the different works in the series long before we can find the reason behind that instinctual response. Even when Stella's method is understood, the principle tends to slip away in the presences of the varied works. In the Protractor

series, more than in any of Stella's previous works, he is testing and straining the viewer's visual skills.

Flin Flon IV, like the Protractor paintings in general, was profoundly influenced by Islamic art. Stella's acute sensitivity to his visual environment and the manner in which he uses and transforms other art forms is underestimated in the critical evaluations of his work. In 1963 Stella traveled to Iran with Stanley Woodward, a wealthy retired diplomat and art collector, and Henry Geldzahler, then curator of twentieth-century art at the Metropolitan Museum of Art. Stella was captivated by the architecture and elaborate decorative patterns that had long been part of the Islamic tradition. The artist recalled:

The trip was a very big experience for me. It was an alien world, but not that alien, and the architecture is so terrific. I'd been involved with my life in New York and just seeing something so different yet so familiar was fascinating. There's all that interlacing, or interweaving, in barbarian decoration—I'd touched upon it in my dissertation at Princeton. Things double back on themselves, like snakes swallowing their tails. This came out in the Protractor series.[17]

Stella's statement clearly indicates his fascination with the elaborate, abstract ornament decorating Islamic buildings. Stella had already investigated an artistic tradition based on interlaced linear patterns, which would prepare him for the experience in Iran. He had written his senior thesis at Princeton University on Hiberno-Saxon manuscript illumination. Generally, Stella's fascination with Islamic art places him in the tradition of Western artists from Delacroix to Matisse who have found inspiration in the exoticism of the Near East. Stella was also interested in the central role this abstract art form played in the culture and how it expressed the system of divine symmetry understood to underlie all aspects of life. When Stella's interlaced patterns are compared to Islamic ornament, the differences are also readily apparent. Islamic ornamental patterns are rigidly repetitive, and, despite their elaborateness, the order of the patterns is easily perceived. The overlapping, which was probably based on textile and rug weaving, is logical and continuous. Stella's work, in contrast, reveals the artist's willfulness and his desire to make his art according to a unique vision.

During the time he was making the Protractor series, Stella also expressed his strong interest in the art of Henri Matisse. Like Matisse, Stella has been misunderstood as a decorative artist, when he is in fact concerned with fundamental issues of perception and creativity. Both Matisse and Stella deal with the conflicting desires for intuition and logic, for formal strength and sensual abandon. Matisse's art, which walks a thin line between abstraction and figuration, later affected the increasing anthropomorphism of Stella's abstract shapes in his Exotic Birds; Matisse's interest in figure/ground relationships and illusionism versus surface paralleled Stella's continuing concern with those issues; and Matisse's use of unexpected colors to orchestrate his compositions provided an example for Stella. Stella has said of the general confluence of these interests: "You know, I was thinking about a combination. It was really Matisse, and painters who had traditionally been interested in Orientalism. When I really experienced it firsthand, I was completely taken by it too. It was exotic. Everything was truly uplifting."[18]

The Protractors are most closely related to Matisse's *Dance* (1909) at the Museum of Modern Art, New York, and to the large murals and studies for *The Dance* commissioned by Albert Barnes. In Matisse's works the curves of the dancers' bodies enliven the picture space and produce a buoyant mood, as do the arcs of the Protractors. Matisse's distortion of anatomy and intersection of body parts, where limbs simply disappear or become joined to another figure, are devices no less arbitrary than Stella's intersecting protractors. The arched design of the Dance mural in Paris (Musée d'Art Moderne de la Ville de Paris) and the one in Merion, Pennsylvania, resembles the shaped Protractor canvases and portends Stella's interest in the relationship between painting and architecture. The Protractors, including *Flin Flon IV*, energized Stella's art and foreshadowed the even more aggressive shapes and spatial discoveries of his Polish Villages.

Between 1971 and 1973 Stella created his Polish Village series. The paintings are regarded in the Stella literature as marking a distinct break in the artist's career. Yet, despite their important innovations, the Polish Villages are closely related to ideas Stella was already pursuing. The Polish Villages were based on a group of forty-two drawings, of which forty were utilized. The initial thirteen were executed in two versions. In the first version, different geometric areas of the painting are distinguished not only by color but by texture through applied layers of felt, paper, and canvas. The second version uses thick plywood, pressboard, and Masonite for the different sections. The last twenty-seven examples include a third vari-

ation with obliquely tilted planes projecting from the surface of the works. *Chodorow I* (1971) is derived from one of the first thirteen sketches and is the first version of its design.

The Polish Villages continue and extend the fanciful and illogical interpenetration of shapes that had marked the Protractors. They prolong Stella's interest in pictorial illusionism, not as a system that attempts to mimic the three-dimensional structure of objects, but as a contradictory method of free invention that enlivens art. In pursuing this goal, he has alternated between curved and angular forms. The Polish Village series particularly recalls spatial ambiguities that had been set out in his Irregular Polygon series of 1966, but that extend further back to the illusional projection of the jogs in *Marquis de Portago*. During our discussions, Stella indicated that the spatial incongruities in the Protractor series were related to those in the Polish Villages, and he concluded: "All of the possibilities are taken into account. Not *all* of them, I mean, but I begin to accept variety as a way of doing things."[19]

Chodorow I abounds with visually exciting uncertainties.

Do we read the red plane to the right as a trapezoid flat with the surface or see it as a rectangle, either receding into space or, alternatively, pro-

jecting toward us? The white area of canvas to its lower left suggests a base or a floor, the white stripe to its immediate left a corner, and the blue rectangle next to that, a front or back wall. The red encourages reading the shape as projection, while the blue reads as recession. Yet the blue rectangle itself is held to the surface by the tan plane that extends from above and seems to overlap it. Such visual puns and reversals take place throughout the entire canvas. Their contradictions— the simultaneous suggestion and denial of illusional space —energize the visual experience. Stella has said:

I made the kind of individual, personal decisions where things intersected or overlapped.... In the Polish pictures, because you know where a band would stick in, I could both extend it to be parallel, I could narrow it to a point, and so that way I could arbitrarily change it.[20]

Despite the connections between Stella's earlier works and *Chodorow I*, the painting is simultaneously more assertive and more subtle in its illusionism than many of Stella's previous works. The assertiveness comes through the angularity of the forms, which imply deeper space than the shallow interlaced patterns of the Protractors. The sharply contrasting colors also heighten the contradictory spatial messages as opposed to the pastel tones of

Flin Flon IV. In terms of subtlety, the small textural differences between attached canvas and felt create their own spatial clues. The fine lines that Stella left between each of the shapes allow us to see the canvas support and thus assert the two-dimensionality of the entire work in contradiction to all the spatial clues that forms, colors, and textures provide.

The illusional inventiveness of the Polish Villages is a culminating point in the history of linear perspective in Western art. Even Leonbattista Alberti, who in the fifteenth century wrote the first treatise on its use in the arts, noted the exciting paradoxes perspective systems could create. Soon after the discovery of linear perspective in the early Renaissance, Masaccio deliberately misused it in *The Trinity* (1427; Florence, Santa Maria Novella) to communicate the divinity of God by placing him in two locations simultaneously. By the middle of the century, Paolo Uccello was both admired and criticized by contemporaries for his elaborate perspective systems, which imaginatively extended the limits of pictorial illusionism. In the twentieth century, one of the most thoughtful artists to study form and space and to explore the inherent contradictions between the two-dimensional canvas and the

three-dimensional character of vision was Juan Gris. Born to the modern world's relativistic view and bred on Cubism's fractured space, Gris built his art on spatial contradictions. His *Guitar with Sheet Music* (1926; private collection) bears a striking resemblance to Stella's *Chodorow I* for its imaginary projections, its conflicting spatial messages, and its implausible planar reversals. Gris's inquisitive, speculative mind resembles Stella's, as does his intention to humanize abstraction through viewer involvement. In the presence of his works, we ask, where are we standing, what is our orientation, and what are we seeing? These two artists challenge the eye and the mind.

Stella's art concerns the exploding of boundaries and the questioning of assumptions. As part of this endeavor, he makes connections with other enterprises. The Polish Villages also relate to Stella's long-held interest in architecture. As early as 1959 Stella related *Jill* (Lawrence Rubin Collection), one of the Black Paintings, to the ziggurats that had interested him on a trip to Central America. In addition, the art historian Robert Rosenblum has made the convincing suggestion that such paintings as *Dade City* (1963; Lawrence Rubin Collection), in Stella's Dartmouth series, his most dynamically shaped composi-

tions up to that time, were inspired by a visit in March 1961 to Frank Lloyd Wright's campus for Florida Southern College in Lakeland. The design of the college's inter-locking, diamond-shaped buildings indeed finds reso-nance in the paintings.[21] Stella has long been an admirer of Wright's architec-ture, and since 1959 he has maintained a close friendship with the architect Richard Meier, who is known for the manner in which he turns simple geometry into complex spatial experiences.[22] Most recently Stella has proposed his own architectural design for the Kunsthalle in Dresden. When asked about the archi-tectonic nature of the Polish Villages and their relationship to architecture, Stella responded, "I think that's true, and, of course, they were named after buildings, and the architecture and the underly-ing structure, and the archi-tectonic ideas are part of it."[23]

Chodorow I is indeed an architectonic painting. The lower quadrant is the most contained and stable area. As discussed above, its central section may be read as a roomlike spatial schema. The upper area of the painting is anchored by the tan vertical rectangle, as chimneys anchor Wright's domestic buildings, and the projecting green, blue, and red bars are cantilevered like dramatic rooflines from that rectangle,

the uppermost bar acting as a cornice for the work. Stella's paintings, of course, have none of the practical require-ments of architecture. Their speculative and imaginative sensibility is closest to archi-tectural drawings. Drawings by contemporary architects, as well as those from Frank Lloyd Wright's estate, were frequently exhibited in New York galleries around 1970—the time Stella conceived the Polish Villages. The best of these drawings combine structure with imaginative experiments in space and form in a manner that paral-lels Stella's painting ideas.

The dual goals of construc-tion and free invention in *Chodorow I* and the other Polish Villages also led Stella to an interest in Russian Constructivism. The dynami-cally intersecting planes of the Polish Villages, their material variety, and relief construction are similar to works by El Lissitzky, Kasimir Malevich, Vladimir Tatlin, Liubov Popova, and others. This relationship is not in the nature of an influence because the Polish Villages were well underway by the time Stella began to contem-plate their affinities with Russian Constructivism.[24] But the similar sensibility tells us something about Stella's work. The most interesting of the Russian Constructivists were inspired by modern sci-ence and engineering, but

they refused to relinquish their idealism and creative fantasy to the pragmatic demands of actual industrial projects. Their works walk a tightrope between the fantas-tic and the possible, allowing the artists to maintain their artistic freedom. In contrast, the Constructivist art that Stella most dislikes is that of the Bauhaus, where he believes such freedom was limited by a rigid program-matic doctrine. Stella high-lights the ironic affinities between Bauhaus classicism and the architecture of the fascists and Stalinists.[25]

The titles of the Polish Villages were inspired by the book *Wooden Synagogues* (1959).[26] Given to Stella by Richard Meier, the book is one of the few existing records of a remarkable group of build-ings in Eastern Europe that were destroyed by the Nazis. The individual and handmade appearance of the wooden synagogues, seen in the sur-viving photographs, attracted Stella. The buildings are also startling in their inventive shapes. Constructed over gen-erations, they featured irregu-lar massing and multiple, steeply pitched roofs project-ing into space. Their singular character is enhanced by the fact that they no longer exist, and thus they suit the distinc-tive nature of Stella's artistic experiments in the Polish Villages. Although Stella intended no specific political

statement in his title refer-ences to the destroyed Polish synagogues, his works cer-tainly support a deep belief in the power of creative freedom.

Given the conjectural and experimental disposition of Stella's geometric works and his overwhelming desire to show that abstraction is the dominant form of twentieth-century art, it is not entirely surprising that he would eventually investigate the way figuration might be incorpo-rated in an abstract art form without also introducing (what he considers to be) the limiting or retrogressive character of recognizable objects. It was necessary for Stella to challenge and rein-vent the figurative tradition, the dominant legacy in paint-ing, in order to show the range and flexibility of his abstraction.

Between 1975 and 1977 Stella created fifty-six works in his Exotic Bird series, including *Laysan millerbird* (1977). The Exotic Birds, like the Protractors, began with mechanical drafting instru-ments. In this case, Stella used, not the relatively simple shape of the protractor, but the type of drafting instru-ments known generically as irregular curves. In 1975, in a California antique store, he happened on an elaborate set of templates—nearly one hun-dred variations—used in nau-

tical design. Later, he also purchased sets of French curves and railroad curves.

The discovery of these templates and the use of the French curves greatly increased Stella's vocabulary of forms. More important, these engineering and design tools gave his work the impression of organic shapes while not being so specific as to limit their interpretation— each was a distinct family of shapes with slightly varied members. The nautical templates—three are seen in *Laysan millerbird*, in the upper and lower center and in the upper right corner— feature a single sweeping curve that varies from compressed to attenuated. They appear like stretching muscles or sweeping wings. The railroad curves are long, nearly straight bars or slightly irregular angles used to make the subtle gradings of railroad beds. In *Laysan millerbird* a railroad curve appears to the left side, and a bar is seen in the upper section. Four more bars form a loose W configuration. Because of their shaftlike design, the railroad curves may be equated with inanimate natural objects like tree branches. The French curves are the most complex and self-contained shapes, featuring double opposed curves; a blue one appears to the lower left of *Laysan millerbird*, and a purple variation dominates

its center. The French curves have asymmetrical balance, suggesting a sort of upper and lower body as found in many living creatures; they exhibit their own type of contrapposto. These templates and drafting instruments provided Stella with a transition from geometry to organicism.

Like the Protractors, the irregular curves allowed Stella an improvisational freedom in designing the work. In making the original drawings, he could intuitively place these instruments on the paper, move them around easily until the motif satisfied him, and then trace that motif. Stella called this technique his "own version of coming free on the surface," and said it eliminated the "need to erase, paint or redo."[27] As was the case with the Protractors, Stella creatively undermined the intended use of these objects —tools themselves became his pictorial vocabulary.

Stella was certainly aware of the Surrealist use of automatic techniques and the manner in which the Abstract Expressionists emptied automatism of its magical connotations and used it in a more pragmatic fashion. (As an undergraduate at Princeton University, Stella had studied with William Seitz, who had written the first doctoral dissertation on Abstract Expressionism, and who emphasized its utilization

of automatic techniques.) Robert Motherwell referred to the Abstract Expressionist use of automatism as "plastic automatism" and called it "much more a device for formal invention."[28] Stella's discovery of the irregular curves is his own version of automatism, a technique that gives him a beginning point for the work and promotes free invention.

In *Laysan millerbird* and the other Exotic Birds, the compositions suggest the notion of living presences. The placement of shapes is irregular rather than symmetrical. The forms do not dramatically penetrate each other as they do in the Polish Villages; rather, they gently touch, rest upon one another, spring from common origins, and slightly overlap. All of this suggests the way creatures intermingle in the natural world. Stella has commented, "Those little pieces, those amoebic shapes, many of them are point to point, and they're touching and doing something to each other."[29] The designs of the irregular curves and the manner in which they interact, as well as Stella's color choices, evoke an atmosphere of delicacy and gentleness. Indeed, the Exotic Birds are among Stella's most lyrical paintings.

The artist's original drawings for the Exotic Birds were translated into foam-core maquettes, in which the irreg-

ular curves became solid objects projecting at various angles from the surface. Their projection raised the issue of real and illusional space, as had the projecting and receding panels in the last paintings of the Polish Villages series. But, rather than an interaction of planes, the irregular curves acted as figures that demanded an environment. Stella was thrown into the situation of dealing with a traditional figure/ ground relationship. He was confronted with the problem of creating a ground that both avoided the conventional atmospheric illusionism of realist painting and was more vibrant than the flat fields of earlier modernist abstraction. He found two resolutions. One was to paint the field actively and thus energize it, an idea that had already been used by the Abstract Expressionists, especially Willem de Kooning. The second was to extend the field into space and actually to penetrate it. The fact that the overall shape of the Exotic Birds is rectilinear in the manner of traditional pictures highlights these innovations. Stella has said:

I just accepted the backgrounds, which I couldn't up until then accept. And I guess that was conventional in some ways, except that the background was the support. When the background and support become one and interact in a successful way with the imagery or figuration or what-

ever you want to call it, you have something that is different.[30]

In *Laysan millerbird* the green outer field is creased horizontally and extends forward along the centerline of the composition. The yellow inner ground is creased vertically and folds backward—a dynamic spatial relationship is created. In addition, the two fields are penetrated in six areas by irregular curves, as if the organic forms are emerging from and disappearing into a continuous space. These penetrations, although modest, are extremely significant for Stella's later work. Even in the Polish Villages and Brazilian pictures, as in traditional relief sculpture, the rear plane remains unbroken. The penetrations in the Exotic Birds hint at the continuous space that surrounds all parts of the composition and is terminated only at the wall on which the work hangs. Subsequently, Stella expanded this idea in the Indian Birds, Circuits, and Moby Dicks.

The Exotic Birds were industrially fabricated in honeycomb aluminum in two versions of each design, one three times the original and the other five-and-one-half times the original in size. After the lengthy fabrication, the individual parts were delivered to Stella's studio, where they were painted and assembled. Strangely, the

monumental scale—*Laysan millerbird* is nearly thirteen by nineteen feet—heightens the delicacy and grace of the work. It fills our visual field and looms above us, but it is hard to believe such huge forms could float as ethereally as these do. Stella's use of honeycomb aluminum, a sophisticated industrial product normally employed for aeronautics, makes this effect possible. His experimentation with new materials is a continuation of the speculative attitude that informs his art generally. Stella said: "One of the biggest problems I had with the Exotic Birds was how to paint them. I tried out ground glass and other new materials. We got heavier at painting as I painted on the reliefs, and I think they got better. If I were to do it again, I think I'd paint them all like this."[31] In *Laysan millerbird* and the other Exotic Birds, not only does the inventive and energetic paint handling stand out, but the edges of the irregular curves remain unfinished so one is encouraged to see the honeycomb aluminum core and appreciate the structure of the work as well as the paint application.

As with Stella's other works, the Exotic Birds are also related to the artist's visual and emotional discoveries outside of the world of picture making. During the time Stella was painting the Exotic Birds, he married Harriet

McGurk and soon afterward began a family. It would seem that the joyful mood of the Exotic Birds may be associated with this new domestic happiness. McGurk also introduced Stella to a passion of hers, bird-watching, and in 1976, when he was beginning the Exotic Birds, he traveled to the Florida Everglades to study rare birds. Bird-watching requires the ability to identify elusive presences by shape and distinctive color amid a continuous field of foliage. Although *Laysan millerbird* and the other Exotic Birds are abstract compositions, they might be likened to the visual experience of such delicate creatures, poised upon irregularly shaped branches amid a continuous background. Stella titled the Exotic Birds after a list provided in a book by James C. Greenway, Jr., *Extinct and Vanishing Birds of the World*.[32] Like *Marquis de Portago* and those for the Polish Villages, Stella's titles for the Exotic Birds have a romantic twist. They suggest experiences that are wondrous, and things that are rare in our world.

Between 1980 and 1982, in his most concentrated period of artistic activity, Stella fashioned sixty-eight large reliefs, the Circuits. In *Vallelunga I* and *Misano*, two of the Circuits, the visual tension, ambiguity, and complexity

that Stella had courted in his earlier career reached an explosive culmination. The reliefs explore the limits of the artist's organizational abilities and the fringes of what the eye and mind can comprehend. In them, Stella combined geometric and organic forms with his most assertive paint handling and spatial projection up to that time. Speed of vision and agility of the mind are emphasized.

Implied motion had long been an aspect of Stella's work. It is found in the repeated jogs of *Marquis de Portago*, the advancing and receding space of *Gray Scramble*, and the delicately balanced forms of *Laysan millerbird*. In 1971 Robert Rosenblum perceptively wrote about the implied speed of Stella's Running V compositions: "Few, if any, paintings in the history of art have created so compelling a kinesthetic response in the spectator, who is swept up by the velocities of these pictorial highways (as many as twenty-seven lanes wide!) and forced, as if behind the wheel of a speeding car, to follow the abrupt careening shifts in the road."[33]

Rosenblum's analogy is prophetic of Stella's later interest in automobile racing. The titles of the Circuits refer to various automotive race-tracks throughout the world, and Stella's interest in racing extends back at least to

Marquis de Portago. In 1976 Stella was commissioned by BMW to paint one of their race cars. The resulting black-and-white grid overlaid with lines made using French curves, which interact with the contoured body of the car, is related to the Circuits. The design may have been inspired by the patterns painted on test models for wind-tunnel tests—visualizations of shapes at high speeds. Stella subsequently became friends with two of the BMW team drivers, Ronnie Peterson and Peter Gregg, and began traveling to Europe to see Grand Prix circuit racing. Both Peterson and Gregg, who were internationally known drivers, met tragic ends. Peterson died as a result of injuries suffered at the Monza Grand Prix in 1978, and Gregg committed suicide in 1980. Gregg and Stella earlier had been involved in a severe accident when their Porsche overturned on the way to Le Mans. In 1980 Stella dedicated an edition of prints, The Polar Co-Ordinates, to Peterson. Although Stella never participated in a professional race except to ride in practice runs, he purchased a Ferrari and is known to drive it very fast. Auto racing is marked by its competitive excitement and danger. Although the danger in art is not physical, these are features that mark Stella's

work. As in Stella's art, precise engineering and preparation are required in car racing. In the sport and in Stella's work, these are all dedicated to challenging, intuitive, and high-risk activity. The artist has commented:

One of the things that's true about racing is that it's very hard-edged. There is all the equipment. But the experience is very blurred, and it's slurred and slipping and sliding and there's a lot of banging and denting and maiming, unfortunately, at the end.... And I think you know it happens in real life, and you try to get it to happen in painting, to make the paintings come out, to break out of their limits, and be expressive, to happen on more than one level.[34]

The relationship between automotive racing and Stella's Circuits may be understood conceptually. The reliefs picture neither race cars nor particular tracks, but they do give the sensation of dizzying speed. *Vallelunga I* and *Misano* present us with a maze of forms, some of which suggest the twisting roadways of racetracks. Sudden changes in direction are like the swerving path of a race car at speed. Our visual reflexes must be somewhat akin to those of the driver. The multiple spatial levels of the Circuits and the tangle of bright colors and indistinct forms suggest objects that are seen for only a split second. The viewer is thrown back

upon her reflexes, and the eye moves quickly from area to area, relying on instantaneous impressions as it tries unsuccessfully to grasp the entire composition. Stella has indicated that the title Circuits not only signifies racetracks but also refers to "the intricate connections within the structural networks of the picture."[35] One also thinks of the elaborate electronic and computer circuitry that is now common in the modern world, but even more of that most complex chemical and electrical circuit, the human brain.

Vallelunga I and *Misano* embody raw visual energy. In *Vallelunga I* the delicate forms and the figure/ground balance of *Laysan millerbird* are torn asunder. Although Stella's Indian Bird series of 1978–80 had opened up this ground, the integrity of the forms had remained intact, as did their delicate edge-to-edge relationship. In *Vallelunga I*, we are confronted with a whole new level of pictorial dynamism. The viewer is thrust into a labyrinth of pictorial creation. *Vallelunga I* also features a new vocabulary of forms. Here the more self-contained irregular curves have been discarded and replaced by a new drafting instrument, the Flexicurve. Suited to the new compositional energy, the Flexicurve may be bent to form any number of shapes. It is seen to the left side and

lower right section of *Vallelunga I*. The Flexicurve is simultaneously a found object, which the artist may quickly apply to the composition, and one he may manipulate with the twist of his wrist. It is a graph of energy and suggests both twisting racecourses and long fluid brushstrokes.

The other shapes used in *Vallelunga I* also have a new origin. They are the leftover pieces, the negative shapes, from previous foam-core maquettes that Stella found lying around his studio. Here chance, intuition, and feeling play an essential role. The defining feature of these found objects is irregularity. They refuse to coalesce into recognizable images. Stella altered many of them—most often by cutting away their centers—which contributes to the difficult spatial reading of the Circuits. These forms are primarily rectilinear, as opposed to the curvilinear character of the Flexicurves. Thus, Stella forces two radically different types of expression—the rectilinear and the organic—to collide. For example, the green angular projection to the upper right side of *Vallelunga I* has thrust into the white meandering curve to the left—a powerful force and counterforce are expressed.

Like several other early Circuits, *Vallelunga I* continues the rectangular framing edge found in the Exotic

Birds. Although this may have been a gesture toward tradition in the face of so much that is new in the work, paradoxically it highlights the degree to which the artist has punched through the background plane. Using found shapes as templates to cut out that plane, Stella has eliminated at least fifty percent of its surface area. It is as much a dynamic shape as any of the other forms in the work. In addition, the shapes in *Vallelunga I* project nearly two feet from the wall. The maze into which we are thrown is both two- and three-dimensional.

Stella's method of painting *Vallelunga I* also differs from that of the Exotic Birds. Whereas freedom of paint application and such exciting effects as glitter were pioneered in the Exotic Birds, the effect of paint there is to differentiate the parts of the composition. In the Circuits, paint was applied before the pieces were assembled. Colors, like the forest green found in *Vallelunga I*, were painted on widely varied shapes eventually placed in diverse locations. Our visual tendency to unify areas with like colors is at odds with the dissimilar character of the forms and their placement. The viewer reacts to the brushwork, which is among the most freely executed of Stella's career, on a visceral level. The painterly incidents—

scumbled pigment, perspectival lines, broad brushstrokes, spontaneous doodling—are immediately compelling. Among the most interesting effects in *Vallelunga I* are several areas of converging lines to the lower left and right sides of the relief. They suggest the linear scaffolding for one-point perspective. This illusional spatial system contrasts dramatically with the real space of the projecting relief forms. Here the two artistic modes hit head on.

Misano (1982) offers an even more energetic composition than *Vallelunga I*. The background plane has been entirely eliminated, and shapes appear to float freely, hung from supports that cannot be seen when one stands directly before the relief. The roughly rectilinear outline of the work does not so much limit it as give it a sense of compressive forces. The energies within struggle against an invisible barrier. In *Misano* the Flexicurves are tightly coiled, and they vary in expressive thickness from wiry extensions to muscular bands. In the lower left corner the combination of a ring and two coiled curves creates a helix effect. Cutout shapes, like the one in the upper left quadrant, consist of more open space than solid matter.

The colors in *Misano* are even closer in tone and value than those in *Vallelunga I*, so

that the contrasting effects of unity and diversity are even greater. In *Misano* the surface of each form contains a rough crosshatched pattern, which derives from the parabolic curves of polar coordinates. Polar coordinates are used in cartography and mathematics to determine latitudinal and longitudinal location, and their complex curving lines are formulated on specially designed graph paper. Stella traced the lines from this graph paper onto the maquettes for the Circuits. One version of each Circuit was created in magnesium; only in this version were lines etched into the surface. The lines create a series of directional vectors, which further fragment the forms. The ragged etched lines also personalize the industrial components of the work and complement Stella's rough-edged paint application. The magnesium works are the most successful versions of the Circuits. Stella has again used science and mechanics in a personal and experimental manner to reinforce his individual artistic vision.

Misano and the other Circuits are closely related to the mature stage of Abstract Expressionism. It is interesting to note that the earlier Exotic Birds in their biomorphism bear a relationship to Abstract Surrealism and early Abstract Expressionism. Like the Abstract Expressionists,

Stella converted an organic sensibility into fields of energy, where the viewer is engaged not by the drama of presences within the composition but by the sheer force and vitality of the artist's process. The Circuits relate to Motherwell's more expressive Elegies to the Spanish Republic, Gottlieb's Bursts, and such de Kooning paintings as *Excavation* (1950; The Art Institute of Chicago), but their closest affinity is with Pollock's drip paintings. The heroic scale of Pollock's works, the dense allover patterning of his compositions, the speed suggested by his lines, and even the projecting rather than recessional surface resulting from layers of pigment piled one onto the other are inspirations for Stella's Circuits.

The Circuits were created in a period of intense artistic activity that resulted in Stella's longest involvement with a single series. The reliefs themselves have a density, energy, and intricacy unrivaled in his career. In his own words, he had been working "flat out."[36] The series was broken in 1983 by Stella's decision to accept an invitation to deliver the Charles Eliot Norton Lectures at Harvard University; he was only the second artist asked to participate in that prestigious event. By coincidence, Stella had been invited to be

an artist-in-residence at the American Academy in Rome. His residence in Rome gave him the opportunity to study Italian painting in preparation for the lectures.

Stella's investigation of Italian art led to a profound interest in Caravaggio. It is not surprising that Caravaggio, one of the most forceful and dramatic artists in history, should attract Stella. The Italian master diverted the harmonies of the Renaissance and the eccentricities of Mannerism into a new, dynamic, and emotional art through his powerful manipulations of form, light, and space. Caravaggio's searing light, his authoritative use of positive and negative space, and his illusion of dramatically projecting figures give his works a life-or-death intensity. Over time, Stella traveled to see nearly all of Caravaggio's extant paintings. The most exotic of his trips was a voyage to the island of Malta to view the huge *Beheading of John the Baptist* (1608; Malta, Cathedral of San Giovanni dei Cavalieri). Twelve reliefs of 1983 and 1984, the Malta series, relate to this trip.

Mellieha Bay (1983), one of the Malta series, is both connected to the Circuits and breaks strikingly from them.

The Circuits are concerned with ever-growing complexity. Their intensity comes from the rich visual experience of

form, space, color, and texture. By contrast, *Mellieha Bay* engages us through its simplicity. (This shift reminds one of how the exhaustive intricacy of Analytic Cubism was transformed into the sparer Synthetic Cubism.) Stella's transition was influenced by both Caravaggio and the architecture of Malta. *Mellieha Bay* is even more architectonic than the Polish Villages. The architecture of Malta appealed to Stella because it is spatially inventive and individualistic; it features an irregular and humanized geometry. The rectilinear masses of the houses are piled asymmetrically on ascending slopes and set against the curving shape of the fortified harbor. An abstraction of all of these forms and even the sandstone color of the buildings and gray tone of the water can be found in *Mellieha Bay*. Stella was clearly affected by a romantic view of Malta's history: "For a time some special power radiated out of that island. It was as if a sort of uranium was there, as if they possessed the power of the pyramids."[37]

The visual excitement and adventure of Malta merged in Stella's mind with the experience of Caravaggio's painting. *The Beheading of John the Baptist* depends far more on pictorial drama than on narration for its powerful effect. In it, John has already been

killed, but the beheading is yet to come. The forcefulness of the painting lies in the contrast between the slow, sweeping movement of the arch to the upper left and the aggressive, twisting posture of the executioner in the lower center. Similarly, Stella utilizes the fiberglass ring in the upper left of his relief to direct the eye to the aggressively intersecting forms below. The angular projection extending to the right even reminds us of the executioner's knife, which protrudes menacingly from a sheath strapped to his back, and the red comma at the center of Stella's composition is reminiscent of the pool of blood in the Caravaggio. In the lower section of *Mellieha Bay* angular and curvilinear shapes and positive and negative forms strain against each other. Like *The Beheading of Saint John the Baptist, Mellieha Bay* contrasts the contemplative feelings inspired by the empty ring with contentious emotions derived from the active and thrusting shapes below it.

Mellieha Bay, like the Circuits, is constructed largely from found materials that have been resuscitated by the artist. The fiberglass rings, for instance, were scraps from another project. The forms used, however, are simpler and larger than those in the Circuits. In addition, Stella chose not to paint the surface

of the relief. Instead, he used a wide variety of materials, including fiberglass, etched aluminum, etched magnesium, and sheet steel to provide color and texture. He created powerful and restrained effects by contrasting the warm earthy tones of the fiberglass with the coldness of the metals. Varied emotional responses are encouraged by the distinction between the roughly etched magnesium sheets and the aluminum fragments that contain delicate lettering derived from a manufacturer's printing plate. The nearly overwhelming convolutions of the Circuits give way to the more monumental and tempered expression of the Malta series, influenced by the compositional structure of Caravaggio. In *Mellieha Bay* Stella showed that pictorial power and emotional drama equal to those of the Circuits could be derived from restraint rather than excess.

Throughout his career, Stella has been concerned with invigorating abstract art through pictorial drama. Geometry was an imaginative tool for him. In his early works it was used in exciting new ways to show the complexity of thought and vision. Real space and illusionism interacted and conflicted as a way of heightening pictorial tension. In the Exotic Birds, the Indian Birds, and the

180

Circuits, Stella found a way to transform geometry into an organic sensibility. The forms of these paintings were accompanied by a new energetic and improvisational paint handling. The physical activity of the artist became the driving force behind the Circuits. In the Malta series, Stella largely eschewed painterly effects to refocus on the presence of large geometric forms.

Stella's Cones and Pillars, his major series from the mid-1980s, combined monumental geometric elements with his more painterly and organic discoveries, thus integrating the two major traditions of abstraction—the biomorphic and the constructivist. The cones and pillars function as dramatic actors, while the more painterly areas largely serve as their stage. Unlike the irregular curves, which resemble organic forms, the cones and pillars are such simple shapes that they refuse to give up their geometric character. Yet, paradoxically, they interact so as to seem lifelike in a theatrical manner. In them we have two types of abstract actors—the pillars tend to be more passive, while the cones are more active. The cones penetrate and thrust, while the pillars huddle, overlap, and group. This relationship is evident in *La scienza della fiacca* (1984). A single cone dramatically

pierces the composition from the upper right, while the three pillars seem to tumble over one another in the face of its challenge. Unlike the gentle lyricism of the Exotic Birds, *La scienza della fiacca* presents heroic and monumental forces. The linear striations on the cones and pillars encourage the sense of titanic presences bulging into our space, as well as continuing Stella's longtime dialogue between two- and three-dimensional vision. These stripes of varying widths yield one of the most convincing illusions of three-dimensionality in Stella's work—the cones and pillars seem full-bodied and robust. Yet we are simultaneously aware that the shapes are flat and that illusionism has been used to fool the eye. We are prompted to consider the creative theatricality of the entire artistic enterprise. Stella has said: "One of the things that we were working on a lot in the Cones and Pillars was bending and curving, which gave forceful shapes, but at the same time the issue has always been that we're working in the planar surface."[38]

The ground of *La scienza della fiacca* was the first part of the work executed. Stella painted the constructed canvas, which contains a semicircular and a trapezoidal section, with energetic brush drawing in blue, white, red, and flesh tones. The brush-

work contrasts with the geometry of the cones and pillars, providing an environment for their dramatic action, but, because of the forcefulness of both brush drawing and color, there is no sense of traditional atmospheric space. Rather, the ground asserts itself as equal but opposite to the geometry of cones and pillars. Stella's ground is indebted to the art of Willem de Kooning, in which assertive brushwork created an environment around his figures without traditional spatial recession. The de Kooning retrospective at the Whitney Museum of American Art, which Stella visited, took place in 1983, just before the Cones and Pillars were begun, and works Stella saw there served as models for his use of this idea.

Stella's interest in Russian Constructivism, for its abstract and experimental character, has been mentioned in relation to the Polish Villages, yet it is also apparent in the Cones and Pillars. The geometric forms of the series might generally be regarded in light of works by such artists as Lissitzky, Popova, and Tatlin. Yet the differences are perhaps more telling than the similarities. Stella's Cones and Pillars differ in aggressive scale, the interaction of geometric design and paint handling, and the dual presentation of real and illusional

space. Most important, the reference points for Russian Constructivism, as seen in Lissitzky's Proun compositions like *Proun GK* (1922; New York, The Museum of Modern Art), are to be found in architecture. (This is the reason that cones and pillars, uncommon building shapes in the modern world, are largely exempted from their vocabulary of forms, in which rectilinear shapes dominate.) The Constructivists' works recall buildings and urban design—constructed and inanimate objects. Stella's cones and pillars interact in a figurative manner, yet they more successfully avoid direct references to the outside world than do the Russian Constructivist works with their architectural associations. Thus Stella's works are simultaneously more dramatic and more abstract than Russian Constructivist art.

The figurative drama—without figuration—of forms in the Cones and Pillars points to one of the primary sources for the series. Between 1982 and 1984 Stella created a group of prints called *Illustrations after El Lissitzky's Had Gadya*, in which the forms of the cones and pillars first emerged.[39] The individual prints were titled after lithographs by Lissitzky entitled *Had Gadya* (1919). The "Had Gadya," a moralizing folkloric song, is part of the Passover cere-

mony. It involves one force overcoming another in succession and teaches the impermanence of earthly power. A portion of the song goes, "Then the dog came and bit the cat; Then a stick came and beat the dog; Then a fire came and burnt the stick." The song provides a direct narrative sequence of a stronger power overcoming a weaker one. From it, Lissitzky created simplified illustrational imagery in a folkloric and slightly Cubist manner. Although Lissitzky's style did not interest Stella, the idea of an abstract narrative, inspired by the original song, did. In Stella's view, narration was another aspect of traditional painting that might be appropriated to vitalize modern abstraction. In *La scienza della fiacca* the interplay between the aggressive cones and passive pillars acts out the strong/weak force narrative of "Had Gadya." Stella's cones and pillars capture the violent energy of the song without the need to describe figures or events; they thus maintain both immediacy and universality. Their forcefulness has an epic quality that led Stella to his next group of constructions. In his Moby Dick series of 1986–89 Stella pushed the dramatic implications of the Cones and Pillars series even further.

The Moby Dick series began with a new shape, the wave. Previously, the projecting forms in Stella's constructions had been planar—their surfaces were flat and their shaped design had been confined to their edges. By contrast, the waves are curved-space structures; they feature both curved edges and curved faces. Thus, they fill space in a much more thorough manner than do the planar projections. Stella's concerns with movement through space are well served by the waves, which undulate along their entire surfaces. The waves appeared in the Loomings series of 1986, where they played a minor role as accents to the dominant cones and pillars; wave forms may be traced back to Stella's print series *Illustrations after El Lissitzky's Had Gadya*. In the prints, however, the waves are two-dimensional configurations and thus a far less significant discovery than the curved-space structure that eventually emerged in the Moby Dick series. In turn, the two-dimensional wave shape in the prints was probably suggested by the fifth plate in Lissitzky's *Had Gadya*, "Then a fire came and burnt the stick," which contains a relatively restrained vortexlike configuration somewhat similar to the waves. (This is one of the very few images that Stella derived from the Lissitzky prints.)

Stella's invention of the wave, however, is marked by original methods. The waves began as pencil drawings on paper, which feature interconnected lines that surge, curl, and crest in freely undulating patterns. Unlike Stella's previous designs for compositions, which had utilized drafting tools, the drawings rely entirely on the artist's imagination and his freehand form invention. They show Stella's ability to create a family of lively shapes that embody ideas of metamorphosis, growth, and interaction without losing their abstract character. Once satisfied with the shapes in a particular drawing, Stella cut them out and transferred them to bristol board, which he could bend and twist three dimensionally. Then, the waves were incorporated in the maquettes for entire compositions. The constructions were professionally manufactured in steel and aluminum and delivered to the studio for painting and assembly. Stella named the series Moby Dick.

The second group of works in the Moby Dick series was the Belugas, which consists of thirteen reliefs, including *The Ramadan* (1988). In addition to the wave configuration, the early Belugas feature round dish-shaped bases decorated with designs inspired by Chinese lattices and angular patterns derived from the designs for cast-iron, ornamental rain gutters. *The Ramadan* exhibits the three-dimensional dynamism of the curved-space structures. The gray and light green wave at its center twists outward as it surges toward the upper right sector of the composition; it turns inward as it flows toward the lower left side into the concavity of the dish and surges outward once more at the bottom. The sea green wave at the bottom crests outward and spills over the edge of the work, curving behind the dish. The lighter green tendril to the left extends not only beyond the construction but so far behind the face of the relief that it nearly touches the wall on which it hangs. In Stella's earlier works the viewer was never sure whether such a side view of the constructions should be taken into full account. In *The Ramadan*, as well as the other Moby Dicks, the answer is provided; the sides and backs as well as the front surfaces of all the forms are painted. The full spatial flow of the work is meant to be seen as the viewer moves from a frontal to lateral positions. Stella has noted:

I don't know why I had such trouble painting on the back sides of pieces, but the biggest breakthrough we had with the Moby Dick pieces was just accepting the fact that you're going to paint on both sides of everything. When I just accepted it and didn't give it a second thought, then I didn't have a problem.[40]

The fluidity of shapes in the Moby Dick series and the ease with which the forms came to the artist reminded him of water and led to the term *waves*. In that nomenclature Stella is suggesting an analogy with the most fluctuating substance most of us experience in daily life. His waves do not look like water but rather embody the concepts of change and movement. Ever since Leonardo da Vinci made his drawings of water formations (c. 1500; Royal Library at Windsor Castle), water has served as a visual model for the flow of life forces. The idea of liquidity is evident not only in the shapes of Stella's waves but also in their paint application. This is especially true for the sea green wave at the center of *The Ramadan*, which features thin, reflective lacquer washes.

In the Moby Dick series Stella also pays homage to Picasso's Boisgeloup paintings of the early 1930s. Stella has a deep admiration for this period of Picasso's work and was able to study carefully a number of the Boisgeloup paintings during the 1980 Picasso retrospective at the Museum of Modern Art. Inspired by his love for the voluptuous Marie-Thérèse Walter and perhaps by the rhythms of the sea, Picasso created a series of bathers, nudes, and still lifes of unrivaled sensuality. He transformed the female body into rhyming shapes—ovoids and undulating curves. At the same time he renewed his use of consistent value changes, which had been absent from his work since early Cubism, to suggest mass and volume.

Stella learned from Picasso's lively organic forms and his suggestions of volumetric projection as well as from the mood of spirited and fluid creativity in Picasso's paintings. Yet he did not succumb to Picasso's figuration. *The Ramadan* most closely resembles Picasso's *Bather with Beach Ball* (1932; New York, The Museum of Modern Art), a work that inspired Roy Lichtenstein in a very different manner. The leaping and reaching gray curves at the center look like Picasso's bather, and the geometric configuration to the left takes after the cabana in Picasso's painting. After finishing *The Ramadan* Stella repainted its central area a golden yellow, which is similar to the golden triangles on the bathing suit of Picasso's bather.

The organic waves in *The Ramadan* are vitalistic, and by contrast the geometric U-shaped patterns to the upper left appear fragile. They are simultaneously supported by and lashed by the waves and seem analogous to a frail vessel adrift amid powerful forces. As is the case with the waves, they do not resemble a ship so much as the concept of something fabricated and vulnerable amid titanic natural forces. Whereas the waves in *The Ramadan* are fully volumetric, the shiplike form is actually flat and its geometric shapes only tentatively suggest volume through their concentric pattern, although they finally deny the illusion because of the projection of the red outer band.

The circular shape of the concave, cast-aluminum dish that forms the base for *The Ramadan* complements the vortexlike pattern of the waves. It provides real space into which the waves recede, and the Chinese lattice design painted on its surface gives the illusion of further recession. The base suggests a global environment for the forms attached to it, and the lattice intimates an exotic, faraway locale.

The Ramadan gives the impression of high adventure —an artistic voyage into new aesthetic waters. It is dominated by powerful surging forces accompanied by an undertone of frailty. This reading is supported by the titles for the Moby Dick series, which were taken from chapters of Herman Melville's classic American novel. While Stella's individual constructions are not related to the specific chapters for which they are named—the Ramadan was Queequeg's Muslim day-long fast—the reference to *Moby Dick* reveals the breadth of Stella's ambitions. He sought to create epic works parallel to Melville's majestic book. Stella has said of *Moby Dick*, "There's no depression in it, every line is up."[41] At first this would seem a strange interpretation of Ahab's dark and obsessive journey. Stella, however, is considering the book from Ishmael's point of view and finds it a quest for self-knowledge. Ishmael develops, as does the reader, increasing depth and sophistication of character through his adventure. In a similar manner, Stella continues to grow and learn through the process of making his art, his own Promethean quest that requires energy, boldness, and a willingness to challenge the odds.

1 Frank Stella, "A Conversation with Frank Stella," interview with Avis Berman, *Architectural Digest* (September 1983), 74 and 78.

2 Frank Stella, interview with the author, September 16, 1992.

3 Frank Stella as quoted in Hilton Kramer, "Frank Stella: 'What You See Is What You See,'" *New York Times*, December 10, 1967, sect. 2, 39.

4 Stella, interview with the author, September 16, 1992.

5 Ibid.

6 The *Marquis de Portago* exists in two original versions. The Meyerhoff painting is *Marquis de Portago* (Version I). After Stella had designed the entire Aluminum Paintings series in sketches, he painted three of them, of which the Meyerhoff painting was one. Stella then decided that the aluminum color was too dark. He acquired a lighter aluminum color and began the series again. It was the lighter-colored *Marquis de Portago* that was shown in the Leo Castelli exhibition of the Aluminum Paintings.

7 Valerie Petersen, "Reviews and Previews," *Art News* 57, no. 9 (November 1960), 67.

8 Michael Fried, *Three American Painters: Kenneth Noland, Jules Olitski, Frank Stella* (Cambridge, Mass.: Harvard University, Fogg Art Museum, 1965). Michael Fried, "Shape as Form: Frank Stella's New Paintings," *Artforum* 5 (November 1966), 18–27; William Rubin, *Frank Stella* (New York: The Museum of Modern Art, 1970).

9 Stella, interview with the author, September 16, 1992.

10 Rubin, *Frank Stella*, 47.

11 Stella, interview with the author, September 16, 1992. Stella originally considered using the title *Marquis de Portago* for a Black Painting.

12 Brenda Richardson, *Frank Stella: The Black Paintings* (Baltimore: The Baltimore Museum of Art, 1976).

13 Calvin Tomkins, *The Bride and the Bachelors* (New York: Penguin Books, 1962), 279–81.

14 Stella, interview with the author, September 16, 1992.

15 Rubin, *Frank Stella*, 79.

16 Carl B. Boyer, *A History of Mathematics* (New York, London, Sydney: John Wiley and Sons, 1968), chapter 27.

17 Calvin Tomkins, "Profiles: The Space around Real Things," *The New Yorker*, September 10, 1984, 84.

18 Stella, interview with the author, September 16, 1992.

19 Ibid.

20 Ibid.

21 Robert Rosenblum, "Introduction" in Lawrence Rubin, *Frank Stella Paintings, 1958–1965: A Catalogue Raisonné* (New York: Stewart, Tabori & Chang, 1986), 19.

22 As one result of their common interests, Meier has written perceptively about Stella in Richard Meier, *Shards by Frank Stella* (London and New York: Petersburg Press, 1983).

23 Stella, interview with the author, September 16, 1992.

24 This observation was first made by Philip Leider, in *Stella since 1970* (Fort Worth: The Fort Worth Art Museum, 1978), 93–98.

25 Stella, interview with the author, September 16, 1992.

26 Maria Piechotka and Kazimierz Piechotka, *Wooden Synagogues* (Warsaw: Arkady, 1959).

27 William Rubin, *Frank Stella, 1970–1987* (New York: The Museum of Modern Art, 1987), 64.

28 Robert Motherwell, "The Modern Painter's World," *Dyn* 1, no. 6 (November 1944), 12.

29 Stella, interview with the author, September 16, 1992.

30 Ibid.

31 Ibid.

32 James C. Greenway, Jr., *Extinct and Vanishing Birds of the World* (New York: American Committee for International Wildlife Protection, 1958).

33 Robert Rosenblum, *Frank Stella* (Harmondsworth and Baltimore: Penguin Books, 1971), n.p., near illus. 23.

34 Stella, interview with the author, September 16, 1992.

35 Rubin, *Frank Stella, 1970–1987*, 98.

36 Tomkins, "Profiles: The Space around Real Things," 92.

37 Rubin, *Frank Stella, 1970–1987*, 128.

38 Stella, interview with the author, September 16, 1992.

39 Rubin, *Frank Stella, 1970–1987*, 131–35.

40 Stella, interview with the author, September 16, 1992.

41 Ibid.

FRANK STELLA

Marquis de Portago (Version I), 1960

Aluminum paint on canvas, 93½″ × 71½″
(237.5 × 181.6)

FRANK STELLA

Gray Scramble, 1969

Alkyd paint on canvas, 69" × 69"
(175.3 × 175.3)

FRANK STELLA

Flin Flon IV, 1969

Polymer paint and fluorescent paint on canvas, 96" × 96"
(243.8 × 243.8). National Gallery of Art, Washington, D.C.,
Robert and Jane Meyerhoff Collection

FRANK STELLA

Chodorow I, 1971

Felt and canvas collage, 108″ × 106″
(274.3 × 269.2). National Gallery of Art,
Washington, D.C., Robert and Jane
Meyerhoff Collection

FRANK STELLA

Laysan millerbird, 1977

Mixed media on aluminum metal
relief, 154″ × 225″ × 25″
(391.2 × 571.5 × 63.5)

188

FRANK STELLA

Vallelunga I, 1981

Mixed media on aluminum
metal relief, 114″ × 128″ × 20″
(289.6 × 325.1 × 50.8)

FRANK STELLA

Misano, 1982

Mixed media on etched
magnesium, 107″ × 126″ × 22″
(271.8 × 320.0 × 55.9)

189

FRANK STELLA

The Ramadan, 1988

Mixed media on cast aluminum,
113" × 102½" × 26" (287.0 × 260.4 × 66.0)

190

FRANK STELLA

La scienza della fiacca, 1984

Oil, urethane enamel, fluorescent
alkyd paint, acrylic, and printing ink
on canvas, magnesium, aluminum,
and fiberglass, 143″ × 151″ × 30″
(363.2 × 383.5 × 76.2)

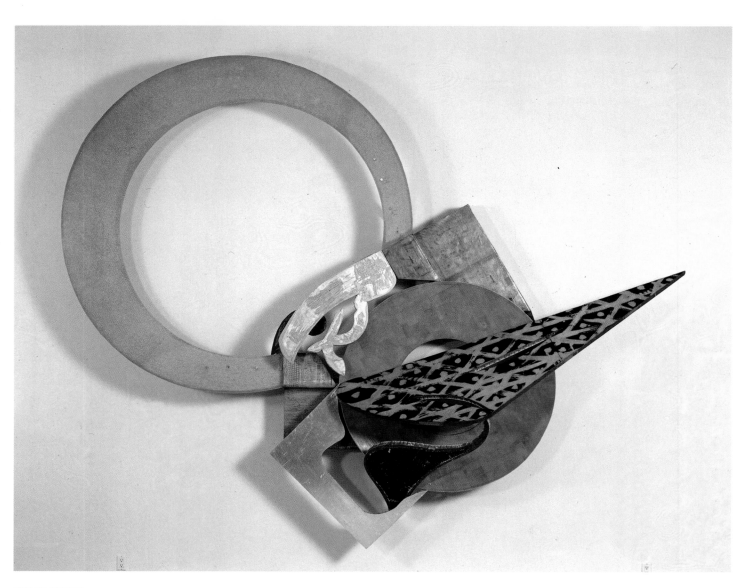

FRANK STELLA

Mellieha Bay, 1983

Metal and fiberglass wall
construction, 138″ × 173″ × 42″
(350.5 × 439.4 × 106.7)

Selected Bibliography

Jasper Johns

Bernstein, Roberta. *Jasper Johns' Paintings and Sculptures, 1954–1974: "The Changing Focus of the Eye."* Ann Arbor, Mich.: UMI Research Press, 1985.

Crichton, Michael. *Jasper Johns.* Rev. ed. New York: Harry N. Abrams and the Whitney Museum of American Art, 1993.

Francis, Richard. *Jasper Johns.* New York: Abbeville Press, 1984.

Gablik, Suzi. "Jasper Johns's Pictures of the World." *Art in America* 66 (January 1978), 62–69.

Rose, Barbara. "Decoys and Doubles: Jasper Johns and the Modernist Mind." *Arts Magazine* 50 (May 1976), 68–73.

_____. "Jasper Johns: Pictures and Concepts." *Arts Magazine* 52 (November 1977), 148–53.

_____. "Jasper Johns: The Tantric Details." *American Art* 7 (Fall 1993), 46–71.

Rosenthal, Mark. *Jasper Johns: Work since 1974.* London: Thames and Hudson, 1988.

Rosenthal, Nan, and Ruth E. Fine. *The Drawings of Jasper Johns.* Washington, D.C.: National Gallery of Art, 1990.

Roy Lichtenstein

Alloway, Lawrence. *Roy Lichtenstein*. New York: Abbeville Press, 1983.

Boime, Albert. "Roy Lichtenstein and the Comic Strip." *Art Journal* 28 (Winter 1968–69), 155–59.

Coplans, John, ed. *Roy Lichtenstein*. New York: Praeger, 1972.

Cowart, Jack. *Roy Lichtenstein, 1970–1980*. New York: Hudson Hills Press, 1981.

Deitcher, David. "Lichtenstein's Expressionist Takes." *Art in America* 71 (January 1983), 84–89.

Fry, Edward. "Inside the Trojan Horse." *Art News* 68 (October 1969), 36–39, 60.

Hindry, Ann, ed. "Special Roy Lichtenstein." *Artstudio* (Paris) 20 (Spring 1991).

Waldman, Diane. *Roy Lichtenstein*. New York: Harry N. Abrams, 1972.

____. *Roy Lichtenstein*. New York: Solomon R. Guggenheim Museum, 1993.

Robert Rauschenberg

Bernstein, Roberta. "Robert Rauschenberg's 'Rebus.'" *Arts Magazine* 52 (January 1978), 138–41.

Cage, John. "On Robert Rauschenberg, Artist, and His Work." *Metro 2* (May 1961), 36–51.

Feinstein, Roni. *Robert Rauschenberg: The Silkscreen Paintings, 1962–1964*. New York: Whitney Museum of American Art, 1990.

Hopps, Walter, with an essay by Lawrence Alloway. *Robert Rauschenberg*. Washington, D.C.: National Collection of Fine Arts, 1976.

Kotz, Mary Lynn. *Robert Rauschenberg: Art and Life*. New York: Harry N. Abrams, 1990.

O'Doherty, Brian. "Rauschenberg and the Vernacular Glance." *Art in America* 61 (September–October 1973), 82–87.

Rose, Barbara. *Rauschenberg*. New York: Vintage Books, 1987.

Stuckey, Charles F. "Reading Rauschenberg." *Art in America* 65 (March–April 1977), 74–84.

Swenson, G. R. "Rauschenberg Paints a Picture." *Art News* 62 (April 1963), 44–47, 65–67.

Tomkins, Calvin. *Off the Wall: Robert Rauschenberg and the Art World of Our Time*. New York: Penguin Books, 1980.

Ellsworth Kelly

Axsom, Richard H. *The Prints of Ellsworth Kelly: A Catalogue Raisonné, 1949–1985.* New York: Hudson Hills Press, 1987.

Baker, Elizabeth C. *Ellsworth Kelly: Recent Paintings and Sculptures.* New York: The Metropolitan Museum of Art, 1979.

Bois, Yves-Alain, et al. *Ellsworth Kelly: The Years in France, 1948–1954.* Washington, D.C.: National Gallery of Art, 1992.

Coplans, John. *Ellsworth Kelly.* New York: Harry N. Abrams, 1971.

Goossen, E. C. *Ellsworth Kelly.* New York: The Museum of Modern Art, 1973.

Hindry, Ann, ed. "Special Ellsworth Kelly." *Artstudio* (Paris) 24 (Spring 1992).

Rose, Barbara. "Ellsworth Kelly's New Paintings: A Search for Reasonable Order." In *Ellsworth Kelly: Curves/Rectangles.* New York: Blum Helman Gallery, 1989.

Sims, Patterson, and Emily Rauh Pulitzer. *Ellsworth Kelly: Sculpture.* New York: Whitney Museum of American Art, 1982.

Storr, Robert. *Ellsworth Kelly: New Work.* New York: Blum Helman Gallery, 1988.

Upright, Diane. *Ellsworth Kelly: Works on Paper.* New York: Harry N. Abrams, in association with The Fort Worth Art Museum, 1987.

Frank Stella

Frackman, Noel. "Tracking Frank Stella's Circuit Series." *Arts Magazine* 56 (April 1982), 134–37.

Leider, Philip. *Stella since 1970.* Fort Worth: The Fort Worth Art Museum, 1978.

____. "Shakespearean Fish." *Art in America* 78 (October 1990), 172–91.

Richardson, Brenda. *Frank Stella: The Black Paintings.* Baltimore: The Baltimore Museum of Art, 1976.

Rosenblum, Robert. *Frank Stella.* Harmondsworth and Baltimore: Penguin Books, 1971.

____. "Stella's Third Dimension." *Vanity Fair*, November 1983, 86–93.

Rubin, Lawrence, with an introduction by Robert Rosenblum. *Frank Stella Paintings, 1958–1965: A Catalogue Raisonné.* New York: Stewart, Tabori & Chang, 1986.

Rubin, William. *Frank Stella.* New York: The Museum of Modern Art, 1970.

____. *Frank Stella, 1970–1987.* New York: The Museum of Modern Art, 1987.

Stella, Frank. *Working Space.* Cambridge, Mass., and London: Harvard University Press, 1986.

Index

Index

Photograph Credits

Richard Carafelli, page 188 top
Gamma One Conversions, pages 49, 58, 59
Neil A. Meyerhoff, Inc., page 163
National Gallery of Art, Washington, Dean Beasom, pages 85, 134
National Gallery of Art, Washington, Edward Owen, pages 51 top, 55, 88–96, 129–31, 132 right, 133, 135, 160, 161, 164 bottom, 185, 186, 188 bottom, 189–91
Glen Steigelman, Inc., page 136
Dorothy Zeidman, pages 51 bottom, 54